THE RENAISSANCE AND
MANNERISM IN ITALY

THE HARBRACE HISTORY OF ART

ALASTAIR SMART

THE RENAISSANCE
AND MANNERISM
IN ITALY

with 178 illustrations

HARCOURT BRACE JOVANOVICH, INC.

For Lydia Clare Marita

N
6915
.S63
1971

Library of Congress Catalog Card Number: 76–113711
ISBN 0–15 576595–7 PAPERBOUND
ISBN 0–15 176825–0 HARDBOUND

*Printed by Buchdruckerei Winterthur AG, Switzerland
Bound by Van Rijmenam n.v., The Netherlands*

Contents

PART FOUR The High Renaissance in Venice and The North

NOTE

Measurements are given in inches, with centimetres in brackets. Height precedes width.

CHAPTER ONE

Introductory: The Renaissance

The idea that the 15th century in Italy constituted a new age, in which art and scholarship made a fresh beginning by going back to the forms and values of classical antiquity, is not one that has been invented by later writers. It was present in the minds of men living at the time. The father of art history, Giorgio Vasari, writing in the mid-16th century, called this phenomenon *rinascita*, 'rebirth', which is what 'Renaissance' literally means, and traced its origins to the late 13th century, when Giotto, among painters, had made a decisive break with Byzantine traditions which had been paralleled by comparable developments in the other arts. Vasari perhaps exaggerated the degree to which it was a complete break with the past. Certainly many later critics, including the famous Swiss historian Jakob Burckhardt, have tended to do so: it is important, for example, to recognize the continuing strength of religious forces throughout the period. But the break was nevertheless there.

In Florence in the mid-15th century, almost all educated men took the view that a new epoch had begun. The Middle Ages had contrasted the light of Christian civilization with the darkness of pagan antiquity. Petrarch, a slightly older contemporary of Chaucer, was the first to dissent from such a model of history. For him classical Rome was the only true measure of cultural achievement; he looked forward to a time in which those yet unborn might 'find a way back to the clear splendour of the ancient past'. The sense that what was modern could emulate but never hope to surpass the great works of the ancients was expressed by Alberti, whom we shall meet as an architect but who – in characteristically Renaissance fashion – was equally renowned as a poet, musician,

7

athlete and scholar: 'I believed ... that Nature, the mistress of things, had grown old and tired. She no longer pro-duced either geniuses or giants, which in her more youth-ful and more glorious days she had produced so marvel-lously and abundantly.' But Alberti put this statement in the past tense; it is from the dedication of his *Della pittura*, of the 1430s, and this dedication was to his friends Brunel-leschi, Donatello, Luca della Robbia, Ghiberti, and al-most certainly Masaccio – the leaders of the new movement in architecture, sculpture and painting.

Admittedly the desire to emulate antiquity was not entirely new: Charlemagne had been hailed as a second Augustus, and his court had been the centre of an in-fluential revival of classical learning; but neither the Ca-rolingian 'renaissance', nor that of the 12th century, which gave birth to the great universities, can compare either in the richness or in the comprehensiveness of its achievement with the 15th-century Renaissance in Italy. By comparison with that vast cultural tide, which, appearing first in Florence, manifested itself with equal vigour in Padua, Venice, Mantua, Rome and many other cities, these ear-lier 'renaissances' seem but tributary rivers.

The Renaissance in Italy was the product of a new urban civilization, centred upon rich city-states that vied with each other in commerce and in the pursuit of power and glory. The programme inaugurated in Florence in the year 1401 for the sculptural decoration of the Cathed-ral precincts must be seen in this light; and patriotic considerations lie behind many of the other important commissions of the period. The guilds had long assumed a large responsibility for the embellishment of the city with works of art, and in the early 15th century they enjoyed increased wealth and power. Further, the rise of a rich *bourgeoisie* encouraged private patronage to an extent hith-erto unknown. The example set by Cosimo de' Medici, 'Pater Patriae', who was himself likened to Augustus because of his encouragement of the arts and letters, was followed by others, such as Palla Strozzi, Tommaso Spi-nelli and Felice Brancacci. Moreover, the increase in secu-lar patronage encouraged a new freedom in the choice of subject-matter, and one of the most notable features of Renaissance art, whether in Florence or elsewhere, is the

scope that was now given to portraiture and to represen-
tations of scenes from classical mythology (or *poesie*); the
one being a natural reflection of that desire for immortal
fame which Burckhardt singled out as a dominant char-
acteristic of Renaissance man, and the other providing a
visual equivalent of the poets' imitations and emulations
of such Latin authors as Ovid and Horace.

Yet most of the commissions given to painters, sculp-
tors and architects during the Renaissance were of a reli-
gious nature. Among the painters of the period, such great
figures as Masaccio, Piero della Francesca, Bellini, Leo-
nardo, Michelangelo, Raphael, Correggio and Tintoretto
all produced their supreme works in the service of the
Church, whether directly through ecclesiastical patronage
or indirectly at the behest of some private individual or
public body. Even Titian, whose most original works are
his *poesie* and his portraits, emerges at the end of his long
life as one of the profound religious painters of the High
Renaissance. The history of sculpture presents a similar
picture, and the tragic tone of the great religious works
that crown the careers of both Donatello and Michel-
angelo, the supreme sculptors of the 15th and 16th cen-
turies, seems far removed from the spirit of confidence in
human endeavour that we normally associate with Re-
naissance art. Indeed, in respect of Tuscan art, Vasari's
'three ages' – the three main phases of development into
which he divided the period from Cimabue in the 13th
century to his own times – all conclude upon a note of
despair: the 'first age', after the impetus provided by Giotto
and his immediate followers, reels under the impact of the
Black Death; the second under that of Savonarola (and
nothing better illustrates the changed climate of thought
in late 15th-century Florence than the last agonized works
of Botticelli, of which the qualities of late Donatello are
curiously prophetic); and the third under the still more
potent influence of the Counter-Reformation, of which
the effects were various, ranging from the melancholia ex-
pressed in Michelangelo's *Last Judgment* and in his frescoes
in the Cappella Paolina to that general sense of guilt which
is typified by the famous letter addressed by the early 16th-
century artist Ammanati to Ferdinand I, with its warn-
ings against the sinfulness of representing figures in the

nude and its earnest recommendation that 'those already executed ... should be covered up', so that Florence might 'cease to be regarded as a nest of idols, or of lustful pro-vocative things, which are highly displeasing to God'.

In our approach to the art of the Renaissance, we should therefore avoid the temptation to make easy gen-eralizations. No period of history, perhaps, was more complex, and the splendid tapestry of creative achieve-ment that stretches over the two centuries between the birth of Masaccio in Florence and the death of Tintoretto in Venice was woven from variegated strands: the emula-tion of antiquity, that primary inspiration which justifies the term 'Renaissance' and which by the early Cinque-cento took precedence over the imitation of Nature; the study of human anatomy, bringing with it a new under-standing of the very nature of Man; the unashamed delight in the human body which informs the *poesie* of Correggio and Titian, but which must be set against the prudery of an Ammanati; the creation, in the Renaissance portrait, of a mirror capable on the one hand of reflecting the individual personality and on the other of giving expres-sion to an ideal of human dignity and perfectibility; the application to design, whether in architecture or in the arts of painting and sculpture, of mathematical ratios cor-responding to the harmonious order which Renaissance man perceived at the heart of the universe; the concept of man as the lord of creation, conflicting with the older medieval insistence upon his inherent sinfulness and low-liness in the sight of God, but inspiring the artist to give a new dignity and humanity to his interpretations of hal-lowed religious themes; the exploration of external nature, which was to give rise to the independent art of landscape painting; the development of the easel picture and the birth in Venice of a new art of colour orchestration – of all these characteristics and innovations is the art of the Renaissance compounded.

Ghiberti and his contemporaries in Florence

In the year 1401 the most influential of the Florentine guilds, the Arte dei Mercanti di Calimala (finishers and dyers of wool cloth) announced a competition for a pair of bronze doors for the Baptistery of San Giovanni. With the inauguration of this enterprise, which led to an extra-ordinary burst of creative activity centred upon the Cathedral and its workshops, a new chapter opens in the history of European art and architecture. The competition was judged in the following year, and the prize went to the young Lorenzo Ghiberti. Ghiberti and his principal rival in the competition, Filippo Brunelleschi, together with the youthful Donatello, who as Ghiberti's apprentice was to assist him in the work, sum up in their personalities and in their achievement the qualities that determined the character of the Renaissance style in Florence.

The competition reliefs submitted by Ghiberti and Brunelleschi have been preserved, and a comparison be-tween them tells us much (*Ills. 1, 2*). The subject chosen was the *Sacrifice of Isaac*, a subject that could not fail to extend the powers of the contestants, since it embraced a wide variety of different images – old age, youth, draped and nude figures, landscape forms and animal life, to-gether with those distinctions in dramatic expression that were required by the representation of violent action (in the figure of Abraham), submissive surrender (in that of Isaac) and swift motion (in the intervening angel).

Brunelleschi's composition is more dramatic than Ghi-berti's, but Ghiberti's conception has a greater dignity. Where Brunelleschi was content with a design in which the action moves chiefly across the surface, in Ghiberti's relief there is a novel suggestion of space which represents the greatest advance in the treatment of landscape up to

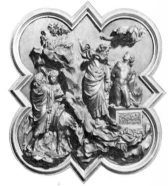

1. LORENZO GHIBERTI (1378–1455). *Sacrifice of Isaac, 1401–2. Gilt bronze 18 × 16 (45 × 38). Bargello, Florence*

2. FILIPPO BRUNELLESCHI (1377–1446). *Sacrifice of Isaac, 1401–2. Gilt bronze 18 × 16 (45 × 38). Bargello, Florence*

this date. Here Ghiberti made experiments in the grada-
tion of distances, giving his foreground forms higher relief
than those in the background – innovations that over
twenty years later were to be developed with still greater
subtlety in his *Porta del Paradiso* (*Ill. 3*). Moreover, whereas
Brunelleschi cast his figures separately, and independently
of the background to which they were then pinned, in
Ghiberti's panel the relationship between the figures and
the background of landscape and sky is of the most inti-
mate nature, and only one figure – that of Isaac – was cast
separately. What is perhaps of still greater significance is
that the nude figure of Isaac in Ghiberti's relief was mod-
elled directly upon the antique. Such qualities would have
excited interest at the time; and the sheer mastery shown
by Ghiberti in his technical handling of bronze relief-
sculpture may well have been decisive.

Perhaps a further factor in Ghiberti's favour was the
ease with which he was able to assimilate, within the
context of a style rooted in the Gothic tradition, the new
taste for the classical. His first Baptistery doors – now
on the north side, but originally at the east entrance, where
they were displaced by the *Porta del Paradiso* – adhere to
the general pattern established nearly a century earlier by
Andrea Pisano in his south doors: the narrative scenes
(devoted to New Testament subjects) are twenty-eight in
number and therefore relatively small, and they are set into
Gothic quatrefoil frames. Forming, as it does, a link be-
tween the late 14th-century development within the Go-
thic style which we call International Gothic and the
more austere, more 'classical' tendencies that first mani-
fested themselves in 15th-century Florence, the art of Ghi-
berti would have been all the more acceptable by virtue of
its transitional character, its happy combination of the old
and the new.

In 1425, a year after the first doors were set in place,
Ghiberti received the commission for a new pair of gilt-
bronze doors to face the Cathedral, on the Baptistery's
east side. So splendid are these that they moved Michel-
angelo to declare that they were worthy to be the Gates of
Paradise – hence their name. They differ fundamentally
from his first doors: the number of scenes is reduced from
twenty-eight to ten, and, as in his own two reliefs and

3 *(opposite)*. LORENZO GHIBERTI
(1378–1455). *Porta del Paradiso,*
1425–52. Gilt bronze 180×99
(427×251). Baptistery, Florence

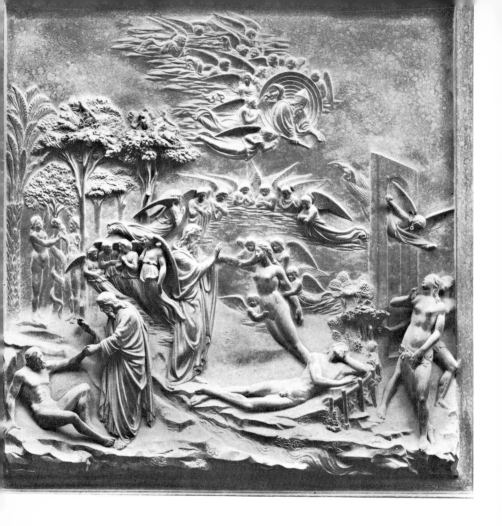

4. LORENZO GHIBERTI (1378–
1455). *Creation of Adam and Eve
with the Fall and Expulsion, 1425–52.
Gilt bronze 31×31 (79×79).
Porta del Paradiso, Baptistery, Florence*

Donatello's *Feast of Herod* relief on the Siena font (see
Ill. 15), the quatrefoil framings are abandoned in favour
of a rectangular format. Thus each relief is larger, allowing
a profusion of naturalistic detail, and each is conceived
in a pictorial way based on the new science of perspective.
The subjects are taken from the early books of the Old
Testament, from the Creation of Adam and Eve to the
story of Solomon and the Queen of Sheba; they are set
in a framework embellished with fruit and flowers, ani-
mals, classicizing figurines and portraits in the round,
which include a penetrating self-portrait.

14

There is no more striking instance of Ghiberti's power of design than the first scene (*Ill. 4*), its wandering hills and dales forming a continuous landscape in which a number of incidents are represented. As the eye follows the sweeping rhythms of the composition it is led gently from one scene to its sequel, from the pristine innocence of the first man to his ultimate Fall. The sinuous lines and the complex profusion of detail are fundamentally Gothic in character, but there are hints in the treatment of the figures of their origin in classical sculpture (see *Ills. 5, 6*). Elements in the reliefs reflect Ghiberti's knowledge of such contemporary International Gothic painters as Pisanello and Gentile da Fabriano, and also of the revolutionary frescoes by the young Masaccio in the Brancacci Chapel (see Chapter Four). There are allusions to classical buildings such as the Colosseum, and to the new architecture of Brunelleschi and Michelozzo. Ghiberti's profound interest in antiquity appears also in his *Commentarii*, where he traces the history of the arts from classical times until the moment of his own triumph in the Baptistery competition. These three volumes constitute the first attempt in modern times to write a history of the arts; and they reflect a new attitude to genius and to individual attainment, in contrast to the medieval acceptance of the anonymity of the artist.

Simply as a teacher, Ghiberti exercised an immense influence. During his long career many of the leading artists of 15th-century Florence passed through his workshop – among sculptors Donatello, among architects Michelozzo, and among painters Masolino, Uccello and Benozzo Gozzoli. And while Masaccio's influence was greater, a tendency persisted to modify the heroic austerity of his style – a tendency to be explained very largely by the unassailable prestige of Ghiberti's masterpiece, in which the heroic is so happily married to the graceful, and in which older aspirations are given a new perfection.

The half-century spanned by Ghiberti's work upon the north and east doors of the Baptistery was a period of equally vital resurgence in architecture. After his failure in the Baptistery competition Brunelleschi was virtually to abandon sculpture in favour of architecture. His dome for Florence Cathedral (*Ill. 7*), while making concessions

5. LORENZO GHIBERTI (1378–1455). *Cain ploughing, detail of Cain and Abel panel, 1425–52. Gilt bronze 18×16 (45×38). Porta del Paradiso, Baptistery, Florence*

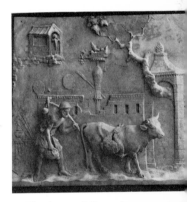

6. *Ploughman and Oxen. Roman relief, AD 50. Staatliche Antiken-sammlungen, Munich*

15

to Gothic traditions, was erected without centering – a triumph of architectural genius and engineering skill second to none in the age, and inconceivable without Brunelleschi's careful study of Roman building methods. In the Foundling Hospital (1419–24), in his two great churches, San Lorenzo and Santo Spirito (*Ill. 21*), and in the exquisite Pazzi Chapel, he created a new style of architecture, characterized by an ideal of ordered harmony which was founded both upon the study of antiquity and upon the sensitive application of mathematical ratios to the proportions of a building. It was Brunelleschi, also, who developed experimentally the system of mathematical perspective which was later outlined by Alberti in his *Della pittura*, and which made so fundamental a contribution to the revolutionary style of painting ushered in by Masaccio (see *Ill. 20*).

Apart from Brunelleschi, the most important Florentine architect in this period was Leon Battista Alberti. The son of a Florentine patrician who had been exiled to Genoa, Alberti became famous as a classical scholar many years before he designed his first building: he had studied Latin and Greek at Padua, and law at the University of Bologna; by the age of twenty he was known as the author of a Latin comedy. By the 1430s he was living in Florence, as a member of Brunelleschi's circle. About this time he made a methodical study of the ancient monuments of Rome. His greatest literary work, the *De re aedificatoria*, which revived the principles of the Roman architectural theorist Vitruvius, was almost certainly begun in the 1440s; and it was in these years that he first appeared as an architect.

Alberti was not a builder like Brunelleschi: once he had conceived the design of a building he left its erection to assistants. It was in this manner that, shortly before 1450, he undertook for Sigismondo Malatesta the remodelling of San Francesco at Rimini. The Gothic church was to be transformed into a Roman temple, and was renamed the Tempio Malatestiano; its interior was embellished by lavish sculptural decorations by Agostino di Duccio, devoted largely to pagan and astrological themes. The façade is based on a Roman triumphal arch and, together with the later façade of Santa Maria Novella in

Florence (*Ill. 27*), designed according to a system of harmonious mathematical ratios, it reveals Alberti's scholarly and inventive genius. Alberti's theories of proportion were, like Brunelleschi's, closely related to the mathematics of musical harmony: it is not therefore surprising to find him warning his principal assistant at Rimini against the slightest change in design, lest he 'force all this music out of tune'.

Alberti designed only two entire buildings, both in Mantua. The church of San Sebastiano, of 1460, is much altered but still preserves Alberti's rigorous centralized plan in the form of a Greek cross. At Sant'Andrea, of 1470–72, his highly original aim was a perfect concordance between the façade and the nave walls, achieved through the motif of the Roman triumphal arch. The façade is treated as one vast triumphal arch topped by a pediment; inside, the walls are conceived as a series of overlapping triumphal arches whose central and flanking openings are formed by alternately large and small chapels, replacing the traditional aisles. No building of this splendour and subtle coherence had been imagined since classical times.

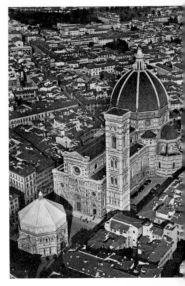

7. *Florence Cathedral (1296–1462), Campanile (1334–59) and Baptistery (5th, 11th and 13th centuries)*

A development that strikingly affected the whole aspect of 15th-century Florence was the building of the great palaces, in which the leading families vied with each other in magnificence. Alberti's façade to the Palazzo Rucellai, begun in 1446, is notable for a typically scholarly and tasteful use of pilasters of different orders to lend variety. But the first, and in many ways the most impressive, of the Florentine palaces is the Palazzo Medici, later Medici-Riccardi, which is the work of Michelozzo. The heavily rusticated exterior has something of the appearance of a fortress; but within the colonnaded courtyard (influenced by Brunelleschi's Foundling Hospital) all is intimacy and grace, and the atmosphere is reminiscent of that of a monastery cloister.

In the Medici Palace the prototype of the Florentine *palazzo* was established, with its massive street frontages and inner courtyard: its influence is apparent both in the vast Palazzo Strozzi, possibly the work of Benedetto da Maiano, and in the more elegant Palazzo Gondi, designed by Giuliano da Sangallo. Sangallo was to dominate

Florentine architecture in the closing years of the century: while in his early work he may be described as a follower of Brunelleschi, he developed into an architect of considerable originality, and the villa at Poggio a Caiano which he built in the 1480s for Lorenzo de' Medici, with its Ionic portico, in many ways anticipates the villas of Palladio.

The new architecture created by the Florentines made a profound impact upon other Italian cities. When Pope Pius II – the scholar-poet Aeneas Sylvius Piccolomini – chose to remodel his birthplace of Corsignano, transforming what was then a mere village into a city designed on a unified plan, it was to a Florentine that he turned – Bernardo Rossellino, who had superintended work on the Palazzo Rucellai for Alberti. The new city, named Pienza after the Pope, is a superb example of town-planning. Rossellino's conception of the value of the scenic view, which is reflected in the layout of the gardens of the Palazzo Piccolomini – leading the eye towards the hills to the south – marks an important stage in the history of taste.

At Urbino, the impressive Ducal Palace built for Federigo da Montefeltro reflects very clearly the immediate influence of Alberti: it was entirely remodelled by the Dalmatian architect Luciano Laurana, who stamped his personality upon Urbino much as Brunelleschi and Alberti impressed theirs upon Florence. The interior courtyard indeed surpasses its Florentine models in the purity and elegance of its design and in the beauty of its detail. In Lombardy, a type of 'Romantic-Renaissance' architecture was created by the Florentine Antonio Averlino, known as Filarete (or 'lover of virtue'), himself one of Brunelleschi's followers. Filarete's major work is the Ospedale Maggiore in Milan (1456–65); it still has Gothic touches, but is remarkable for its large-scale formal plan with courtyards grouped round a chapel. In an architectural treatise, Filarete included trenchant criticisms of the Gothic style still fashionable in northern Italy, and defended the classical revival.

Donatello and the works for Florence Cathedral and Orsanmichele

The half-century spanned by Ghiberti's work on the Baptistery doors was a period of extensive sculptural activity in Florence, centred at first on the Cathedral and the church of Orsanmichele nearby. Sculptures were ordered for the façade and other areas of the Cathedral, and for the exterior niches of the Campanile and Orsanmichele that yet remained unfilled. In addition to Ghiberti, two sculptors in particular found in such commissions the means to express an original vision which separates them from their lesser and more conservative contemporaries – Nanni di Banco and Donato di Niccolò di Betto Bardi, known as Donatello.

In 1407 Nanni di Banco was commissioned to make one of a pair of *Prophets* for the Porta della Mandorla of the Cathedral, the other being ordered from Donatello. A year later he again shared a commission with Donatello, this time for an *Isaiah*, of which the more famous *David* by Donatello was intended to be the companion. Somewhat later Nanni executed his masterpiece, the *Assumption* over the Porta della Mandorla, a finely wrought relief which shows a reversion to a Gothic ideal uncharacteristic of his earlier style. But the work that marks him out as one of the pioneers of Renaissance sculpture is the group known as the *Santi Quattro Coronati* (*Ill. 8*), which occupies one of the exterior niches at Orsanmichele. Executed a decade or so before Masaccio's frescoes in the Brancacci Chapel (see Chapter Four), these coldly impressive figures, which show the influence of Roman funerary monuments, anticipate the classic dignity of the Apostles in Masaccio's *Tribute Money* (*Ill. 25*).

After Nanni di Banco's early death it was left to Donatello, the greatest European sculptor since the end of the

8. NANNI DI BANCO (*c.* 1384–1421). *Santi Quattro Coronati, 1410–14. Marble, about life-size. Orsanmichele, Florence*

9. DONATELLO (*c.* 1386–1466).
David, c. 1408–12. *Marble h. including
base* 75 1/4 (*191*). *Bargello, Florence*

10. DONATELLO (*c.* 1386–1466).
St George, 1415?–17. *Marble
h.* 82 1/4 (*209*). *Bargello, Florence*

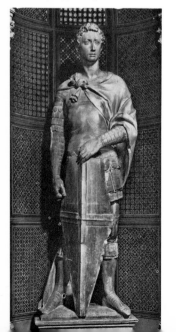

classical age, to explore, in his own original and incalcu-
lable fashion, the lessons that were to be learnt from the
widespread revival of interest in antiquity. Donatello was
a close friend of Brunelleschi, with whom (at some date
unknown) he made a visit to Rome to study the ancient
monuments. His *St Mark* at Orsanmichele and the *St John
the Evangelist*, commissioned for the façade of the Cathe-
dral, are perhaps the first works to embody the new heroic
ideal conceived by the early Renaissance: in their power
and dignity they look forward to Michelangelo, whose
Moses must owe something to the *St John*. In these works
Donatello emerges as an independent artist on an equal
footing with his master Ghiberti, whose *St Matthew* and
other statues for Orsanmichele his own *St Mark* and,
above all, the more celebrated *St George* were to surpass
in the modernity of their style and in their suggestion of an
inner life that quickens the cold marble.

In 1416 Donatello was asked to make certain altera-
tions to the earlier *David* (Ill. *9*), which had been pur-
chased by the Signoria for a new home in the Palazzo
Vecchio. It is probable that originally the figure had held
a scroll in his right hand and a sling in his left, in allusion
to David's dual role as prophet and warrior-king, but
that what was now required was an image that placed a
greater stress upon purely civic virtues: the statue already
bore a Latin inscription to the effect that those who fight
for the fatherland will be aided by the gods. It would
seem that the alterations now made by Donatello consisted
of the removal of the scroll and the transference of the
sling to the right hand, together with the addition of the
head of Goliath at David's feet. It is interesting to turn
from this early work to the *St George* (Ill. *10*), designed for
a niche at Orsanmichele and probably begun in 1417.
The two statues are closely comparable in their subject-
matter: both are representations of triumphant warriors;
and as befitted a statue commissioned by the Guild of
Armourers Donatello's *St George* was originally accoutred
in a bronze helmet and held a sword in his right hand.

Yet in the interval between the commissions for the
two works a considerable change had taken place in Do-
natello's style. The *David* has an elegance and slightly
effeminate grace which betray the origin of the young

sculptor's style in the Gothic tendencies prevalent in Ghi-
berti's workshop. In the *St George* there is a more virile
strength, and no work of the period expresses more clearly
that accession of confidence in the spirit of man that is
common to the humanists, poets and artists of 15th-cen-
tury Florence. It is a figure tense with inner life and latent
movement, as of one standing alert and ready to receive a
command. Here the art of sculpture has conquered a new
realm of expression, that of implied action.

From the year 1412 there are payments to Donatello
for the first of a series of Prophets for the Campanile of the
Cathedral – all of them triumphs of realism. It was the
manifestation of a similar realism in Donatello's wooden
Crucifix at Santa Croce that led Brunelleschi, according
to an unverifiable tradition, to criticize the sculptor for
having 'crucified a peasant'.

There can be no doubt that the realism of Donatello's
style helped to establish his early reputation. The ideals of
15th-century humanism demanded an art capable of re-
flecting both an image of the visible world and of man's
central place in the scheme of things; and Donatello, rather
than his master Ghiberti, was the true founder of the new
style in sculpture, as his younger contemporary Masaccio
was to be in painting. Nevertheless, the theorists of the
Renaissance period never placed a primary emphasis upon
the representation of appearances: from Alberti to Leo-
nardo, the highest excellence was always reserved for the
painter or sculptor who penetrated beyond the mask to the
inner soul, and whose art reflected deeper realities than
those visible to the outer eye.

The expressive power of Donatello's realism is particu-
larly marked in his early Madonnas, such as the low reliefs
at Berlin and Boston. The first of these, the so-called
Pazzi Madonna (*Ill. 11*), may well have exerted a direct
influence upon Masaccio's Pisa altarpiece. In its icono-
graphy it derives ultimately from the type of Madonna
created in the early 14th century by the Lorenzetti, in
which the tender relationship between Mother and Child
is lovingly dwelt upon; but the intense realism gives the
image a new poignancy, and the powerful harmony of the
simple, interlocking forms elevates it to the category of the
sublime. There is in these grave Madonnas a strong ele-

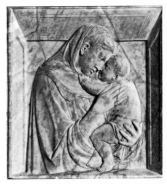

11. DONATELLO (*c.* 1386-1466).
*Pazzi Madonna, c. 1422. Marble
29 ¹/₄ × 27 ¹/₄ (74.5 × 69.5).
Staatliche Museen zu Berlin*

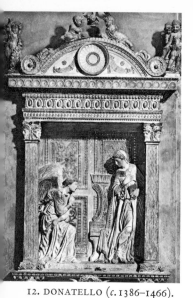

12. DONATELLO (c.1386–1466).
*Annunciation Tabernacle, 1428–33.
Pietra serena and gold 165³/₈ × 97⁵/₈
(420 × 248). Santa Croce, Florence*

13. FRA FILIPPO LIPPI (c.1406–
69). *Annunciation (detail), 1440–50.
Panel 68⁷/₈ × 72 (175 × 183).
San Lorenzo, Florence*

ment of the tragic, as there is in the early reliefs of Michel-
angelo; a brooding quality which almost outweighs the
tenderness, and which compels us, in dwelling upon
Christ's infancy, also to contemplate his Passion. The
Berlin and Boston reliefs are among the profoundest ex-
pressions of the religious spirit in Renaissance art, and they
disclose a dimension of Donatello's genius of which his
earlier works give us only passing hints.

These reliefs contain something in addition of that
power to disturb that becomes still more marked in several
of Donatello's late works, such as the *Madonna* at Padua
and the *Magdalen* in the Florentine Baptistery. This is a
quality that is difficult to define, for it arises not merely
out of his attempt to penetrate the psychology of the in-
dividual but also from those more mysterious springs of
the creative process that determine an artist's predilection
for particular arrangements and dispositions of form, and
which in Donatello's case produced compositions that
are seldom untouched by strangeness. It is this power that
gives such individuality to his greatest designs, such as the
Annunciation Tabernacle at Santa Croce (*Ill. 12*), the *Feast
of Herod* on the Siena font (*Ill. 15*) and – perhaps above
all – the reliefs in the Old Sacristy at San Lorenzo
(*Ills. 42, 44*).

About 1425 Donatello formed an association with
Michelozzo, who was a sculptor as well as an architect.
A few years later the two partners worked together on the
imposing tomb of John XXIII (the Anti-pope) in the
Florentine Baptistery and probably on the tomb of Car-
dinal Brancacci which was to be set up at Sant'Angelo a
Nilo in Naples. The exterior pulpit of Prato Cathedral,
a variation upon the theme of the better known *Cantoria*
for the Cathedral of Florence, was also commissioned
from both men, and it is probable that Michelozzo exe-
cuted the elegant framing of the *Annunciation Tabernacle*
at Santa Croce (*Ill. 12*), that most lyrical of Donatello's
early masterpieces.

Of the independent works in sculpture produced by
Michelozzo the most important is the monument to the
poet Bartolommeo Aragazzi (1437) in the Cathedral at
Montepulciano. This can be regarded as the first of the
great humanist memorials to enshrine, in Machiavelli's

words, 'the desire to perpetuate a name'. The most important of these memorials in the history of tomb-sculpture is Bernardo Rossellino's monument to the humanist Chancellor of Florence, Leonardo Bruni, celebrated as the historian of his city and as the translator of Aristotle (*Ill. 14*). Years earlier, while on his way from Florence to Arezzo, Bruni had by chance encountered the Aragazzi Monument as it was being carried in ox-drawn carts to Montepulciano, and he had stopped to converse with a sweating driver who had his own opinion of the vanity of poets. The Bruni Monument reflects the immediate influence of the tomb of John XXIII; but the effigy is placed lower, focussing attention directly on the humanist at whose death – according to the inscription – 'the Greek and Latin Muses could not restrain their tears'. The tomb of the Cardinal of Portugal (*Ill. 121*), by Bernardo Rossellino and his younger brother Antonio, raised this *genre* of sculpture to new heights of splendour and magnificence. The monument stands in a specially designed chapel containing a ceiling in glazed terracotta by Luca della Robbia and painted decorations by Antonio and Piero Pollaiuolo and Alesso Baldovinetti. The altarpiece for the chapel, representing the Cardinal's three patron saints, is also the work of the brothers Pollaiuolo (this is now in the Uffizi, having been replaced in the chapel by a copy).

The three greatest sculptors of the age – Ghiberti and Donatello from Florence, and Jacopo della Quercia from Siena – all participated in the erection of a new font for the Baptistery of Siena Cathedral (see Chapter Eight). Ghiberti's two reliefs, which include a *Baptism of Christ* in the position of honour, facing the Baptistery door, were begun in 1417 and anticipate the 'pictorial' qualities of the compositions on the *Porta del Paradiso*. Two reliefs were also commissioned from Jacopo della Quercia, but characteristic procrastination on his part led in 1423 to the handing-over of one of the subjects – the *Feast of Herod* – to Donatello, who also went on to make some of the subsidiary figures of Virtues and *putti*.

Donatello's interpretation of the story of *Herod's Feast* (*Ill. 15*) is a superb example of his mastery of *stiacciato*, or flattened, relief, in which the illusion of great distance is given within a very shallow surface. It also reveals him as

14. BERNARDO ROSSELLINO (1409–60). *Monument to Leonardo Bruni, 1444/6–1449/50. Marble. Santa Croce, Florence*

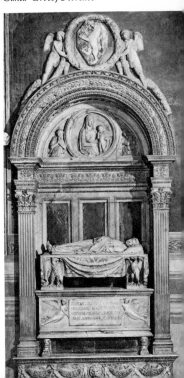

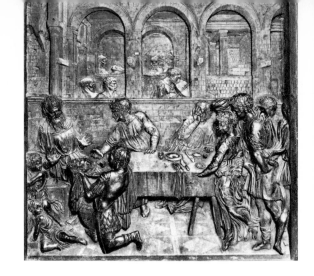

15. DONATELLO (c. 1386–1466).
Feast of Herod, 1425. *Bronze*
$35^5/_8 \times 35^5/_8$ *(60 × 60). Baptistery
font, Siena*

one of the supreme dramatic artists of all time. The em-
phasis is upon the reactions of Herod and his guests at the
moment when a soldier bears in the Baptist's head. The
composition bursts open from that grisly image with ex-
plosive force: Herod and the guests of honour shrink back
in horror; on either side figures either cower or flee away.
Beyond the banqueting hall, a musician is still playing:
we see him through an archway bent over the instrument
to whose sounds Salome danced; but the brutal faces of
two executioners, framed and isolated by another archway
to the left, offer a reminder of the grim sequel to her pleas-
ures. Salome herself occupies a prominent position in the
main scene – a Maenad-like figure in a posture of im-
balance, her draperies still swirling about her, one clutch-
ing hand held behind her, the other extended like a claw,
her eyes fixed intently upon her father. She is represented

16. ANDREA DEL SARTO (1486–
1531). *Presentation of the Baptist's
Head to Herodias,* 1523. *Fresco.
Chiostro dello Scalzo, Florence*

24

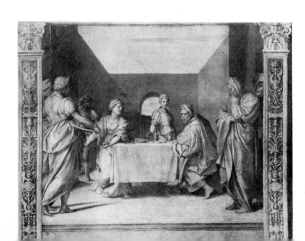

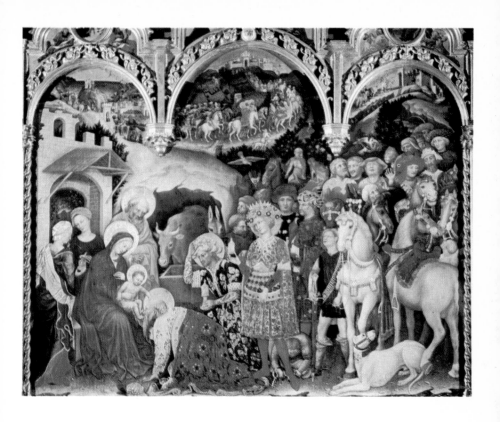

again, alongside her mother, in a back room beyond the musicians' gallery, at an earlier moment when the soldier shows them the Baptist's head as proof that the king's command has been carried out.

By uniting all these incidents within one scene Donatello was able to heighten the dramatic intensity of a story which in traditional practice was told in a sequence of four or five separate episodes. An important means to the unity that Donatello achieved was his thoroughgoing application to his composition of the principles of mathematical perspective. The main orthogonals of this system – the imaginary diagonal lines leading back into space, – combining with other elements of the design (such as Herodias's outstretched arm), meet at the figure of the musician, who represents the apex of a large pyramidal form underlying all the active flurry of incident; this motif is reversed

17. GENTILE DA FABRIANO (c. 1370–1427). *Adoration of the Magi (central panel of Santa Trinità Altarpiece), 1423. Tempera on wood 112×107 (285×272). Uffizi, Florence*

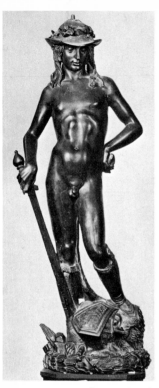

18. DONATELLO (c. 1386–1466).
*David, c. 1435?. Bronze h. 62¹/₄
(158). Bargello, Florence*

in the two figures of Herodias and the seated guest, whose forms divide outwards from the centre.

The *putti* made by Donatello for the Siena font, in their ease of movement and organic unity of articulation, surpass their antique models, and like other works of Donatello in this period – notably the bronze *David* (*Ill. 18*), of uncertain date, which stood at one time in the courtyard of the Medici Palace, the so-called *Amor-Atys* of about 1440, also in bronze, and the *Cantoria* for Florence Cathedral – they demonstrate the profundity of his response to the spirit of antiquity. It is difficult to think that the elegant *David* was not modelled in part upon an antique *Mercury*, and such an inspiration would account for the hat and the boots – although it is Goliath's helmet, rather than the boots, that is winged.

Donatello's ability to reinterpret the antique attains its highest expression in the marble *Cantoria*, or singing-gallery, executed in the 1430s. The Cathedral authorities had commissioned two *cantorie*, one from Donatello and one from Luca della Robbia, and they originally stood opposite one another in the choir. The frieze of *putti* at play in Donatello's *Cantoria* makes a forceful contrast to the more genteel figures of Luca della Robbia. Whereas Luca's child-musicians sweetly 'praise God in his sanctuary', Donatello's riotous infants abandon themselves to a wild, rumbustious dance. No work of the Renaissance is more instinct with the joy of living.

Masaccio, Masolino and the Brancacci Chapel

The new style forged by Donatello has its counterpart in Florentine painting in the work of the artist whom we know as Masaccio, a pejorative form of the name Tommaso (Thomas) given to Tommaso di Ser Giovanni di Mone. Masaccio's death in his twenties must be accounted among the greatest tragedies in the history of art; for to imagine what the works of his maturity might have been like, and to conceive of a development running parallel to that of Donatello in sculpture, is to become aware of a loss so vast that it is comparable only with the impoverishment that would have been ours if Michelangelo had never lived to paint the Sistine Chapel ceiling.

As it is, Masaccio left behind him but three major works – the frescoes in the Brancacci Chapel in the church of Santa Maria del Carmine in Florence, executed between *c.* 1425 and his death in 1428; the fresco of the *Trinity* at Santa Maria Novella, painted in 1425; and a now dismembered and fragmentary altarpiece executed in 1426 for the Carmelite church at Pisa, of which the central panel of the *Madonna and Child* is in the National Gallery in London, the other portions being at Pisa, Naples, Berlin and Vienna.

Bernard Berenson, the great American historian of Italian art, has summed up the character of Masaccio's art in a passage that is now famous: 'Giotto born again,

19. MASACCIO (1401–28?). *Adoration of the Magi (predella panel of Pisa altarpiece), 1426. Tempera on wood 8¹/₄ × 24 (21 × 61). Staatliche Museen, Berlin-Dahlem*

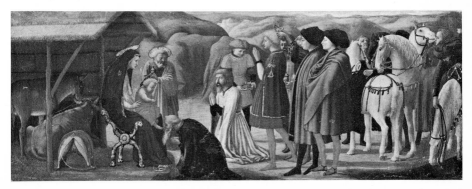

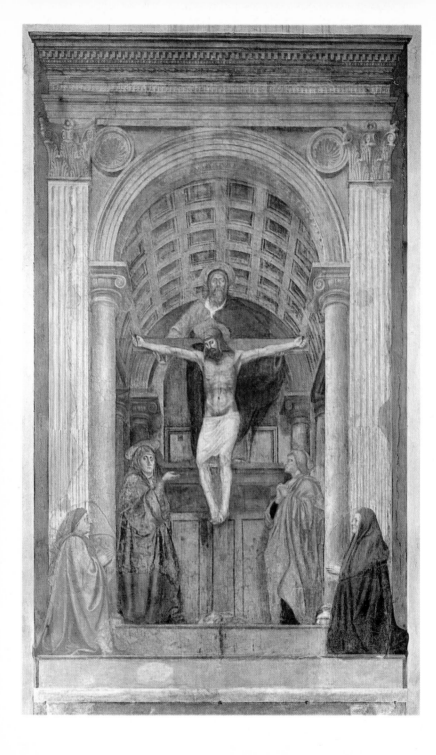

starting where death had cut short his advance, instantly making his own all that had been gained during his absence, and profiting by the new conditions, the new demands – imagine such an avatar, and you will understand Masaccio.' We may picture the Brancacci Chapel cycle as the central peak of a mountain range stretching back to the frescoes painted by Giotto about a hundred years earlier in the Bardi and Peruzzi Chapels at Santa Croce in Florence, and forward to the Sistine Chapel ceiling of Michelangelo, painted nearly a hundred years after. The work of each of these three masters constitutes one of the highest points in the development of the art of fresco-painting, in which the Florentine genius attained its most characteristic expression. The origins of Michelangelo's fresco-style in that of his two great predecessors is confirmed by early studies which he made of figures from both the Peruzzi and Brancacci Chapel cycles.

Just as the art of Giotto represents a reaction against the Italo-Byzantine tradition, and that of Michelangelo a rejection of the decorative classicism of the late 15th century, so Masaccio made a clean break with the elegant naturalism of International Gothic, returning instead to the sublime ideal of Giotto and to the inexhaustible springs of classical antiquity. He was moulded by the same forces that determined the paths followed by Donatello and Brunelleschi: with Masaccio, painting became the rival of sculpture in its exploration of plastic form. Where Giotto only partly understood how to model his figures in terms of light and shade, Masaccio virtually reduced this problem to the terms of an exact science; and whereas in Giotto humanity still inhabits a medieval world, Masaccio fills his stage with those noble figures that so forcibly recall the heroic types of the classical age.

In the *Trinity* fresco at Santa Maria Novella (*Ill. 20*) the treatment of the architectural setting gives the illusion that we are looking through an arch flanked by classical pilasters, into a tunnel-vaulted chapel in the style of Brunelleschi. Masaccio shared Donatello's passionate interest in the new science of mathematical perspective, and the *Trinity* is one of the first works of art ever to make use of it.

In order to measure the spiritual gulf that separates Masaccio from the Late Gothic masters it is only necessary

20. *(opposite)* MASACCIO (1401–28?). *Trinity, 1425. Fresco. Santa Maria Novella, Florence*

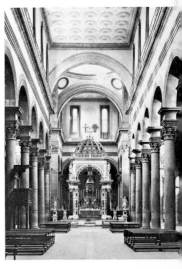

21. FILIPPO BRUNELLESCHI (1377–1446). *Nave, Santo Spirito, Florence, 1445–82*

22. MASACCIO (1401–28?).
*Expulsion of Adam and Eve from Paradise, c. 1424–8. Fresco.
Brancacci Chapel, Santa Maria del Carmine, Florence*
23. MASOLINO (1383/4–1447?).
*Fall of Man, c. 1424–8. Fresco.
Brancacci Chapel, Santa Maria del Carmine, Florence*

to compare the *Adoration of the Magi* executed by Gentile da Fabriano in 1423 for the church of Santa Trinita in Florence (*Ill. 17*) with the predella panel of the same subject (now in Berlin) from Masaccio's Pisa altarpiece (*Ill. 19*). Where Gentile displays a world of courtly elegance, and lavishes his superb craftsmanship upon an art of sumptuous colour and captivating detail, Masaccio remains aloof from all such distractions: his mind fixed

upon a loftier and more severe ideal which finds no place for what is decoratively beguiling, he goes at once to the heart of things, insisting upon the priority of visual truth over interior fantasy. While Gentile's figures are quite in-substantial, those of Masaccio are sculptured broadly in terms of light and shade, and cast deep shadows upon the ground: light has become a modelling agent, the means by which the eye apprehends the nature of reality.

To many of Masaccio's contemporaries, the Pisa altar-piece may well have appeared ugly, and not everyone would have understood a purpose so singleminded in its rejection of the inessential and so austere in its aspiration to the sublime. It is scarcely surprising that Masolino, who worked alongside him in the Brancacci Chapel, Uccello, who took over many of his ideas, and such painters as Fra Angelico and Benozzo Gozzoli, who were equally indebted to him, all preferred a path a little below the lofty heights that Masaccio had conquered. At all events, Florentine painting after his death is characterized, in general, by a form of eclecticism in which the structural and spatial principles of Masaccio are combined with the pleasurable graces of the International Gothic masters.

The two ideals confront one another at the entrance to the Brancacci Chapel, where Masolino's *Fall of Man* stands opposite Masaccio's *Expulsion of Adam and Eve from Paradise* (*Ills. 22, 23, 24*). The frescoes were intended to form a pair, and they are the only scenes from Genesis included in the cycle, which otherwise is devoted to the life of St Peter, the chief of the Apostles. No two compo-sitions brought within the same decorative scheme could present a greater contrast. Masolino's conception is entirely undramatic; and the idyllic overtones of his interpretation of the subject are underlined by his graceful, almost lan-guorous representation of Adam and Eve. Masaccio's figures by comparison seem to be lacking in grace, but they convey an immediate impression of the momentous-ness of the drama in which they are involved.

Nothing comparable with the life of these figures had been seen in European painting since the classical age. The early writers praised Masaccio as an 'imitator of na-ture', but the way to the new realism created by Masaccio lay in great measure through a thoroughgoing reassessment

24. *Brancacci Chapel, Santa Maria del Carmine, Florence. Frescoes by* MASACCIO *and* MASOLINO, *c.1424–8; completed 1484/5 by* FILIPPINO LIPPI

of the art of antiquity. Masaccio's Eve was modelled directly upon a *Venus pudica,* and there are other passages in the Brancacci Chapel where the direct influence of classical prototypes may be presumed.

The *Tribute Money* (*Ill. 25*) leads us into the spaces of the world. The story of the shekel required by the tax-collector and miraculously found in the fish's mouth, which is told in the Gospel of St Matthew, is a type of miracle, a wonder-working, more characteristic of the Apocryphal Gospels than of the Synoptics. The decision to introduce this subject, an exceedingly rare one in medieval and Renaissance art, may be connected with a new tax on income and property imposed by Florence in 1427,

which was opposed by Masaccio's patron Felice Bran‑ cacci. However, the theological intention that lay behind the choice is far more important. In one of his sermons St Augustine had interpreted the story of the shekel as a symbol of the Redemption: Christ had given his life freely, as he had also paid the tax‑gatherer although noth‑ ing had been due from him; and through his sacrifice on the Cross he had freed all men from what was due from them on account of their sin. Furthermore, St Peter be‑ comes Christ's agent in his dealings with the tax‑gatherer, just as his successors in the Papal Chair of St Peter are themselves his representatives; the subject is thus closely analogous to the Giving of the Keys.

In Masaccio's conception, Christ's command to St Peter has been made into a symbol of divine power worthy to stand beside, and to supplement, the theme of the ad‑ joining fresco of the *Expulsion from Paradise*. The Apostles are represented as men invested with that same authority, as delegated by their Master. They stand in the bare land‑ scape like columns or pillars hewn out of stone. A sense of awe is suggested by this landscape, with its wind‑ blasted trees and distant, bleak mountains. The whole

25. MASACCIO (1401–28?). *Tribute Money (detail of central group), c. 1425–8. Fresco. Brancacci Chapel, Santa Maria del Carmine, Florence*

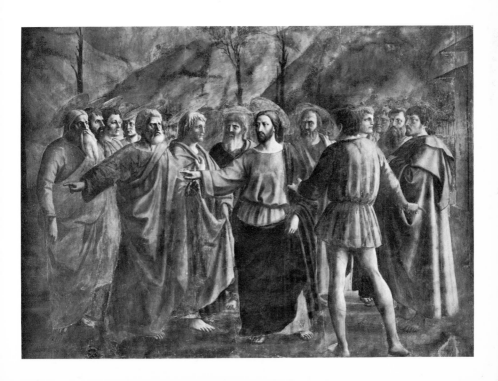

scene is treated accurately in terms of a perspective mathe-matically correct, the eye of the spectator being related to the level of the Apostles' heads.

Of the other frescoes in the Brancacci Chapel, the most interesting are the scenes of *St Peter healing with his Shadow* and the *Baptism of the Neophytes*, both on the altar wall. The first of these, situated to the left of the altar, on the lower register, opens out into a prospect of a typical Florentine street, under whose high walls St Peter and his retinue move solemnly forward in slow procession towards the spectator. The calculated perspective creates the illu-sion of deep recession, which is all the more striking be-cause the vanishing-point of the orthogonals lies outside the picture-space. The fresco was designed in relation to the corresponding scene to the right of the altar – *St Peter and St John distributing Alms* – in which the orthogonals established by the buildings in the background converge to the left. The addition of the Baroque altarpiece has obscured the intended harmony and coherence of Masac-cio's conception.

The *Baptism of the Neophytes*, directly above the scene of *St Peter and St John distributing Alms*, is now in a poor state of preservation; and the damage that it has suffered has largely destroyed the effect, which must have been most powerful, of the bare mountains hanging above the shivering figures. These massive figures indicate that Ma-saccio was more advanced in his treatment of the nude than Donatello himself; for they have an amplitude and a subtlety of articulation that we associate with the High Renaissance rather than with the early years of the Quattro-cento. The general effect is of a full, strong light which models the forms of the figures in a deep space; within these broad masses the light flickers and falters in a glow of half-lights and half-defined nuances of shade. It is only a short step from these tonal subtleties to the mastery of light as a modelling agent achieved by Leonardo. The Brancacci Chapel became the school for generations of painters from Florence and beyond; but only Michel-angelo, who drew in the chapel as a boy, fully appreciated the heroic quality of Masaccio's genius. Adapting Beren-son's famous phrase, we may say of the Sistine Chapel ceiling: 'Masaccio, born again ...'

Uccello and his contemporaries

During the 15th century science was to become, as never before, the handmaid of art. The application of scientific method to painting eventually found its supreme exponent in Leonardo; yet Leonardo's achievement represents the fulfilment of tendencies that had long been under way in Florence. To begin with, we may describe as scientific the methods used by the Renaissance masters to evoke a con-vincing illusion of reality, and to this end one of the most important innovations was the study of the optical effects of light, which after the death of Masaccio was to be ex-plored further by such artists as Domenico Veneziano and Piero della Francesca. No less significant was the practical application to painting of the new laws of mathematical perspective, first outlined by Alberti and subsequently re-formulated by Piero della Francesca and Leonardo. To these developments we may add the rise of anatomical studies, the effects of which are immediately apparent, for example, in the figure-style of Antonio Pollaiuolo.

A work that typifies the spirit of Quattrocento painting in Florence is the *Martyrdom of St Sebastian* (*Ill. 26*) exe-cuted in 1475 by Antonio Pollaiuolo and his brother Piero for the Pucci Chapel at Santissima Annunziata. It is a picture that gives the impression of a conscious demon-stration of skill: the composition is uncompromisingly geometrical in structure; the treatment of space follows Alberti's system of perspective construction to the letter; the figures are posed in such a manner as to show off to the best advantage the artist's profound knowledge of anat-omy, the same poses being repeated in a front and a back view; beyond the figures, a prospect of wooded country and winding rivers carries the eye back to a far horizon. By giving prominence in the middle-distance to a Roman

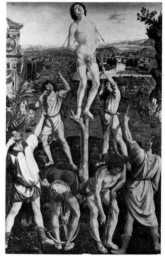

26. ANTONIO (*c.* 1432–98) *and* PIERO (*c.* 1441–96) POLLAIUOLO. *Martyrdom of St Sebastian, 1475. Oil on wood* 114³/₄ × 79³/₄ (*291 × 203*). *National Gallery, London*

35

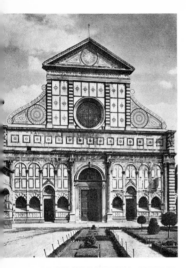

arch, Pollaiuolo did not omit to pay his respects to classical antiquity.

The whole process by which the elaborate intellectual edifice of Quattrocento style was erected is summed up by two passages in Leonardo's notebooks:

'The first marvel of painting is that it appears detached from the wall or other flat surface, deceiving people of subtle judgment with this object that is not separated from the wall's surface ..., and this is why the painter must make it his concern to study shadows which are the companions of light ... The second thing is that the painter must, through serious reasoning and subtle investigation, fix the true quantity and quality of light and shade ... The third thing is perspective, which is a most subtle discovery in mathematical studies, for by means of lines, it causes to appear distant that which is near, and large that which is small ...'

'It is a necessary thing for the painter, in order to be good at arranging parts of the body in attitudes and gestures which can be represented in the nude, to know the anatomy of the sinews, bones, muscles and tendons. He should know their various movements and force, and which sinew or muscle occasions each movement, and paint those only distinct and thick, and not the others, as do many who, in order to appear to be great draughtsmen, make their nudes wooden and without grace, so that they seem a sack full of nuts rather than the surface of a human being, or indeed, a bundle of radishes rather than muscular nudes.'

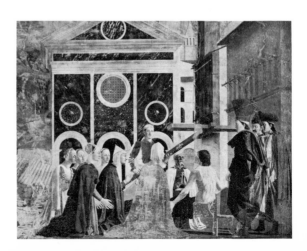

Different solutions to such problems can already be seen in the work of some of Masaccio's contemporaries, notably Domenico Veneziano and Paolo Uccello, and in that of the much younger Andrea del Castagno, whose work has certain affinities with theirs.

Although his name indicates that he was a Venetian by birth, Domenico Veneziano belongs to the history of Tuscan painting. By 1439 he was in Florence, receiving payment for frescoes in Sant'Egidio – a project in which one of his assistants was the young Piero della Francesca. The Sant'Egidio frescoes have been destroyed, and little else survives from Domenico's hand. He is known principally by one major work, the *St Lucy Altarpiece* painted about 1445, of which the central panel is in the Uffizi (*Ill. 34*).

Like many other painters of the period, Domenico softened the stern ideal of Masaccio with the more delicate qualities of International Gothic, and the *St Lucy Altarpiece* constitutes one of the happiest unions between the two traditions in early Renaissance art. The four attendant saints possess much of the monumental dignity of Masaccio's figures, but they exhibit at the same time a gracefulness that is closer to Gentile da Fabriano; and while the scene is closed at the back by Renaissance architecture, the foreground arches are pointed, in the Gothic style. The effect of the whole is highly decorative, and yet the various elements of the design are bound together by a sense of extensive and airy space which would not have been possible without the use of linear perspective.

The division of the composition into three parts by the architectural forms reflects the traditional polyptych, in which the central cult-image and the attendant saints were each painted on a separate panel. Here, however, all the figures are brought together within a single setting: the hieratic display of saints has become a *sacra conversazione*, a holy conversation – a development paralleled slightly earlier in the work of Filippo Lippi and Fra Angelico. But perhaps the most original feature of the *St Lucy Altarpiece* is the melodious handling of the pearly light.

In the central panel it is almost as though the fall of the light had determined the character of the only active gesture in the composition, that of the Baptist, who draws

our attention to the Christ-Child (himself turning his head in acknowledgment), for St John's arm follows the direction of the slanting shadow falling upon the shell-shaped niche behind the Virgin's throne. Beyond the arches of the arcade, we glimpse the dark foliage of orange-trees, heavy against 'the vault of blue Italian day'. Within the room itself the light is muted, and the delicate and unusually high-pitched tonalities that predominate in the composition contribute to the impression that we have suddenly entered a cool courtyard that shields us from the heat of the sun. We can understand from this serene and noble conception Piero della Francesca's indebtedness to the older master, both as a composer and as a colourist.

By contrast the art of Paolo Doni, known as Uccello, contains an element of conflict, and it is easy to see him as a divided personality, torn between the opposing claims of scientific method and interior fantasy. The first of these two aspects of his genius won him early recognition as one of the pioneers of perspective and foreshortening; the second brought him his nickname of 'Uccello' ('bird'), alluding to his delight in introducing fanciful birds and animals into his pictures, in the manner of the International Gothic masters.

At the age of ten Uccello entered Ghiberti's workshop, where he probably remained for another seven or eight years. To his early training under Ghiberti can be traced many of his most distinctive characteristics – that love of decorative embellishment which at times recalls the craft of the goldsmith; an endless delight in the beauty of the graceful outline; and, with these, a predilection for rounded and simplified forms. His relationship to Masaccio is less clear. By the time that the decoration of the Brancacci Chapel was under way Uccello had departed for Venice, where he worked as a mosaicist at San Marco. The full impact upon him of Masaccio's revolutionary style must, therefore, be dated after his return to his native city in the year 1431, by which time Masaccio was no longer alive to shape the course of Florentine painting. In Venice, meanwhile, Uccello would have come increasingly under the sway of North Italian Gothic, as represented especially by the frescoes executed by Gentile da Fabriano and Pisanello in the Doge's Palace.

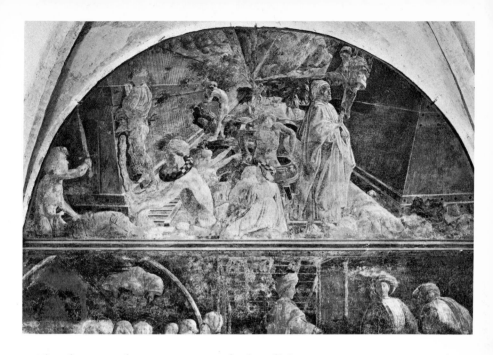

These factors go a long way to account for the stylistic differences that are apparent in the two phases of Uccello's execution of the *Genesis* cycle in the Chiostro Verde (so called from the predominantly green colour of the frescoes) at Santa Maria Novella. The first scenes, which include the *Creation of Adam* and the *Fall*, were probably painted shortly after his return to Florence in 1431. The second series, devoted to the story of Noah, of which the scene of the *Deluge* is the most celebrated (*Ill. 29*), can be assigned to the middle years of the following decade. It is only in the *Noah* frescoes that Uccello shows a thoroughgoing assimilation of the new ideals: not only is the *Deluge* a conscientious exercise in the rendering of perspective, but perspective here serves a dramatic purpose which even anticipates the telling exploration of deep space in Baroque painting. Scarcely less impressive, despite the severe damage that the fresco has suffered in every area, is Uccello's treatment of the nude: the doomed, struggling figures express an energy and a sinewy strength unique in Florentine painting of the period, and before the time of Antonio Pollaiuolo there is nothing quite comparable with this searching exploitation of anatomical knowledge for its own sake.

29. UCCELLO (1396/7–1475). *Deluge, c. 1445. Fresco transferred to canvas. Chiostro Verde, Santa Maria Novella, Florence*

39

The *Deluge*, then, must be considered one of the major expressions of the new scientific spirit in early Quattro-cento painting. Above all, it was a demonstration of the potentialities of mathematical perspective. Uccello's ob-session with perspectival problems may indeed date from the publication in 1435 of Alberti's *Della pittura*. At all events it was in the following year that he was commis-sioned to paint a fresco in Florence Cathedral simulating a wall-tomb with an equestrian statue, in honour of the English commander Sir John Hawkwood (*Ill. 30*). The striking *di sotto in su* perspective (viewed from below) was unprecedented, and the Hawkwood Monument became the model for a pendant, also in fresco, ordered by the Ca-thedral authorities from Andrea del Castagno (*Ill. 32*). Castagno's fresco was commissioned in commemoration of Niccolò da Tolentino, the hero of the Battle of San Romano of 1432, when the Florentines had won a victory over the Sienese. Castagno painted his fresco in 1456, and it must have been about the same time that Uccello was asked by the Medici to illustrate the Battle of San Romano in three large panels (now in the National Gallery in London, the Uffizi and the Louvre) intended for a room in the Medici Palace.

Uccello gave the *San Romano* panels a heroic emphasis which is underlined by the skilful massing of the broad and simplified forms of the rearing horses. In the picture in London (*Ill. 60*) Niccolò da Tolentino, seated on a prancing white charger, is shown in the act of directing the battle. The opposing forces occupy the whole fore-ground area, which is laid out like a narrow stage. On this stage lie broken lances, pieces of armour and the bodies of fallen soldiers, all treated in a receding perspective. The ground plane has clearly been visualized in terms of the Albertian method for constructing perspective, with the vanishing-point of the receding orthogonals lying at the centre of the composition. This system, however, breaks down in the distant landscape, with its rolling hills, and the dominant effect of the picture is one of decorative pattern rather than design in space. Nor does Uccello evoke any sense of the horror of the battlefield: he gives us rather the pageantry of war, and it is not surprising that in the 15th century the *San Romano* series should have been

30. UCCELLO (1396/7–1475).
*Painted Monument to Sir John
Hawkwood, 1436. Fresco transferred
to canvas. Cathedral, Florence*

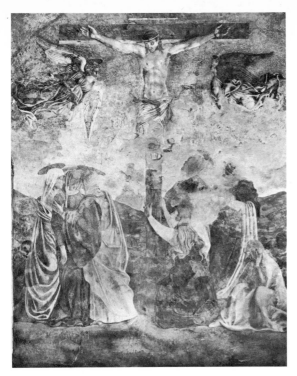

31. ANDREA DEL CASTAGNO
(1421/3?–57). *Crucifixion, 1445–50.*
Fresco. Castagno Museum,
Sant'Apollonia, Florence

nicknamed 'The Joust': indeed Uccello's wooden steeds
so lack any conviction of reality that they suggest a joust
of rocking-horses.

The splendour of the interlocking shapes and contrast-
ing colours recalls some of Alberti's precepts in the *Della
pittura*: 'The picture will have charm when each colour is
very unlike the one next to it ..., bright colours being al-
ways next to dark ones. With such contrasts, the beauty
of the colours will be more manifest and lovelier. And
among colours there are certain friendships, for some join-
ed to others impart handsomeness and grace to them.
When red is next to green or blue, they render each other
more handsome and vivid. White not only next to grey
or yellow, but next to almost any colour, will add cheer-
fulness. Dark colours among light ones look handsome,
and so light ones look pretty among dark ones.'

In the *San Romano* series Uccello gave free rein to the
poetic side of his nature, and in his last works – the predella
panels of the *Story of the Profaned Host*, part of an altarpiece
for the Confraternity of the Corpus Domini at Urbino,

32. ANDREA DEL CASTAGNO
(1421/3?–57). *Painted Monument to
Niccolò da Tolentino, 1456. Fresco.
Cathedral, Florence*

and the marvellous *Stag Hunt* in the Ashmolean Museum
at Oxford – the vein of fantasy is, if anything, still more
in evidence. In the *Stag Hunt* especially, Uccello seems to
make a conscious return to his International Gothic begin‑
nings, and there is a hint in some of the figures that he may
also have looked with interest at the work of his Flemish
contemporaries, whose skill in the rendering of naturalistic
detail was already being noticed in Italy (indeed, a Flem‑
ish painter had displaced Uccello in the commission for
the Urbino altarpiece). More significantly, the evolution
of Uccello's late manner demonstrates the continuing
vitality of International Gothic; a style into which he
breathed something of the grandeur and rationality of Ma‑
saccio's ideal, so liberating it from its late‑medieval con‑
text and making it modern.

Andrea del Castagno, on the other hand, was much
more of a realist. His work is marked by a rigorous devo‑

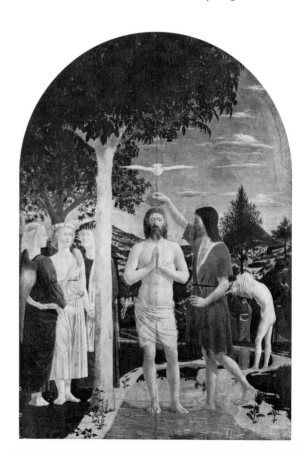

33. PIERO DELLA FRANCESCA
(1410/20–92). *Baptism of Christ,
before 1445. Tempera on wood
66 × 45³/₄ (167 × 116). National
Gallery, London*

42

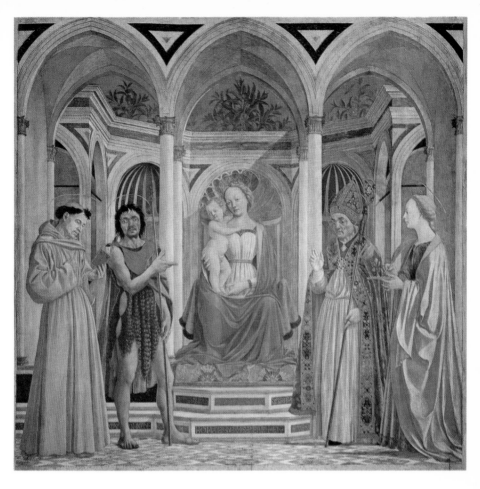

tion to expressive draughtsmanship – as opposed to the
modelling of Masaccio – and by a severity of vision that
reflects an uncompromising and in some ways harsh per-
sonality. This harshness probably accounts for the per-
sistent legend that he murdered Domenico Veneziano in
a fit of jealousy (in fact he died of plague, like Masaccio,
some four years before his supposed victim). Castagno's
earliest preserved work is a frescoed chapel ceiling at San
Zaccaria in Venice, consisting of stern figures of Evange-
lists and Apostles, which dates from 1442. Few of his
other works can be dated precisely; almost all of them are
in Florence, notably in the former convent of Sant'Apol-
lonia, now the Castagno Museum.

34. DOMENICO VENEZIANO
(d. 1461). *St Lucy Altarpiece (central
panel), c. 1445. Tempera on wood
$82^1/_8 \times 83^3/_8$ (209 × 213). Uffizi,
Florence*

43

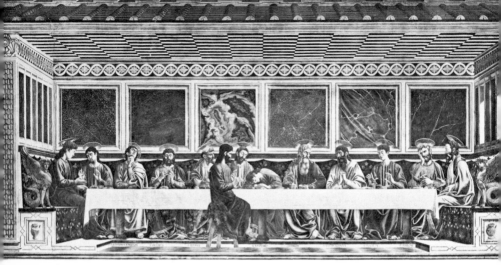

35. ANDREA DEL CASTAGNO
(1421/3?–57). *Last Supper,*
1445–50. Fresco. Castagno Museum,
Sant'Apollonia, Florence

The fresco of the *Crucifixion* at Sant'Apollonia (*Ill. 31*)
– recently detached from its underlying drawing, or *sinopia*
– shows the overwhelming power with which, under the
influence of Masaccio and even more of Donatello, he
reinterpreted traditional subject-matter. The often violent
articulation of his figures derives from a searching study of
anatomy, and his attempt to convey movement by the use
of expressive outline became a characteristic feature of
Florentine painting. At Sant'Apollonia Castagno also
painted a *Last Supper* on the refectory wall (*Ill. 35*): the
setting is entirely antique, and the walls are covered with
marble panels whose colours and patterns are used to
create a sense of unease as well as grandeur. The Apostles'
faces, made more vivid by their thick hair and deep-set
eyes (particularly in the case of the swarthy Judas), are
thrown into relief by the strong light which gives Castagno
an excuse for dark, linear shadows.

A virtuoso display of illusionistic perspective charac-
terizes Castagno's monument to Niccolò da Tolentino
(mentioned earlier), and similar qualities also appear in a
remarkable fresco series of *Famous Men and Women*, for-
merly in the Villa Legnaia and now in the Castagno
Museum. These include heroes of the past and Sibyls, as
well as representations of Dante, Petrarch, Boccaccio, and
three contemporary *condottieri*: all were painted so that they
actually seem to be standing in recesses in the wall – a
type of illusionism carried to extremes by the Mannerists
in the 16th century.

Fra Angelico and Fra Filippo Lippi

Despite the rise of humanism and the cult of pagan antiq-uity, the occasions on which the normal course of the religious life of 15th-century Italy was seriously disturbed were few. In Florence the most striking instance of such conflict came to a head at the end of the century in the

36. FRA ANGELICO (c.1395/1400?–1455). *Deposition, c. 1440. Tempera on wood* $69^1/_4 \times 72^5/_8$ *(176 × 185).* *Museo San Marco, Florence*

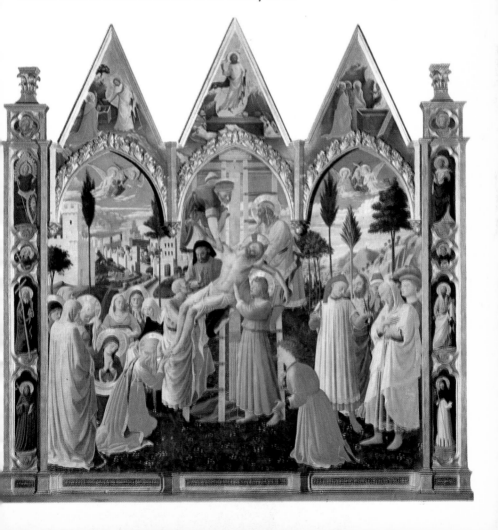

notorious 'Burning of the Vanities' under Savonarola;
but for the art historian the chief lesson of that deplorable
event is that it stands as a reminder of the sustained potency
and vitality of religious forces throughout the century.
Moreover, the 'purely human curiosity about this world'
which, in the words of J.B. Bury, characterized the atti-
tude of the humanists could itself be placed in the service
of a religious art capable of appealing to the believer with
a new directness and intimacy: never, indeed, had the
stories of the Faith been presented to the outward eye more
vividly or with greater conviction of reality. To appreciate
this fact it is only necessary to turn to two of the friar-
painters of the 15th century, Fra Angelico and Fra Filippo
Lippi, artists who have often been compared and indeed
contrasted (for their personalities were very different), but
whose development followed a roughly identical path.

Guido di Pietro da Fiesole, called Fra Angelico, was
born near Florence towards the end of the 14th century,
and at an early age he entered the Dominican convent at
Fiesole. He was known in his lifetime by his conventual
name of Fra Giovanni but after his death as Fra Angelico
(or Beato Angelico). Vasari tells of the saintliness of the
man and of his humility and sweetness of nature, but the
name Angelico implies also that he was regarded as the
Aquinas of painting: as St Thomas Aquinas, the greatest
of all Dominican theologians, was called the 'angelic'
Doctor, so Fra Giovanni, the greatest Dominican artist,
was the 'angelic' painter.

In 1436, by order of the Pope, the community at Fie-
sole was transferred to the old Convent of San Marco in
Florence, which Michelozzo had been commissioned by
Cosimo de' Medici to rebuild (*Ill. 39*). Shortly afterwards
Fra Angelico began to decorate the walls of San Marco
with the series of frescoes for which he is most celebrated.
The convent is now the Fra Angelico Museum, and
besides the frescoes painted on the walls many of Fra An-
gelico's altarpieces and predella panels are housed there,
including the large *Madonna and Child enthroned, with Saints
and Angels*, which he executed for the high altar of the
convent church.

Fra Angelico worked as the servant of the Dominican
Order, and his art exactly reflects the spiritual ideals of the

strict reformist movement within the Order which came
to be known as the Dominican Observance. The leader
of the Observants, Giovanni Dominici, had been Prior
of San Domenico at Fiesole shortly before Angelico took
his vows there. Dominici's principal theological work is
the *Lucula Noctis*. Particularly relevant to the art of Fra
Angelico is its view of nature as a source of man's under-
standing of the Divine Nature: through the study of the
natural order, Dominici says, the mind inspired by love
is able to penetrate to a knowledge of the heavenly world.

Fra Angelico's vision of the world was inevitably col-
oured by the new artistic tendencies of the age. There is
much in his earliest work to remind us of the art of another
friar-painter, Lorenzo Monaco; but Angelico belonged to
a later generation, and his formative years coincided with
one of the decisive moments of innovation in European
painting, sculpture and architecture. There can be no
doubting the impact made upon him, at an early date, by
the frescoes in the Brancacci Chapel. The *Annunciation* at
Cortona, of about 1430, which anticipates the more fa-
mous interpretation of the same theme at San Marco
(*Ill. 40*), and the *Annalena Altarpiece*, of about seven years
later, show the increasing influence of Masaccio's sculp-
tural treatment of form and grandeur of design. Never-
theless, there is always in Angelico's works a sweetness
and refinement more typical of Masolino, and very pos-
sibly he recognized that Masolino had shown the way to
a satisfactory synthesis between Masaccio's innovations
and the virtues of Late Gothic decorativeness, or – as we
may express it – between the conflicting demands of the
'sublime' and the 'beautiful'.

The *Annalena Altarpiece* has almost the air of an exer-
cise in the realization of that ideal of ordered space, found-
ed upon the logic of mathematics, which is common to
the work of Masaccio and to the theory of Brunelleschi
and Alberti, while the monumental treatment of the six
Saints clearly owes much to the Apostles of the Brancacci
Chapel. Equally interesting is the use of perspective in the
Cortona *Annunciation*, the prototype of Quattrocento rep-
resentations of this subject. The *loggia* within which the
Virgin is seated is a tribute to the classical architecture of
Brunelleschi, and provides at the same time a convincing

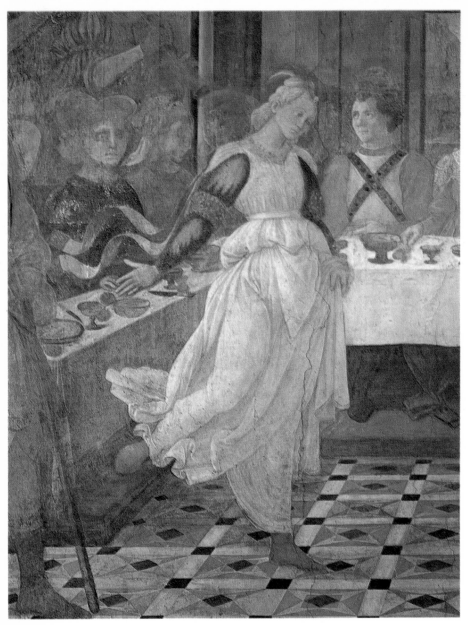

37. FRA FILIPPO LIPPI (*c.*1406–69). *Salome (detail of Feast of Herod), 1452–64. Fresco. Cathedral, Prato*

spatial setting for the Gospel story. This dominating fea-
ture must have made the picture seem strikingly modern to
Angelico's contemporaries; but it is not merely a pictorial
contrivance, for the new perspective is enlisted in the serv-
ice of doctrinal statement; and its deeper significance with-
in the composition lies in the iconographic function of the
receding orthogonals of the *loggia*, which is to direct at-
tention to the little scene of the expulsion of Adam and
Eve from Paradise represented in the top left corner, an
episode that reminds the beholder that it was by her obe-
dience to the message of the Angel that the Virgin Mary,
the second Eve, became the agent of the restoration of what
had been lost by the frailty of the first Eve.

Fra Angelico was a pioneer of landscape-painting, and
Berenson thought him the only true interpreter of the Tus-
can countryside. That landscape has scarcely changed
since the great Dominican painter looked down upon it
from Fiesole, and his fidelity to what he saw can be judged
from the wonderful vista of tree-shaded hills that stretches
back into a grey-blue distance in the Santa Trinita *Depo-
sition* of about 1440 (*Ill. 36*). This important work, like
Domenico Veneziano's *St Lucy Altarpiece* (*Ill. 34*), owes
its composition to the tradition of the medieval triptych:
the tripartite division of the upper frame enabled Fra
Angelico to confine the event of the Deposition within the
central area, and to represent at the sides two symmetrically
balanced scenes of meditation, that on the left containing
the group of the Holy Women, and that on the right a
number of philosophers, one of whom displays the sacred
nails and the Crown of Thorns: it has been well said that
we are shown here the religion of the heart and of the mind.

This way of treating a religious subject in terms of a
pious meditation upon the Gospel story comes into its
own in the series of frescoes painted by Fra Angelico and
his pupils in the friars' cells at San Marco. These scenes
complete an extensive scheme of decoration which must
have been commenced not long after the year 1437, when
Michelozzo began the rebuilding of the convent. Miche-
lozzo had finished the cells on the upper floor by about
1443, and the cell frescoes must have been executed before
Angelico was summoned to Rome, some four years later.
The programme of the decorations was a simple one, and

38. SANDRO BOTTICELLI (*c.*1445–
1510). *Judith with the Head of
Holofernes, 1470–72. Tempera on
wood 12¹/₄×9¹/₂ (31×24).
Uffizi, Florence*

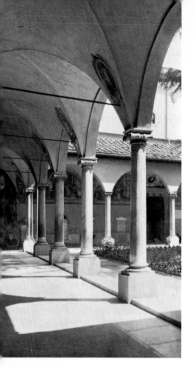

39. MICHELOZZO MICHELOZZI (1396–1472). *Cloisters, San Marco, Florence, after 1437*

the treatment is equally simple and direct: each cell was to contain one fresco depicting a scene from the life of Christ and acting as a counterpart to the solitary window – be-coming a second window, as it were, opening upon the Divine Order. There was no need at San Marco for the painter's hand to compel assent: each scene, accordingly, was conceived as a painted meditation inviting silent con-templation. We can appreciate at San Marco the value of Angelico's 'conservatism', for here there is revived the profound innocence of vision of the 14th-century masters, from Giotto to Agnolo Gaddi.

Of all the San Marco decorations the most perfect, and the most representative of Fra Angelico's genius, is un-doubtedly the great *Annunciation* (*Ill. 40*) facing the stair-way at the entrance to the dormitory. Here the *loggia* within which the Virgin is seated is modelled upon the graceful style of Michelozzo's cloisters in the convent (*Ill. 39*), establishing a sequence of accents and placid intervals which contributes to the almost abstract harmony of the whole. The evolved style of this fresco suggests that it may have been painted after the artist's return in 1449 from Rome, where he had executed his last major work, the decoration of the Chapel of Nicholas V in the Vatican Palace.

The Papal Court was now a centre of humanist learn-ing and culture, and it was said that 'all the scholars in the world flocked to Rome in the time of Pope Nicholas'. There the affairs of the Church and the revival of classical antiquity pursued parallel courses, and the rediscovery of the ancients encouraged a historicism which could be applied to the traditions and to the authority of the prim-itive Church. Thus it was that in the Chapel of Nicho-las V Fra Angelico was given the task of illustrating the lives of the protomartyrs Stephen and Lawrence: they are shown with all the dignity and nobility that the Renais-sance humanists ascribed to the philosophers of antiquity.

In the Chapel of Nicholas V Angelico returned in spirit to the modern classicism of Masaccio. The *St Law-rence distributing Alms* (*Ill. 41*) seems to contain, for in-stance, a memory of the measured harmony of Masaccio's *Trinity* (*Ill. 20*): above all, Masaccio's influence can be detected in the sculptural treatment of the figures and in

the lucid rendering of space. Yet none but Fra Angelico could have conceived these sublime compositions; for they share with the San Marco frescoes and all his other works a unique purity of vision and style which stamps his genius from the beginning, and in which the darkness of the world appears to be dissolved for ever by the clear radiance of morning light.

Fra Filippo Lippi, who was born about 1406, presents a marked contrast to Fra Angelico. The personality of this worldly friar has been immortalized by Browning, and Vasari tells us that his great patrons the Medici turned a blind eye to his vagaries (which included the abduction of the beautiful nun Lucrezia Buti) on the grounds, as Cosimo de' Medici expressed it, that 'the excellences of genius are as forms of light, not beasts of burden' – an indication of the new attitude to genius fostered by the humanist culture of 15th-century Florence.

Filippo's are among the most obviously attractive of Renaissance paintings; his Madonnas are invariably beautiful girls of a particularly exquisite type (Botticelli, Verrocchio and even Leonardo inherited his taste in this re-

40. FRA ANGELICO (*c.*1395/1400?– 1455). *Annunciation, after 1449. Fresco. Convent of San Marco, Florence*

51

spect), richly dressed and somewhat wistful. What places him in a rank of his own is the technical virtuosity and inventiveness of his compositions, his limpid draughts-manship and his subtle yet brilliant use of colour.

As an adolescent, Filippo was placed in the monastery of the Carmine: there he must have seen Masaccio at work in the Brancacci Chapel, and certainly in his own early paintings the influence of Masaccio is paramount. In his first dated work, the *Tarquinia Madonna* of 1437 (Galleria Nazionale, Rome) two other influences appear – that of Donatello, which is particularly clear in the vigorous figure of the Child, and that of Flemish painting, visible in the crisp drapery and the homely interior with its book and open window (*Ill. 100*). The San Lorenzo *Annun-ciation* (*Ill. 13*), of the same period, includes a meticu-lously observed glass bottle which is a virtual quotation from Flemish painting; the composition as a whole is of an unprecedented complexity for the subject, and in it Filippo gives a virtuoso display of exaggerated perspec-tive, based on an off-centre vanishing point. The group of the Virgin and Angel may be compared to Donatello's relief in Santa Croce (*Ill. 12*), though in its combination of engaging realism and elusive poetry the picture points forward to Leonardo's early *Annunciation* (*Ill. 99*).

In the group of the Virgin and Child with saints and angels in the *Barbadori Altarpiece* in the Louvre, Filippo created what is perhaps the earliest *sacra conversazione* (see p. 37). In addition, Filippo here introduced the device of an interrupted feature in the foreground – the altar-rails – to increase the spectator's sense of involvement. In the *Coronation of the Virgin* of 1441–c. 1447 in the Uffizi the same spatial device is used, this time in the form of three-quarter-length figures. The space thus suggested is, how-ever, almost denied by the great overcrowding and lavish detail of the scene, which tend to transform it into linear surface pattern.

Filippo's later pictures are notable for the delicacy of their style; and the figures, with their elongated bodies and small heads, depart some way from Masacciesque solidity. The *Pitti Tondo* of 1452 shows an exceptionally refined sensitivity in its portrayal of the Virgin and Child, who are placed before a highly complex background sug-

41. FRA ANGELICO (*c*.1395/1400?–1455). *St Lawrence distributing Alms,* 1447–9. *Fresco. Chapel of Nicholas V, Vatican*

gestive of the low reliefs of Donatello. In one of Filippo's last paintings of the Virgin and Child, the *Madonna ador-ing the Child* painted for the altar of the Medici Chapel about 1460 (Berlin), instead of a realistic background we find the dark, fairytale woods of International Gothic.

Filippo Lippi was also one of the major fresco-painters of the period. His principal works in this medium are the series in the choir of Prato Cathedral, executed between 1452 and 1464 and representing scenes from the lives of St John the Baptist and St Stephen. The overcrowding characteristic of his earlier work has gone; the frescoes are notable for their grandeur of design, their treatment of space and light, and their realism in the presentation of human character and action.

In the *Funeral of St Stephen* the setting is the interior of a noble church worthy of Brunelleschi; the treatment of detail includes effects of cast shadow – learnt from Ma-saccio – which add to the impression of present reality; and in the figures of the bystanders, many of them actual portraits, there is already more than a hint of the type of composition that was to be developed by Ghirlandaio in

the last quarter of the century. In the *Feast of Herod*, slightly later in date, the graceful movement of the figure of Salome looks forward to the linear expressiveness of Filippo's pupil Botticelli (*Ills. 37, 38*).

No painter of the early Quattrocento, after Masaccio, was more adventurous than Filippo Lippi, or extended further the boundaries of painting. The richness of his achievement is indicated by the very diversity of his influence upon his immediate or ultimate heirs, whether we instance his pupil Botticelli or a close follower such as Ghirlandaio or, more remotely, Leonardo himself.

42. FILIPPO BRUNELLESCHI (1377–1446). *Old Sacristy, San Lorenzo, Florence, 1421–8*

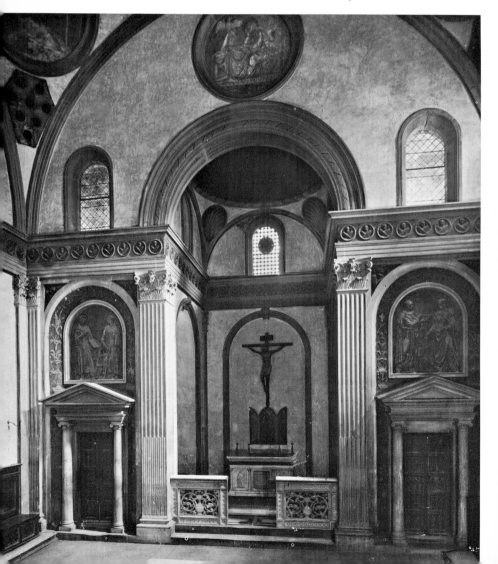

While Ghiberti was working upon the *Porta del Paradiso*, Donatello untertook a similar commission for two pairs of bronze doors, although on a far less ambitious scale. These doors were ordered by the Medici for their funeral chapel in San Lorenzo, known as the Old Sacristy, which had been built by Brunelleschi (*Ill. 42*). They stand on either side of the altar, forming the entrances to cubicles used for storing vestments, candles and other ecclesiastical furnishings; surmounting each pair of doors is a large stucco relief, that over the left door representing St Stephen and St Lawrence and that on the right St Cosmas and St Damian. The walls and pendentives are decorated with eight further reliefs, also in stucco – four of them bearing

43. MICHELANGELO (1475–1564). *Medici Chapel, San Lorenzo, Florence, 1520–34*

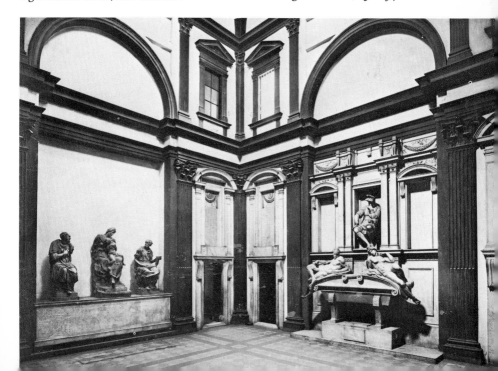

44. DONATELLO (*c.* 1386–1466).
Ascension of St John, c. 1435–40.
Painted stucco relief d. 84⁵/₈ (215).
Old Sacristy, San Lorenzo, Florence

the images of the Four Evangelists and the other four being devoted to scenes from the life of St John the Evangelist. This ambitious scheme represents Donatello's major effort in the late 1430s and early 1440s before his departure for Padua. His style shows a renewed impulse towards auster⁄ ity, a severe classicism which owes much to the influence of the antique: some of the profile heads (such as that of St Cosmas) recall portraits of Caesars on Roman coins. The panels of the doors themselves contain representations of disputing Apostles and martyrs, which are remarkable for their variety and vehemence of action and for their evocation, through facial expression and bodily gesture, of psychological *nuance*.

The most interesting part of the decoration of the Old Sacristy is the series of coloured roundels of the life of St John, in which Donatello devoted himself to complex problems of spatial construction, leading in the *Ascension of St John* (*Ill. 44*) into the realms of purest fantasy. The bare architectural structures in this scene create an atmos⁄ phere of strangeness which makes the modern beholder

think of de Chirico and the Surrealists, while the queer *di sotto in su* perspective contributes to the impression of dreamlike unreality. Altogether the bronze and stucco reliefs in the Old Sacristy underline Donatello's mastery of relief-sculpture as a vehicle for psychological statement and emotional expression – qualities that he was to realize with yet heightened intensity in the Santo Altar at Padua and subsequently, during his final Florentine period, in the unfinished pulpits at San Lorenzo.

Donatello left Florence for Padua in the latter part of 1443 or early in 1444. He was to remain there for the next ten years, undertaking two major works – the equestrian statue of the Venetian *condottiere* and statesman Erasmo Narni, known as Gattamelata, and the elaborate high altar for the basilica of Sant'Antonio (the 'Santo'). The presence of these works in Padua exerted a profound influence upon the art of the region, not least in nearby Venice, and both the Paduan Mantegna and the Venetian Giovanni Bellini were to translate into the terms of painting the grave vigour of the Santo reliefs (*Ills. 47, 67.*)

The statue of Gattamelata (*Ill. 45*) was set up in the piazza outside the Santo. Its only true rival in the entire period of the Renaissance is the Colleone Monument (*Ill. 46*) in Venice, designed by the Florentine sculptor and painter Verrocchio over thirty years later, and it is instructive to compare the two statues. Verrocchio creates a generalized and in a sense an ideal figure; the Colleone Monument is an impressive and commanding work, and in its naturalism and expression of life and movement superior, no doubt, to the Gattamelata. But Donatello's statue is the subtler and more searching of the two: the rather forced swagger of the Verrocchio has no part in this dignified and solemn portrait, in which the simple pride of bearing of the *condottiere* is combined with a sense of humility and a kind of contemplative melancholy, giving a rounded impression, not of a type, but of an individual. Donatello was now near sixty years old, and on the *Gattamelata* he exerted all the strength of his genius. Whereas in the Old Sacristy he had been sparing of all ornament, he now lavished great pains upon the embellishment of such details of the statue as the armour – designed in a fanciful taste, probably with the intention of suggesting remote

45. DONATELLO (*c.* 1386–1466). *Monument to Gattamelata (Erasmo Narni), 1447–53. Bronze, marble base on limestone pedestal* 133⁷/₈×307¹/₈ (*340×780*). *Piazza del Santo, Padua*

46. ANDREA DEL VERROCCHIO (*c.* 1435–88). *Monument to Bartolommeo Colleone, commissioned c.* 1479. *Bronze, h. without plinth* 155¹/₈ (*395*). *Campo Santi Giovanni e Paolo, Venice*

47. DONATELLO (*c*. 1386–1466).
Pietà, 1446–50. Bronze
54³/₈ × 74 (138 × 188).
High Altar of the Santo, Padua

antiquity, and decorated with *putti* – and the elaborate saddle, supported by caryatids. The *Gattamelata* is of great historical importance as the first bronze equestrian statue to have been made since Roman times; and on its completion it must have elicited favourable comparisons with the most celebrated of all classical statues of this kind, the *Marcus Aurelius* on the Capitoline Hill in Rome.

The Santo Altar is Donatello's largest single work in sculpture, comprising a Madonna and Child and six other statues in the round, twelve panels of angels, four reliefs bearing the Symbols of the Evangelists, four large narrative reliefs of the miracles of St Anthony of Padua, and two further panels of the Lamentation over the Dead Christ and the *Pietà* (*Ill. 47*). The altar was dismantled in the 17th century when renovations were under way in the church, and the component parts were wrongly assembled in the 19th century. The original disposition of the various statues and reliefs remains a matter of some uncertainty, although it may be assumed that the statues would have been grouped together, on either side of the *Madonna*, under a canopy supported by columns.

No work by Donatello is stranger or more compelling than the *Madonna and Child*: it is frontal and hieratic like a

Byzantine or Romanesque Madonna, as though Donatello had been asked to reinterpret some venerated image in the neighbourhood. Of the other statues (St Anthony, St Francis, St Daniel, St Justina, St Louis and St Prosdocimus) the finest is perhaps the St Francis, a 'portrait' as subtle as that of Gattamelata, conveying a mood of gentle reverie and humble submission and yet suggesting a man of intellect and will. St Anthony, on the other hand, is represented as more the man of action – appropriately enough, since it is his miracles that form the subject-matter of the principal reliefs. The treatment of this figure must have seemed unusually bold to Donatello's contemporaries, on account of its unfinished appearance: we are now on the threshold of Donatello's late style, with its exploitation of roughness of surface for expressive ends.

The stories that he was required to illustrate on the four main panels present St Anthony as a wonder-worker of the characteristic medieval type; but Donatello raises the childish narratives to the dignity of classical legend. In the *Story of the Irascible Son (Ill. 48)*, in which the saint restores the amputated foot of a young man, the setting is a Roman amphitheatre, and the impression of vastness is enhanced by the naturalistic representation of the sun, high in the heavens amid wispy clouds. Similarly, the drama of the *Miracle of the Mule*, the subject of which is the conversion of a heretic to belief in the doctrine of the Real Presence, takes place in a noble building that suggests an adaptation to the terms of 15th-century classicism of the ancient Basilica of Constantine in Rome.

48. DONATELLO (*c.*1386–1466). *Story of the Irascible Son, 1447–9. Bronze 22^1/$_2$ × 48^1/$_4$ (57 × 123). High Altar of the Santo, Padua*

49. DONATELLO (*c.* 1386–1466).
Resurrection (detail), c. 1460–66.
Bronze, whole pulpit 48³/₄ × 115
(*123 × 292*). *Second pulpit,*
San Lorenzo, Florence

It is only a short step from the Santo *Lamentation* with its congested spaces and frantic gestures to the terrible, emaciated figure of *St John the Baptist*, executed about 1451 or 1452 for the Frari Church in Venice, and the *Mary Magdalen* in the Baptistery in Florence, which dates from a few years later. It is possible to interpret these disturbing works in terms of a reversion on Donatello's part to a 'medievalism' of outlook, especially as they represent a temporary renunciation of bronze or marble sculpture for the medieval craft of woodcarving.

From the period of the execution of these impressive works until his death in 1466, Donatello was principally engaged upon the bronze reliefs for the two pulpits at San Lorenzo, which constitute his final artistic legacy to the world. The reliefs are chiefly devoted to the Passion and Resurrection of Christ. In no other Renaissance represen-tation of the drama of Golgotha are the nerves of pious grief so agonizingly laid bare, or the divine tragedy so stripped of consolation: witness the Bacchante-like frenzy of the mourners in the *Deposition* and – most moving of all – the Christ of the *Resurrection* (*Ill. 49*), wearing upon his features, as it seems, the sorrows of the whole world, and weary from his passage through the heaviness of death. The San Lorenzo pulpits exhibit distinctive qualities that are often found in the last statements of supreme genius in all the arts, of genius that has attained at length to a final wisdom and resignation: in the art of painting, it is nec-essary only to instance the late works of Michelangelo, Titian and Rembrandt, united as they are by a common faculty for immediate expression without any apparent reliance upon rule and precept, and for a directness of statement that appears casual in its easy relinquishment of the pains and struggles of youthful endeavour. In this sense the San Lorenzo reliefs take their place among the most sublime achievements in the visual arts. The tragic sentiment, engraved in every rough-hewn form and jagged plane, contradicts any oversimplified view of the meaning of the civilization which we call the Renaissance. Look-ing forward from the San Lorenzo pulpits into the age of Savonarola and its aftermath, we are the more prepared for the climactic point of despair that marks the last works of Botticelli.

Sculpture and painting in Siena

The most important centre of sculptural activity outside Florence during the first half of the 15th century was undoubtedly Siena, which produced, as the counterpart of Donatello in Florence, one supreme genius in the person of Jacopo della Quercia. In one sense Quercia's development runs parallel to that of Donatello, in that it shows an increasing classicism allied to a strong impulse towards the dramatic. His first certain work is the funeral monument in Lucca Cathedral to Ilaria del Carretto Guinigi, who died in childbirth in 1406. In its present state it consists of the reclining figure of the dead girl – a masterpiece of tender pathos – on a sarcophagus whose garland-bearing *putti* derive from ancient Roman funerary art.

In 1409 the Signoria of Siena commissioned Quercia to design a large marble fountain – the Fonte Gaia – for a site on the Campo opposite the Palazzo Pubblico. For some years the sculptor dithered and procrastinated, spending most of his time elsewhere; and it was not until 1416 that the work began to take shape. It was completed three years later. The Fonte Gaia has now been dismantled and can be studied only in its individual parts, and much of the sculpture has been seriously damaged, but in its original state the fountain must have been extremely impressive, and traces remain of lavish polychrome decoration. Even in the fragmentary *Expulsion* the power of the artist's conception, and the monumental nudes, anticipate the grandeur of Masaccio's fresco of the same subject in the Carmine. Elsewhere, the finely modelled figure of *Rhea Sylvia*, the mother of Romulus and Remus, has a classic grace and inner life that make us think ahead to the Sibyls of the Sistine Chapel ceiling.

While Quercia was engaged on the Fonte Gaia, a plan was drawn up for the erection of a new font in the Siena

50. JACOPO DELLA QUERCIA
(1374/5-1438). *Zacharias and the
Angel, 1427-30. Bronze
23⁵/₈ × 23⁵/₈ (60 × 60).
Baptistery font, Siena*

Baptistery, and Ghiberti and Quercia were called in to
undertake the work. One of the distinctive features of the
font, the embellishment of the traditional hexagonal base –
the font proper – with six bronze reliefs, follows a design
by Ghiberti. Later on Quercia replaced Ghiberti as *capo-
maestro*, and to him is probably due the conception of the
elegant classicizing tabernacle which rises in the middle
of the font, with its prophets in niches, and its surmount-
ing statue of St John the Baptist. Of the reliefs, two each
were commissioned from Ghiberti and Quercia (the others
being left to minor Sienese sculptors); but as we have seen,
Quercia delayed, and his commission for the *Feast of Herod*
was transferred to Donatello (*Ill. 15*). Quercia's one
relief, illustrating St Luke's story of *Zacharias and the Angel*,
was not completed until 1430 – so late that it shows the
influence of Donatello's relief; but in its combination of
an antique gravity of sentiment with a sort of suppressed
excitement it is unmistakably a product of Quercia's imag-
ination (*Ill. 50*). The subtly unified design is given variety
by the use of oblique perspective in the architectural back-
ground; and by the use of simple, massive forms Quercia

51. JACOPO DELLA QUERCIA (1374/5–1438). *Creation of Man, 1425–35. Red marble 32^1/$_4$ × 26^3/$_4$ (82 × 68). Jamb of west door, San Petronio, Bologna*

52. VECCHIETTA (*c.* 1412–80). *Adam and Eve in the Garden of Eden, 1441–9. Fresco. Hospital of Santa Maria della Scala, Siena*

successfully conveys the portentous significance of this heavenly visitation.

In 1425 Quercia received what was undoubtedly his most important commission: this was for the surround of the main portal of San Petronio at Bologna, and included a Madonna and a number of reliefs. There is nothing in Renaissance sculpture quite comparable with the bursting energy that is compressed into these tersely dramatic interpretations of the story of the Creation and the Fall of Man. The intensity of the expression derives to a considerable extent from the monumentality of Quercia's treatment of form. In the *Creation of Man* (*Ill. 51*), for instance, God is a massive figure, muffled in heavy drapery, while Adam recalls some antique representation of an athlete. Equally striking is the sense of the artist's personal engagement in his subject-matter, so that the ancient doctrine about the Fall and its consequences for humanity is given a new immediacy. This dramatic intensity reaches its height in the scene of the *Fall* itself, where an overwhelming impression is given of man's responsibility for his fate. One of the outstanding qualities of the San Petronio reliefs is

63

53. SASSETTA (1392/1400–50).
Stigmatization of St Francis, 1437–44.
Panel from the altarpiece of San
Francesco, Borgo San Sepolcro.
Tempera on wood 34¹/₂ × 20³/₄
(88 × 53). National Gallery, London

their passionate expression of emotion combined with grandeur: it is not surprising that Michelangelo should have declared his admiration for Quercia's art.

Sienese sculpture was greatly stimulated by Donatello's presence in the town during the 1420s: the two most interesting artists to show his influence are Vecchietta and Francesco di Giorgio. Yet the visitor who seems to have left the most profound impression on Sienese painting was Gentile da Fabriano, a man who in most respects represented the opposite of the qualities that Donatello stood for. On the whole Sienese painting remained nostalgic, archaic and decorative (the great exceptions, Domenico di

Bartolo and Vecchietta, are considered below). Indeed, the elegant style carried to perfection by Gentile must have appeared to the Sienese to be a logical and acceptable development of the art of the great Sienese masters of the Trecento.

In Sassetta, the master of Vecchietta, the marriage of these two traditions – 14th-century Sienese and International Gothic – gave birth to a graceful and harmonious style appropriate to the artist's mystical vision, a style which combines in equal measure graceful drawing and luminous colour. In the London *Stigmatization of St Francis* (*Ill. 53*) we can see how Sassetta has adapted the traditional iconography to his own poetic naturalism. The subject is the imprinting upon the body of St Francis of the wounds of Christ, and the presence of a crucifix reminds us of the Franciscan concept of the Saint's spiritual likeness to the crucified Christ: yet the agony of Mount La Verna takes second place to a mood of gentle lyricism, to an almost visionary delight in the beauty of God's Creation. In this respect Sassetta's panel anticipates the most sublime of all Renaissance interpretations of this theme – Giovanni Bellini's *St Francis in Ecstasy* (*Ill. 78*) in the Frick Collection in New York.

The work of Giovanni di Paolo offers obvious points of similarity with that of Sassetta, who influenced his de-

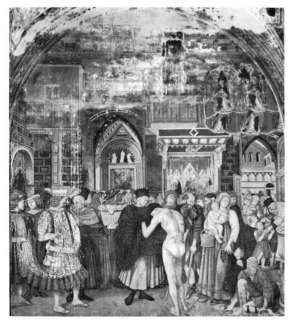

54. DOMENICO DI BARTOLO (*c.* 1400–44). *Distribution of Alms to the Poor*, early 1440s. Fresco. Hospital of Santa Maria della Scala, Siena

65

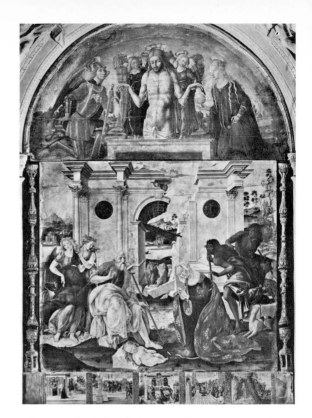

velopment; but his artistic personality was at once gloomier and more nervous, and his fervid 'expressionism' runs
parallel with similar tendencies in contemporary Sienese
sculpture. There is something almost eccentric, yet always
powerful, in the independence of his vision, and his interpretations of even the most traditional subjects are full of
surprises: he clothes his narratives in an atmosphere of
dream, and yet conveys through every meticulously
wrought image a sense of heightened reality. Above all,
he excelled in subjects which gave him the opportunity to
exercise his fantasy: a characteristic example is the small
predella panel in the Johnson Collection at Philadelphia,
representing *A Miracle of St Nicholas of Tolentino*.

If the style of Domenico di Bartolo seems exceptional
in Sienese painting of the early 15th century, it is because
it reflects the direct impact of Masaccio's frescoes in the
Brancacci Chapel. This influence is particularly evident
in his two frescoes in the Hospital of Santa Maria della

Scala at Siena, illustrating the charitable work of the institution: in the *Distribution of Alms to the Poor* (*Ill. 54*), the management of space and perspective, the treatment of the human figure – notably in one impressive nude, seen from the back – and the observation of effects of light and cast shadow all reflect Domenico's study of the Brancacci Chapel cycle. Domenico's frescoes were executed in the early 1440s, when Vecchietta was beginning a much more extensive series of decorations in the hospital. These also show a Florentine influence, but rather that of Masolino and Uccello. Something of the curious charm of Vecchietta's decorations can be judged from the now damaged fresco of *Adam and Eve in the Garden of Eden* (*Ill. 52*), which so congenially evokes that worthy, nostalgic longing of mankind for a state of primal innocence. As a sculptor, Vecchietta excelled in the medium of bronze, his most important work being a ciborium for the church of the Scala Hospital. His bronze relief of the *Resurrection,*

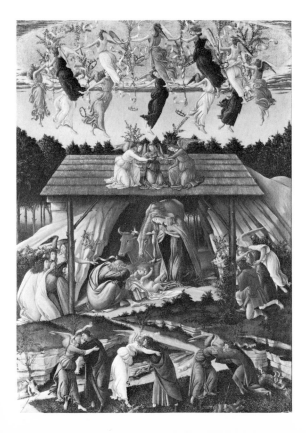

56. SANDRO BOTTICELLI (*c.* 1445–1510). *Mystic Nativity, 1500. Tempera on canvas (transferred?) 42³/₄×29¹/₂ (109×75). National Gallery, London*

which almost certainly formed part of the ciborium, and which can now be seen in the Frick Collection in New York, demonstrates his command of expressive and often contorted outline: at the same time, it reveals a fundamentally archaic approach to the representation of form and space.

Whereas Domenico di Bartolo and Vecchietta reflect in their different ways the lessons of the first phase of the Florentine Renaissance, Francesco di Giorgio belongs to a later generation which was aware of the subtle innovations associated with the names of Filippo Lippi, Botticelli, Filippino Lippi and Verrocchio. He was equally famous as a painter, sculptor, architect, engineer and theorist: indeed in the latter fields he influenced Leonardo da Vinci. In the *Adoration of the Shepherds (Ill. 55)*, executed for the church of San Domenico at Siena, the affinities with Botticelli and Filippino Lippi are particularly close. The imposing triumphal arch that dominates the scene must derive directly from Botticelli's representation of the Arch of Constantine in his fresco of the *Punishment of Corah and the Sons of Aaron (Ill. 82)* in the Sistine Chapel; the Botticellian inspiration of the elegantly posed angel on the far left is only too evident; and in the general flurry of the draperies of the figures there is a suggestion of that quality of disturbance which characterizes the art of Filippino Lippi. Nevertheless, such borrowings do not detract in the least from the mastery evinced in this impressive work. There are qualities in it that are not to be found in Florentine painting of the period – above all, perhaps, that combination of a fundamental decorativeness and a directness of emotional expression which is particularly characteristic of the Sienese School. The tendency in 15th-century Sienese art towards a sometimes violent display of emotion is reflected in Francesco di Giorgio's bronze relief of the *Lamentation over the Dead Christ* (now in Santa Maria del Carmine in Venice), in which the subtle treatment of the figures witnesses to the artist's study of antique sculpture.

When Francesco di Giorgio died, Michelangelo had begun work on his marble statue of *David*. A new age was coming to birth, which was to prove alien to the unique qualities of the Sienese genius.

Although Piero della Francesca enjoyed great fame in his own lifetime, and was described in Luca Pacioli's *Summa arithmetica*, published two years after the painter's death, as 'the monarch of painting', by the 17th century he had been virtually forgotten, and it was left to the modern sensibility, sharpened by the experience of the work of Cézanne and of Analytical Cubism, to restore him to his rightful place among the greatest masters of European painting. At a time when modern painting was searching for a new discipline, while yet barely conscious of its incapacity to attain the heights that Cézanne, as a new Masaccio, had trodden, the ordered mathematical world of Piero della Francesca might well seem to offer an ideal of unsurpassable perfection.

The gradual eclipse of Piero's reputation after his death must have been partly due to the fact that he worked, in the main, outside the principal artistic centres of Italy. It is relevant in this context that the frescoes which he executed in the Vatican were soon destroyed. He is first recorded in the year 1439 as one of Domenico Veneziano's assistants in Florence; but most of his life appears to have been spent in his native town of Borgo San Sepolcro, in Umbria. It was for Borgo San Sepolcro that he painted several of his most important works, including the *Baptism of Christ* (now in London) and the *Resurrection*, and it was there in 1445 that he was commissioned to paint the great *Madonna della Misericordia* (Ill. 57) for the Compagnia della Misericordia, or Brotherhood of Mercy.

From even the most cursory glance at the picture, the profound impression made upon Piero by the work of Masaccio that he had seen in Florence would be sufficiently clear; but there is nothing in Masaccio to compare

with the austere geometry that lends such power to the image of the Virgin, standing, as the protectress of the Compagnia, with her arms extended, so that her cloak forms a tent-like enclosure for the group of suppliants gathered below. The composition has been conceived throughout in terms of basic geometrical forms.

Piero's devotion to mathematics bore fruit in a number of important treatises, among which the *De prospectiva pingendi* was dedicated to Federigo da Montefeltro of Urbino. A consistent application of mathematical theory to the problems of composition underlies his unequalled mastery of interval, a process that begins in a mathematical harmony established in the picture-space itself. In the Borgo *Madonna*, for example, the picture-area consists of a square surmounted by a half-circle, a system repeated in the London *Baptism*, painted for the Priory at Borgo San Sepolcro.

The *Baptism* (*Ill. 33*) is an early work, and there are hints in its luminous colour of the impression that Sassetta's altarpiece in the church of San Francesco at Borgo (*Ill. 53*) must have made upon the young Piero. The cool light that suffuses the whole scene derives both from the same Sienese tradition and from the example of Domenico Veneziano. The tonal scale is pitched unusually high, making possible melodious transitions from the middle tones to those pure whites which in Piero's hands take on an intense colouristic value. Underlying the restrained harmonies of colour there runs the austere prosody of a regular geometric order: the division between the lunette-shape and the rectangular format of the main area of the composition is marked by the outspread wings of the Dove hovering above Christ's head; below, the composition resolves itself into a series of calculated verticals and less emphatic horizontals, with the central, column-like figure of Christ dominating the whole.

The London *Baptism* represents a departure from the method of Masaccio: the deep shadow characteristic of Masaccio's modelling has been abandoned in favour of a luminous treatment which conveys the impression of an envelope of light surrounding every form. There are passages that show remarkable observations of reflected light, and such explorations are carried still further in Piero's later work. Hints of a similar interest occur in Domenico

57. (opposite) PIERO DELLA FRANCESCA (1410/20–92). *Madonna della Misericordia, commissioned 1445. Panel 127^1/$_4$ × 107^1/$_2$ (323 × 273). Town Hall, Borgo San Sepolcro*

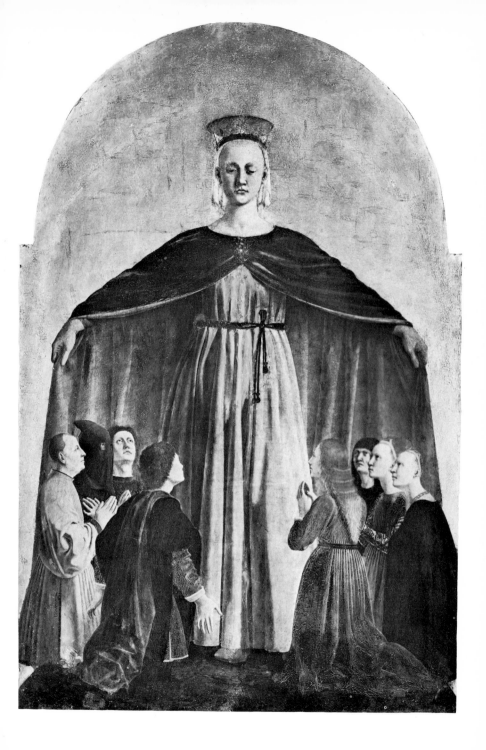

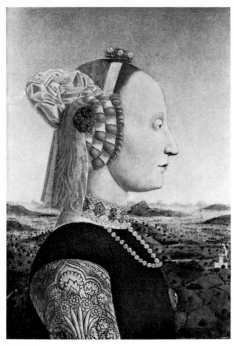

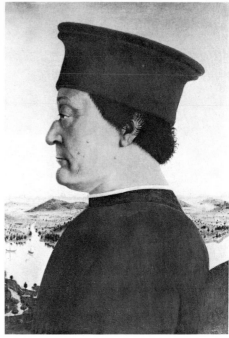

58 PIERO DELLA FRANCESCA
(1410/20–92). *Battista Sforza,
Duchess of Urbino, c. 1465. Oil on
wood 18^1/$_2$ × 13 (47 × 33). Uffizi,
Florence*

59. PIERO DELLA FRANCESCA
(1410/20–92). *Federigo da Monte-
feltro, Duke of Urbino, c. 1465.
Oil on wood 18^1/$_2$ × 13 (47 × 33).
Uffizi, Florence*

Veneziano (*Ill. 34*) and in some of the paintings of Ca-
stagno, one of the early Florentine influences upon Piero.
Piero's use of colour-variation and light to suggest space
and distance would be more apparent in the London *Bap-
tism* if much of the detail in the receding landscape had not
darkened with time; but his mastery of what we may
properly call aerial perspective – distance conveyed in
atmosphere – can be seen in all its fullness in the series of
frescoes at Arezzo.

Piero carried out several portrait commissions, all of
them strict profiles – a convention deriving ultimately from
the portraits of emperors on Roman coins. He painted
Sigismondo Malatesta kneeling before his patron saint (in
a fresco in the Tempio Malatestiano at Rimini of 1451),
and Federigo of Urbino kneeling before the Virgin (in
the *Brera Altarpiece,* probably of the early 1470s). The
portraits of Federigo and his wife Battista Sforza are his
most important exercises in this genre (*Ills. 58, 59*).

These panels were probably painted about 1465, at a
stage in Piero's development when he looked with renew-
ed interest at contemporary Flemish works: the two heads,

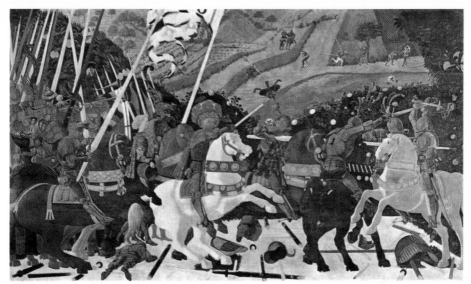

60. UCCELLO (1396/7–1475). *Rout of San Romano (Niccolò da Tolentino at the Battle of San Romano)*, c. 1456. Panel 71 ¹/₂ × 126 (182 × 320). National Gallery, London

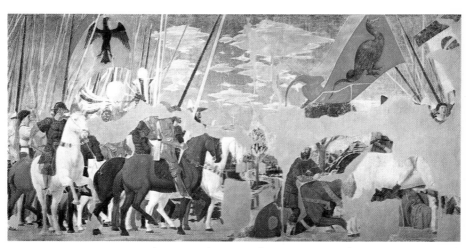

61. PIERO DELLA FRANCESCA (1410/20–92). *Victory of Constantine*, c. 1456. Fresco. San Francesco, Arezzo

although on separate panels, are set against a continuous landscape, showing a panoramic view of the countryside of Urbino, which is rendered with a meticulousness worthy of van Eyck himself. The searching modelling of the two heads – and especially of the hawk-like profile of Duke Federigo – gives them an uncanny flesh-and-blood reality and a mobility of expression which come as a surprise when we recall the cold statuesqueness of Piero's representations of figures from sacred legend. Something of the impression made at the time by this realism of portraiture seems to be alluded to in a contemporary poem in which the painting is represented as addressing the Duke: 'Piero has given me nerves and flesh and bones, but thou, Prince, hast supplied me with a soul from thy divinity.'

About the year 1452 Piero began his great series of decorations in the choir of San Francesco at Arezzo, which probably occupied him altogether for some ten years. The subject-matter of the cycle is the story of the True Cross, which is told in the *Golden Legend* of Jacopo da Voragine. The choice of this colourful medieval legend is explained by the fact that Piero was painting for a Franciscan community: to the Franciscans, the story had a special significance, for it was at the time of the Feast of the Exaltation of Holy Cross that St Francis had received the Stigmata on Mount La Verna. The story had its origin in the ancient association between Golgotha, 'the place of the skull', and the death of Adam, a tradition that had long influenced the iconography of the Crucifix, Christ's victory over death being symbolized by the Saviour's blood that falls upon the skull of Adam lying at the foot of the Cross. In relating the death of Adam to that of Christ the story in the *Golden Legend* threads its way from the Book of Genesis to the narrative in the Book of Kings of the Queen of Sheba's visit to Solomon, and thence to the legends associated with St Helena in the 4th century; it reaches a climax in the victory of the Emperor Constantine (St Helena's son) over Maxentius, when the Emperor fought under the standard of the Cross and by his victory ensured the triumph of Christianity in the West.

The Arezzo cycle opens with the narrative of the last days and death of Adam and of the planting over his

grave by his son Seth of the branch of a tree from Paradise: this branch grows into the tree from which the Cross of Christ is to be made. During her visit to the court of Solomon, the Queen of Sheba, with preternatural insight, recognizes that a bridge has been made from the wood of the same tree, and kneels down in veneration of it. Warned by her that there would be hanged from this tree a man who would destroy the kingdom of the Jews, Solomon conceals the wood. Subsequently it is rediscovered, and Christ's Cross is fashioned from it. The narrative continues with the story of the dream of the Emperor Constantine, when he is told by an angel that his victory over Maxentius will be assured if he enters the field under the sign of the Cross. It then proceeds to an episodic account of St Helena's search for the True Cross and its eventual recovery. The cycle concludes with the triumph of the Byzantine emperor Heraclius over the Persian king Chosroës II, who had come into possession of the Cross; an event that takes us into the seventh century.

The cycle comprises ten scenes in all. No artist ever achieved a more satisfying compromise between the decorative requirements of mural painting and the claims of three-dimensional representation. To take one example, in the scene in which a young man is raised from the dead by the miraculous virtue of the True Cross (*Ill. 28*), the perspective of the lofty buildings leads the eye into a deep space, while the massive forms of the figures in the near foreground – and especially of the crimson-robed bystander on the right – seem to jut out from the surface of the wall: at the same time a tension is set up between this spatial treatment and a scarcely less emphatic insistence upon an almost abstract harmony of shapes aligned with the picture-plane.

Since the human actors in Piero's compositions are invariably frozen into immobility, the value of gesture and implied movement as an activating principle within a particular composition is reduced to a minimum: the pictorial tensions are of the most fundamental kind, composed as they are of relationships of pure form. For Piero, it would seem, the appearances of nature resolved themselves, in his creative imagination, into variants of the Pythagorean absolutes, which he discusses in his treatise

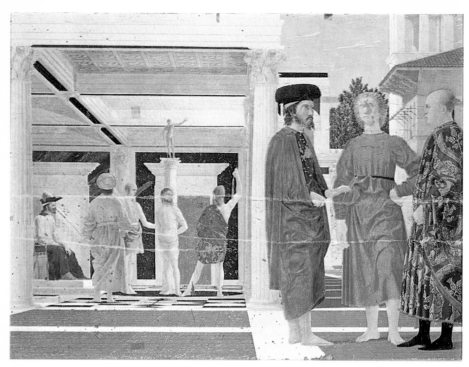

De quinque corporibus regularibus – the five regular and there
fore perfect solids underlying the forms of nature. His pro
cedure, therefore, was not so much the reduction of ap
pearances to their basic essentials as the elevation of natural
form to its highest state in the eternal order of things. The
ultimate effect of his art is to raise experience to the level
of the sublime.

There is much to remind us of Uccello's *Rout of San
Romano (Ill. 60)* in that most impressive of all the Arezzo
frescoes, the *Victory of Constantine (Ill. 61)*; the works are
contemporary, and it is possible that Piero studied the
'cut-out' shapes of Uccello's contrasted black and white
horses and red and yellow banners, perhaps above all his
consummate use of white. Yet while in the Arezzo fresco
there is an analogous effect of clear-cut pattern – of pattern
clarified – the two compositions belong to entirely different
worlds.

In a hushed silence, the army of Constantine advances
in all its pomp and panoply across the field of battle. Not

here that 'antique pageantry' which inspired Uccello's battle-scene; instead, Piero concentrates upon the import of the impending action. There is an echo of Uccello's whimsy in the prancing horse on the far left, but towards the centre of the composition – where the Emperor holds up a white cross in his outstretched hand – the compact severity of the imagery conveys a sense of grave expectancy, of a tension which is released, in the opposing right-hand area of the now damaged fresco, in the despairing soldiery and struggling horses of Maxentius's routed army. Yet there is nothing here either of the impatience with the exquisite that characterizes the work of Masaccio or of the severe austerity of Mantegna: Piero's world is immediately inviting, offering to the eye the sensuous delights of lyrical colour and rhythmic design. Through the cycle there runs, like a melody repeated, a basic colouristic theme of luminous blue and white, so that where warmer colours, such

63. JACOPO BELLINI (*c.* 1400–70/71). *Flagellation, fol. 5 of Bellini's sketchbook. Pen on parchment 16³/₄ × 11 (42.7 × 29). Louvre, Paris*

Piero della Francesca

as reds and orange-yellows, are introduced, they sing out with added force; and all the outdoor scenes, which are preponderant in the cycle, are suffused with the same clear morning light.

The fresco of the *Dream of Constantine*, which occupies the space on the far wall between the window and the flanking scene of the *Victory of Constantine*, evokes all the mystery of night: as the angel descends from the heavens, the darkness is suddenly illuminated by a radiance that is at once supernatural and suggestive of moonlight. There is scarcely anything comparable in Western painting before Raphael's fresco of the *Liberation of St Peter* in the Vatican.

Among the works undertaken outside Arezzo during the progress of the decoration of San Francesco, the *Flagellation* (*Ill. 62*), painted for the Montefeltro Court at Urbino, can be dated fairly early, and the fresco of the *Resurrection of Christ* at Borgo San Sepolcro considerably later. The three princely figures in grave conversation in the right foreground of the *Flagellation*, forming a group dis-

64. BENOZZO GOZZOLI (*c.*1421–97). *Journey of the Magi (detail), 1459–61. Fresco. Chapel, Palazzo Medici-Riccardi, Florence*

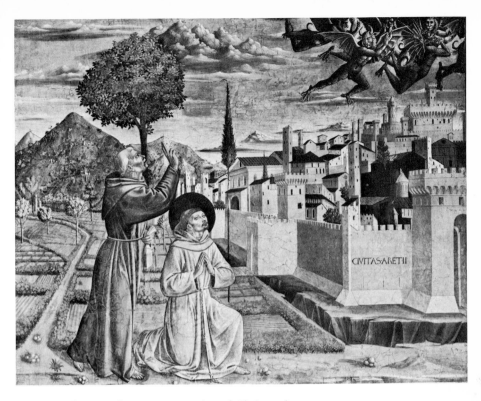

tinct from the more distant representation of Christ at the
Column in the left-hand field of the composition, have
never been convincingly explained. The painting is an
impressive example of Piero's complex use of mathemati-
cal perspective; and all the main orthogonals of the im-
posing architectural setting and of the inlaid pavement
focus attention upon the pathetically lowly figure of Christ.
The picture provides interesting evidence of the renewed
influence of Alberti, notably in the Corinthian capitals
of the columns supporting the portico. Other features of
the composition are anticipated in a drawing of the *Flagel-
lation* by Jacopo Bellini (*Ill. 63*).

The Flemish influence perceptible in the Uffizi por-
traits (*Ills. 58, 59*) also appears in one of Piero's last works,
the unfinished panel of the *Nativity*, in the National Gal-
lery in London: for example, the Christ-Child, a frail
infant lying on the ground, recalls the child in the *Porti-
nari Altarpiece* by Hugo van der Goes, which had arrived
in Florence by 1475. But Piero's geometry, although it is

65. BENOZZO GOZZOLI (*c.* 1421–
97). *Exorcism of the Demons at
Arezzo, 1450–52. Fresco.
San Francesco, Montefalco*

79

now less insistent, is still present, and the part played in the design by measured interval is as important as ever.

As a fresco-painter, Piero della Francesca soared a flight above his Florentine contemporaries, who for the most part were content to move in the direction of a decorative naturalism which was to be consummated in the commanding prose of Ghirlandaio. This tendency is seen clearly enough in the work of Benozzo Gozzoli, the pupil of Ghiberti and the assistant in Rome of Fra Angelico. In a sense Gozzoli's art can be described as a kind of secularization of the style of Angelico, although his early frescoes of the Life of St Francis (Ill. 65) in San Francesco at Montefalco, in Umbria, painted in the early 1450s, are imbued with an intensity and purity of religious feeling entirely appropriate to their subject-matter.

In 1459, Gozzoli was commissioned to paint the famous frescoes of the *Journey of the Magi* around the four walls of the chapel in the Medici Palace in Florence (*Ill. 64*). A number of letters from the artist to Piero de' Medici on the subject of the decorations have been preserved, and it is evident that Gozzoli's cultured patron kept a close eye upon every detail of the work. The lavishness of the ornamentation brings to mind Filarete's account of Piero's personal delight in his costly possessions – 'those jewels and precious stones, of which he has a marvellous quantity of great value', the 'vases of gold and silver and other precious metals' and the 'effigies and images of all the Emperors and Worthies of the past, some made of gold, some of silver, some of bronze, of precious stones or of marble and other materials' – which according to Filarete Piero loved to contemplate and to handle. The wealth of ornamentation in the frescoes is certainly striking; and indeed it is possible that Piero asked Gozzoli to emulate, on a larger scale, the courtly treatment of the story of the *Journey of the Magi* on the Santa Trinita altarpiece painted by Gentile da Fabriano almost forty years earlier (*Ill. 17*). Gentile's picture unquestionably inspired a number of the motifs in the Medici Palace frescoes, including the characterization of the Magi themselves. There could be no clearer evidence of the esteem in which the work of Gentile and the qualities of the International Gothic style were still held.

66. BENOZZO GOZZOLI (*c.* 1421–
97). *Marriage of Isaac and Rebecca
(detail), c. 1474. Fresco.
Camposanto, Pisa*

Of Gozzoli's later fresco-cycles, the most important is
the extensive series of Old Testament scenes painted be-
tween 1468 and 1484 in the Camposanto at Pisa. In such
scenes as the *Marriage of Isaac and Rebecca* (*Ill. 66*) and the
Story of Jacob and Esau, the detailed representation of build-
ings, which now play an increasingly important role in
Gozzoli's designs, shows his assimilation of the new style
in architecture. Gozzoli could never resist a *penchant* for
the anecdotal, and his townscapes bustle with activity
observed from everyday life. It is the kind of contemporary
reportage that was to come into its own in Venetian paint-
ing. If this is not the highest art, it would be unjust to
withhold from Gozzoli the admiration that we willingly
accord to Gentile Bellini and Carpaccio.

67. GIOVANNI BELLINI (*c.* 1430–
1516). *Dead Christ supported by
Angels, c. 1468. Panel
$35^3/_4 \times 51^1/_2$ (91 × 131). Museo
Civico, Rimini*

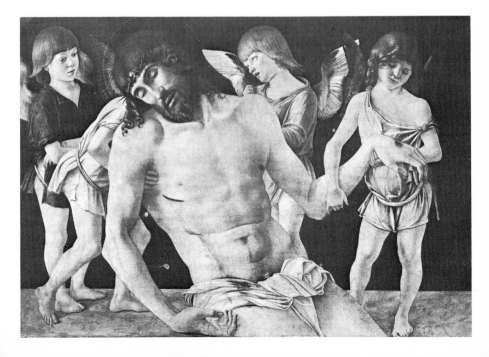

Mantegna, the Bellini and the Venetian Renaissance

Any attempt to trace the origins of the Venetian Renaissance must take account of the relative isolation of the Venetian Republic, which always tended to be eastward-looking, and which was moulded by influences distinct from those that affected central Italy. In the 14th century, Byzantine traditions had persisted longer than in Florence, and there was no Venetian Giotto. Nevertheless, by the early years of the 15th century the work of such masters as Niccolò di Pietro, Jacobello del Fiore and Giambono shows an increasing receptivity to the International Gothic style, largely through the influence of Gentile da Fabriano (see *Ill. 17*), who worked in Venice in 1408, when he decorated the Doge's Palace with frescoes that have since been lost.

Gentile da Fabriano was the master of Jacopo Bellini, the father of Gentile and Giovanni; and together with the brothers Antonio and Bartolommeo Vivarini, the Bellini family were to become the founders of the Venetian School. Few of Jacopo Bellini's paintings have survived, but his sketchbooks in the Louvre and the British Museum reveal the extraordinary range of his interests: he had come under the strong influence of Donatello during a protracted visit to Padua, and although his style remained basically that of the International Gothic masters, the sketchbooks include architectural and perspectival drawings and careful studies after the antique (see *Ill. 63*).

Jacopo Bellini's residence in Padua with his family had crucial consequences for the development of Venetian painting. Padua, which boasted a great university, and which had always preserved the memory of its Roman past, had long been a centre of classical and antiquarian studies. In the early years of the 15th century the leading

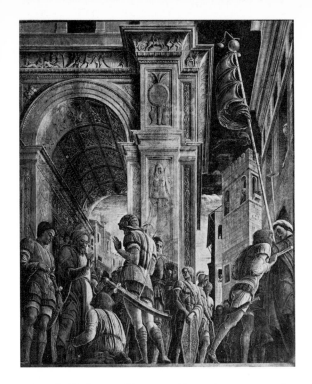

68. ANDREA MANTEGNA (*c.* 1431–
1506). *St James led to his Execution,
c. 1451–6. Fresco. Formerly Ovetari
Chapel, Eremitani Church, Padua
(destroyed 1944)*

painter in Padua was Francesco Squarcione, a somewhat
mysterious figure to whom only two paintings can now
be attributed (a *Madonna and Child* at Berlin and the *St
Jerome Altarpiece* in the Museo Civico at Padua), but
whose importance lies in the fact that he conducted a large
workshop, including Mantegna among his pupils.

The major attraction of Squarcione's workshop was
the collection that he had formed of ancient statuary, re-
liefs, capitals from Roman buildings and other antiqui-
ties, which he set his pupils to copy. In Mantegna's case
this study produced an 'antiquarianism' that is quite dis-
tinct in character from the classicism of his Florentine
contemporaries. At the same time, both Squarcione and
Mantegna were decisively influenced by Donatello's pro-
tracted stay in Padua in the 1440s. Mantegna married Ja-
copo Bellini's daughter Nicolosia, thus cementing a con-
nection between the Paduan and Venetian Schools which
was already close; and it was under the stimulus of Man-
tegna's art that Giovanni Bellini, the supreme Venetian
painter of the 15th century, was to develop.

83

Andrea Mantegna was a genius of extraordinary precocity: he was an independent master by the year 1448, when he was only seventeen, and in the same year joined Antonio Vivarini, Giovanni d'Alemagna and Niccolò Pizzolo in the task of decorating the Ovetari Chapel in the Eremitani Church at Padua. Mantegna's frescoes, most of which were tragically destroyed during the Second World War, were chiefly devoted to the life of St James, and were completed in 1457. The scene of *St James led to his Execution* (*Ill. 68*) is redolent of the spirit of intellectual inquiry and antiquarian zeal that characterized the decorations as a whole. Towering above the figures there rises an impressive archway designed *all'antica*; to the right a palace and a more distant tower lead the eye back into space, the whole action being viewed from below. Placed beside Mantegna's bold and imaginative use of perspective, the thrusting diagonals of Uccello's *Deluge* (*Ill. 29*) seem merely experimental. Mantegna does not invite us, he compels us to enter his spatial world; a world of ancient grandeur, inhabited (to adapt Landor's phrase) by 'indomitable heroes'. The metallic harshness of Mantegna's figures indicate the influence both of Donatello's Santo Altar and of the frescoes lately painted by Andrea del Castagno at San Zaccaria in Venice. But, above all, Mantegna reveals himself in the Eremitani frescoes as the complete exponent of the classical revival.

Similar qualities are found in the altarpiece of the *Madonna and Saints* (*Ill. 74*) executed for the church of San Zeno at Verona shortly after the completion of the Paduan frescoes. The sculptural treatment of the figures of the eight saints grouped on either side of the Virgin must owe much to the Santo Altar, while Donatello's musician-angels have spilled out into Mantegna's picture to form a zealous choir around the Virgin's throne. Classical *putti* are represented in relief on the base of the Virgin's throne and on the frieze that runs round the open *loggia* above. The treatment of space in the San Zeno altarpiece anticipates the illusionism of the great Baroque decorators, in the sense that an ambiguous relationship is established between the highly wrought mouldings of the frame (and especially of the simulated columns dividing the picture-space into three distinct areas) and their continuation in

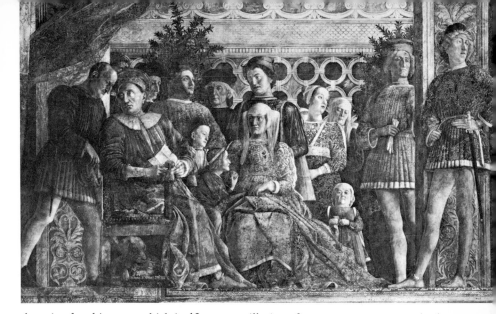

the painted architecture, which itself creates an illusion of deep space behind the frame. Suspended above the Virgin's throne is an ostrich egg, emblematic of the Immaculate Conception – the purest of symbols, such as was to be seen in many a church of the period, and which appears also in the Brera *Madonna* of Piero della Francesca.

In 1459, shortly after the completion of the San Zeno altarpiece, Mantegna was appointed Court Painter to Lodovico Gonzaga at Mantua. The Gonzaga Court was a centre of humanistic learning, and Mantegna was to continue in the service of the family until the time of his death. The most important of his works for the Gonzaga are the frescoes in the Camera degli Sposi (Bridal Chamber) in the Ducal Palace, executed between 1471 and 1474, and a series of nine paintings of the *Triumph of Julius Caesar*, which subsequently came into the possession of Charles I of England.

The decorations painted around the walls of the Camera degli Sposi constitute a vast, extended group-portrait of the Mantuan ruling family (*Ill. 69*). Lodovico Gonzaga's intention in commissioning this work is made clear by the representations of Roman emperors in the spandrels and by the mythological scenes above the arches: it was no less than to draw a comparison between the Gonzaga Court and the imperial families of ancient Rome. The in-

69. ANDREA MANTEGNA (*c.* 1431–1506). *Lodovico Gonzaga and his wife Barbara of Brandenburg seated with Members of their Family, 1471–4. Fresco. Camera degli Sposi, Ducal Palace, Mantua*

70. ANDREA MANTEGNA (*c.* 1431–
1506). *Ceiling decoration of the
Camera degli Sposi, 1471–4. Fresco.
Ducal Palace, Mantua*

fluence of classical reliefs is evident in the frieze⁄like qual⁄
ity of the wall frescoes; but on the ceiling (*Ill. 70*) the
decoration opens up into an astonishing vista of sky and
cloud seen through an illusionistically rendered *oculus*
which must have been inspired by the 'eye' in the dome
of the Pantheon in Rome: over the edge of the surround⁄
ing balustrade, five young women, including a handsome
negress, peer down smilingly into the room below; there,
too, is perched a splendid peacock, while *amorini* play
around, some of them thrusting their heads through open⁄
ings in the balustrade and others balancing themselves
precariously on the inside of the drum.

The ceiling of the Camera degli Sposi marks Man⁄
tegna's final triumph over problems of foreshortening and
trompe⁄l'œil illusionism: its influence on later ceiling paint⁄
ing was immeasurable. Later, in the *Dead Christ* in the
Brera Gallery in Milan, he was able to make use of his
experience to new purpose, and in the violence of the
foreshortening of the Saviour's body to add a novel drama
and pathos to the traditional subject of the *Pietà*, which is
the real subject of the painting. Many years earlier, in the

71. CORREGGIO (1489/94–1534).
*Vision of St John upon Patmos,
1520–23. Fresco. Cupola, San
Giovanni Evangelista, Parma*

Agony in the Garden in the National Gallery in London,
Mantegna had made a similar experiment in foreshorten-
ing in representing one of the sleeping disciples. This
picture must be connected with Giovanni Bellini's version
of the same subject, also in London, which is similar in
composition and which includes a figure of a sleeping
disciple no less boldly foreshortened. The basis of both
compositions is to be found in a drawing by Jacopo Bel-
lini. Such resemblances draw attention to the close rela-
tionship between Mantegna and the Bellini – a situation
which allowed Mantegna, with his strong personality, to
influence Giovanni Bellini and, through him, Venetian
painting in general.

The Mantuan Court attained its highest glory under
Lodovico's grandson Francesco Gonzaga, who married
the famous Isabella d'Este, the strongminded daughter of
the Duke of Ferrara. Isabella was one of the most assidu-
ous collectors in Renaissance Italy, and for her private
apartments in the Ducal Palace at Mantua she commis-
sioned a number of painters to execute mythological sub-
jects from classical antiquity, giving precise instructions

about every detail that was to be included. Mantegna contributed two works, one of them the *Parnassus*, now in the Louvre, a gently humorous vision of the assembled gods and goddesses of antiquity.

Mantegna's counterpart at the Este Court at Ferrara, although on a humbler level, was that extraordinary personality Cosimo (or Cosmè) Tura, whose series of decorations in the Palazzo Schifanoia, painted between 1469 and 1471, embrace a complex mixture of subjects from astrology to classical mythology and contemporary history. The Schifanoia decorations consist chiefly of twelve scenes illustrating the months, and like Mantegna's *Parnassus* they contain an element of playful wit and gentle mockery. Tura was assisted in their execution by his younger contemporary Francesco del Cossa, whose frescoes combine a lively depiction of contemporary life with classical allusions (such as the glimpse, in the scene of *April*, of the Three Graces, nonchalantly posed on a grassy knoll in the distance), and by Ercole de' Roberti, who succeeded eventually to the position of Court Painter to the Duke of Ferrara. All three painters derived their strength from Mantegna, whose influence was to produce a kind of Ferrarese 'Mantegnism', characterized by a predilection for wiry contours, metallic surfaces and snakily creased draperies.

Certain similarities with Ferrarese painting are found in the style of the Venetian Carlo Crivelli, who worked in the Marches, and who had come under Mantegna's influence in Padua. In the *Dead Christ* in the National Gallery in London, as in other interpretations of the same subject, Crivelli reveals his indebtedness to Mantegna's incisive delineation of the human figure, and there are echoes also of Donatello's *Pietà* on the Santo Altar. There is, however, another side to Crivelli – that love of detail and ornamentation which relates him to the International Gothic masters: he loved to depict fruit and foliage, richly embroidered materials, the surfaces of stonework and marble and the wavy intricacies of flaxen locks. He had a taste for charming commentary, and the corners of his pictures often contain a wealth of fascinating detail (*Ill. 72*).

The impact of the severe styles of Mantegna and Donatello upon the Bellini has already been touched upon. It is

72. CARLO CRIVELLI (1435/40–1495/1500). *Annunciation with St Emidius, 1486. Oil on canvas (transferred from wood) 81 1/2 × 57 3/4 (207 × 147). National Gallery, London*

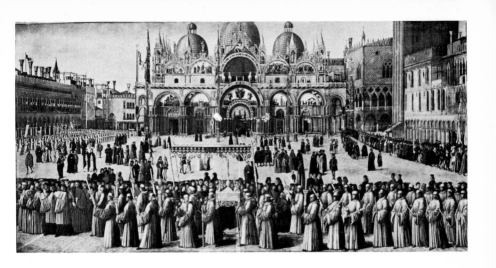

least marked in the work of Gentile Bellini, the older of the two brothers. Little is known of Gentile's early work, but in the 1460s he seems to have established a high reputation as a portraitpainter; and in 1472, on the occasion of the visit of the Doge of Venice to the Court of the Sultan Mohammed II at Constantinople, Gentile was invited to accompany him. There he painted the portrait of Mohammed II which is now in the National Gallery in London – a fascinating study of a potentate and scholar who vied with the Italian humanists in his love of classical literature. On his return from Constantinople, Gentile received from the Scuola di San Giovanni Evangelista a commission to paint three large pictures (now in the Accademia) commemorating the ceremonies that were associated with the relic of the True Cross in the possession of the Scuola. It is easy to understand from the *Procession of the Reliquary of the Cross in the Piazza San Marco* (Ill. 73) why Gentile Bellini has been hailed as the precursor of Canaletto; and only in the work of Carpaccio, who was influenced by him, is there anything in contemporary painting comparable with the splendid realism and truth to atmosphere of these panoramic views of the Venetian scene.

It may be said of Carpaccio that he turned Gentile's descriptive prose into an enchanting narrative poetry: in his *St Ursula* cycle, executed in the 1490s for the Scuola di Sant'Orsola (and now in the Accademia), and in the

73. GENTILE BELLINI (1429/30– 1507). *Procession of the Reliquary of the Cross in the Piazza San Marco*, *c. 1460. Oil on canvas 144$^1/_2$ × 293$^1/_4$ (367 × 745). Accademia, Venice*

89

Stories of St George, St Jerome and St Tryphonius in the Scuola di San Giorgio degli Schiavoni, the subtlety of the treatment of form and light reflects not only the impact of Flemish painting but also that of the later style of Giovanni Bellini.

The art of Giovanni Bellini belongs to a different order of the creative imagination. The work of his early period shows his debt to Squarcione, Mantegna and Donatello; but by the later 1460s such influences had been assimilated (see *Ills. 47, 67*) in a process of maturation and discovery which had revolutionary implications for the future development of Venetian painting. Already in the *Agony in the Garden* in the National Gallery in London, the brittle forms of Mantegna have been softened and transfigured by a suffused light – the tender light of early dawn. Bellini's treatment of light in this picture is without precedent in Venetian painting, and it would be difficult to point to any earlier representation of landscape in Italy in which the role of the sky is so important: the London *Agony in the Garden* stands at the head of that characteristically Venetian development which gave birth ultimately to the independent art of landscape painting.

Bellini was to give an ever-increasing emphasis to his landscape backgrounds, so that in such pictures as the *Transfiguration* in the Capodimonte Museum at Naples, of about 1480, and the *St Francis in Ecstasy* (*Ill. 78*) in the Frick Collection in New York, which is also a late work, it scarcely seems meaningful any longer to regard the landscape as secondary to the human figure. Yet Bellini was far more than a copyist of nature: his landscapes evoke a sense of wonder, an awareness of the holy; Nature, in her still quietude, becomes the very threshold of heaven; and, whether in the two works just mentioned or in those lovely Madonnas in which the beauty of nature seems to pay tribute to the Virgin, the light that bathes the trees and distant hills is at once natural and supernatural.

The perfection of Bellini's Madonnas entitles him to be called the Raphael of Venice. His treatment of the subject reached a climax in the 1480s in a series of important altarpieces, of which the San Giobbe *Madonna enthroned, with Saints* (*Ill. 76*), the more delicate triptych in the Frari Church and the *Madonna of the Trees* in the Accademia

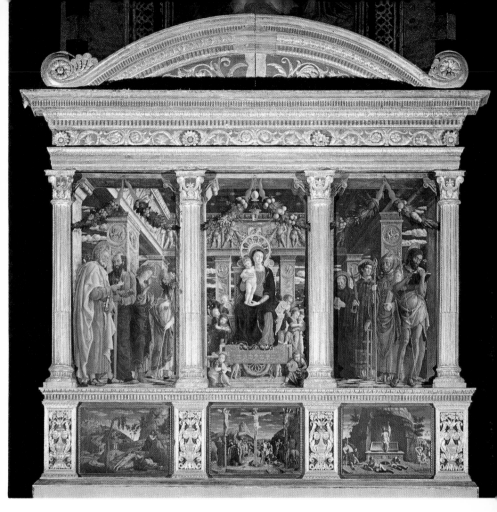

are among the most outstanding. The magisterial qualities of the San Giobbe altarpiece, in which the Virgin's throne is placed beneath a lofty apse decorated with seraphim in gold mosaic and supported by elegantly wrought pilasters, derive directly from the great altarpiece commissioned from Antonello da Messina in 1475 for the church of San Cassiano in Venice, of which some dismembered fragments are preserved at Vienna. The San Cassiano and San Giobbe altarpieces carry to a further stage that attempt at a more realistic interpretation of the *sacra conversazione* which has already been touched upon in connection with Fra Filippo Lippi's *Barbadori Altarpiece*.

74. ANDREA MANTEGNA (*c.*1431–1506). *Madonna and Saints (San Zeno altarpiece), 1457/9. Large panels 86⁵/₈ × 45¹/₄ (220 × 115). San Zeno, Verona*

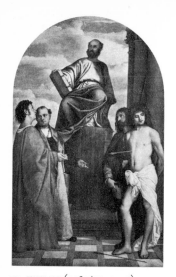

75. TITIAN (1487/90–1576).
*St Mark enthroned, with Saints
Sebastian, Roch, Cosmas and Damian,
c. 1510. Oil on canvas $89 \times 45^{1}/_{2}$
(226×116). Santa Maria della
Salute, Venice*

76. *(opposite)* GIOVANNI BELLINI
(*c.*1430–1516). *Madonna enthroned,
with Saints (San Giobbe altarpiece),
c.*1487. *Oil on wood* $184 \times 88^{1}/_{2}$
(*471 × 258*). *Accademia, Venice*

One of the most enchanting features of the San Giobbe altarpiece is the group of musician-angels at the foot of the Virgin's throne. One may compare the variations on this theme in the Frari *Madonna* and in a later work by Bellini, the impressive *Madonna enthroned, with Saints* executed in 1505 for San Zaccaria. It is not perhaps coincidental that such allusions to the sister art of music should be particularly characteristic of Venetian painting, with its new emphasis upon vibrant colour harmonies.

Antonello da Messina's visit to Venice in 1475 was an event of decisive consequence in Bellini's development. The Sicilian artist introduced a new type of composition in his San Cassiano altarpiece: the Virgin is raised on a throne, above the level of the attendant saints who are grouped in free symmetry on either side. But, even more important, he introduced into Italy the Flemish technique of oil painting.

Antonello had been trained in Naples under Colantonio, a painter who had already come under the strong influence of the Eyckian tradition. Although the precise origins of Antonello's style and the extent of his knowledge of Northern painting are not altogether clear, to the Venetians of the late 15th century his style must have seemed virtually indistinguishable from that of van Eyck or Petrus Christus, and it is interesting to find the early 16th-century chronicler Michiel saying of a portrait in a certain collection that it was 'by Antonello or Memlinc or Jan van Eyck'.

Antonello excelled as a portrait-painter, never including more than the head and shoulders of his sitter and concentrating attention upon the expression of the eyes and mouth (*Ill. 79*). His mastery of the oil medium enabled him to achieve an unprecedented subtlety in the rendering of facial expression, and his portraits are unrivalled in their period for the intensity of observation contained in them. Giovanni Bellini, in his early portraits, followed closely in Antonello's footsteps; but in that masterpiece of his later years, the *Doge Leonardo Loredano* (*Ill. 80*) in London, which dates from about 1501, the searching scrutiny characteristic of Antonello's method takes second place to an objectivity and breadth of treatment which anticipate the portraiture of Titian.

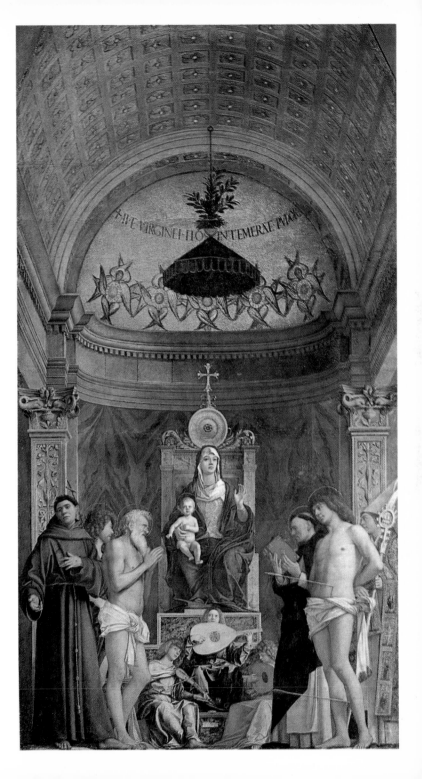

In the year 1483 Giovanni Bellini was appointed Painter to the Republic of Venice. Nothing survives of the various works which he executed at different times for the Doge's Palace, but his reputation as the supreme master working in Venice is confirmed in a letter written by Albrecht Dürer in 1506, during the German artist's visit to Venice. Having commented upon Bellini's piety, Dürer goes on to say that 'he is very old and still the best painter'. Dürer's allusion to Bellini's piety is in tune with other evidence concerning the personality of this good and noble man, and it has generally been assumed that it was entirely on religious grounds that in 1501 he refused a request from Isabella d'Este for a painting of a pagan subject.

Yet towards the end of his life Bellini accepted a similar commission from Isabella's brother Alfonso d'Este. Alfonso wished to have one of his private rooms in the palace at Ferrara decorated with scenes taken from classical mythology, and eventually three artists – Bellini, his pupil Titian and the Ferrarese master Dosso Dossi – contributed pictures to this programme. Bellini's painting, the *Feast of*

77. LORENZO LOTTO (*c.* 1480–1556). *St Jerome in the Desert, 1506. Oil on wood* 18^7/$_8$ × 15^3/$_4$. *Louvre, Paris*

the *Gods* (*Ill. 153*), was completed in 1514 – that is to say, within two years of the painter's death. Subsequently Titian repainted large areas of the picture, including much of the landscape background, in order to harmonize the composition with his own canvases. Despite these alterations, the almost naïve simplicity and charm of Bellini's portrayal of the ancient gods still distinguish the Washington picture from the robuster and more sensuous compositions of Titian and Dosso Dossi.

It would be impossible to exaggerate the importance of this commission in the history of Italian painting. Above all, it liberated the genius of Titian from the confining bands of orthodox subject-matter, providing him with themes exactly suited to his ardent imagination; and in this congenial task he 'loaded every rift with ore'. It may

78. GIOVANNI BELLINI (*c.*1430–1516). *St Francis in Ecstasy, c.1480. Tempera and oil on wood 47¹/₄ × 54 (124 × 142). Frick Collection, New York*

79. ANTONELLO DA MESSINA (*c.*1430–79). *Portrait of a Man (self portrait?)*, *c.*1475. *Oil on wood 14×10 (36×26). National Gallery, London*

80. GIOVANNI BELLINI (*c.*1430–1516). *Doge Leonardo Loredano, c.*1501. *Oil on wood 24¹/₄×17³/₄ (66.5×45). National Gallery, London*

appear paradoxical that Giovanni Bellini, of all painters, should have shared at the end of his long life in this particular moment of discovery and innovation; but there are other works, notably the *Young Woman at her Toilet* of 1515, now in the Kunsthistorisches Museum at Vienna, that indicate that even in extreme old age he was still receptive to new ideas, and that he was willing to learn from his young pupils Giorgione and Titian.

One of the dominant impressions given by Venetian sculpture and architecture of the period is a sense of its continuity with the past. This is particularly noticeable in the sculptural decorations on the exterior of the Doge's Palace, which were carried out in various stages between the late 14th century and the 1460s: the intricately carved Porta della Carta, the work of Bartolommeo Buon, was completed during the period of Donatello's activity at Padua but remains Gothic in style. On the other hand some of the palace-architecture – of which the supreme examples are the Palazzo Corner-Spinelli and Palazzo Vendramin-Calergi, both designed by Mauro Coducci – reflects the influence of Alberti in its subordination of the decorative to the requirements of a larger unity. Decoration did not, however, disappear: the revived Roman idea of coloured marble cladding coincided in Venice with the surviving Byzantine tradition. Venetian palaces differ from their Florentine counterparts in plan even more than in form. They are shallower and have no court-yards: instead they have spacious state-rooms – *saloni* – running through from front to back, and lit by windows grouped in the middle of the façade. In contrast to Florentine practice, there is only one façade, looking on to the canal.

Towards the end of the century the work of the Lombardi laid the foundations of Renaissance sculpture in Venice: Pietro Lombardo's beautiful Mocenigo Monument at Santi Giovanni e Paolo assimilates Florentine motives to the ornate tradition of Venetian tomb-sculpture; and in the Vendramin Monument in the same church and in the Altar of Cardinal Zen at San Marco, executed respectively by Tullio and Antonio Lombardo (the sons of Pietro), the Venetian Renaissance style, moulded by the influence of Donatello, may be said to have attained maturity.

The painters of the Sistine Chapel

The frescoes on the side walls of the Sistine Chapel in Rome (*Ill. 108*), executed in the 1480s, may be said to close the chapter which opened with the masterpieces of Masaccio in the Brancacci Chapel in Florence. Although they were eventually to form only a subsidiary part of a larger decoration, which Michelangelo so illuminated with his genius that all else in the Chapel was thrown into shade, these earlier scenes are of great importance in the history of Renaissance painting. The commission was given to some of the leading Florentine and Umbrian masters of the moment, and their frescoes collectively demonstrate the principal characteristics and tendencies of late Quattrocento style in central Italy.

The programme embraced the parallel representation of scenes from the life of Moses and the life of Christ, on the south and north walls respectively, together with an *Assumption of the Virgin* and other frescoes on the altar wall, in allusion to the original dedication of the Chapel to the Virgin of the Assumption. In the 1530s the frescoes behind the altar were destroyed to make room for Michelangelo's *Last Judgment*, and later in the 16th century, during alterations to the Chapel, the scene of the *Resurrection* on the entrance-wall was repainted; but in general the original scheme remains intact.

It is now clear that the frescoes reflect the struggles of Pope Sixtus IV, the founder of the Sistine Chapel, with the conciliar movement, and that they affirm the ideal of the primacy of the Pope and the authority of the Church. The thematic relationships established between the *Moses* and *Christ* cycles underline this intention; in the Old Testament scenes attention is concentrated upon Moses's role as law-giver, ruler and priest, and upon the Old

81. DOMENICO GHIRLANDAIO
(1449–94). *The Calling of the First
Apostles, 1482–3. Fresco. Sistine
Chapel, Vatican*

82. SANDRO BOTTICELLI (*c.*1445–
1510). *Punishment of Corah and the
Sons of Aaron (detail), 1482. Fresco.
Sistine Chapel, Vatican*

Covenant as the mystical prefigurement of the New Cove-
nant of Christ, very much in the spirit of the *Epistle to the
Hebrews*, with its picture of Christ as 'an high priest for-
ever after the order of Melchisedek'. This politico-religious
purpose explains, for example, the emphatic representa-
tion, at the centre of Botticelli's fresco of the *Punishment of
Corah and the Sons of Aaron* (Ill. 82), of the Arch of Con-
stantine, bearing an inscription in Latin from the *Epistle
to the Hebrews*: 'And no man taketh the honour unto
himself, but when he is called of God, even as was Aaron.'
The Roman arch, which dominates Botticelli's fresco, is
to be read as a symbol of the divinely ordained dominion
of the Papacy.

Throughout the decoration, typological and composi-
tional concordances bring the two cycles into harmony:
thus the *Last Acts and Death of Moses*, by Signorelli, is
paired with the *Last Supper* by Cosimo Rosselli, in which
the Crucifixion and two other scenes from the Passion are
represented in the background; and the figure of Christ in
The Calling of the First Apostles, by Domenico Ghirlan-
daio, replaces the symbolic pillar of Jehovah in *The Cros-
sing of the Red Sea*, also by Rosselli.

Of the six masters employed upon the work – the
Umbrians Perugino, Pinturicchio and Signorelli and the

Florentines Botticelli, Ghirlandaio and Rosselli – it was Perugino, the teacher of Raphael, who was placed in charge, and it was he who was commissioned to paint the three frescoes on the altar-wall, of which the scene of the *Assumption* formed the altarpiece of the Chapel. Although an Umbrian, Perugino had received part of his early training under Verrocchio, and maintained close contacts with Florence. His frescoes in the Sistine Chapel, which he executed with the assistance of his fellow-countryman Bernardino Pinturicchio, are among his first major works. He is best known as the creator of a type of Madonna, gentle and sweet-faced and usually represented in a flowing landscape fringed by distant hills of a deep azure that echoes the blue of a serene sky.

The fresco in the Sistine Chapel of *Christ's Charge to St Peter*, or *The Giving of the Keys* (Ill. 83) is entirely typical of Perugino's graceful, if somewhat nerveless, style. Perhaps the most interesting feature of the composition is the evocation of space, suggesting that Christ's commission to St Peter – a text crucial to the claims of the Papacy – is being enacted upon the vast stage of the world. In the foreground, the principal figures of Christ and his Apostles are strung out in a long row; and far behind them, beyond an immense courtyard, there rises an imposing

83. PERUGINO (1445/50–1523). *Christ's Charge to St Peter (The Giving of the Keys), 1481. Fresco. Sistine Chapel, Vatican*

84. LUCA SIGNORELLI (1441/50–1523). *Last Acts and Death of Moses (detail), 1483. Fresco. Sistine Chapel, Vatican*

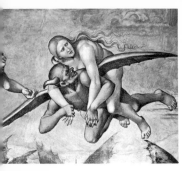

85. LUCA SIGNORELLI (1441/50–1523). *Last Judgment (detail), 1499–1502. Fresco. San Brizio Chapel, Cathedral, Orvieto*

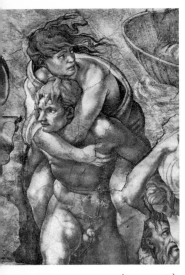

86. MICHELANGELO (1475–1564). *Deluge (detail), 1509. Fresco. Sistine Chapel, Vatican*

building which is flanked by two triumphal arches modelled upon the Arch of Constantine. This edifice, designed in the form of a centralized temple, symbolizes the Church, whose perfection is stated, in accordance with Albertian theory, by its combination of the perfect forms of the circle and the square.

The one scene contributed by Domenico Ghirlandaio, *The Calling of the First Apostles* (*Ill. 81*), while equally decorative in intention, presents a certain contrast to Perugino's composition in the Florentinism of its style, which shows itself especially in a more solid and massive rendering of the human figure. Echoes of Masaccio's *Tribute Money* (*Ill. 25*) in the Brancacci Chapel here mingle with a more direct indebtedness to the fluid tonalities of the figure-style developed by Ghirlandaio's master Filippo Lippi, whose influence is also seen in the rocky landscape. To such ingredients, flavoured somewhat with traces of Flemish naturalism, Ghirlandaio adds that taste for the anecdotal and for the depiction of contemporary modes and manners which characterizes all his fresco-decorations.

Ghirlandaio was the most prolific fresco-painter of the age, and he commanded a large workshop which catered chiefly for the middle-class patron. His fresco of *St Jerome in his Study* in the church of Ognissanti in Florence (to which Botticelli's *St Augustine in his Study* was painted as a pendant) reveals the impact made upon him by the Flemish masters' delight in minute detail; and that he had looked with admiration at the *Portinari Altarpiece* of Hugo van der Goes, which had lately been set up in Florence, is suggested in particular by his altarpiece of the *Adoration of the Shepherds*, painted in 1485 for the Sassetti Chapel at Santa Trinita. The realistic peasant figures of the kneeling shepherds and the way in which the Infant Jesus is placed on the ground are clear allusions to the Northern work.

The genial, illustrative art of Ghirlandaio reaches its highest point in the frescoes of the life of the Virgin and the life of St John the Baptist executed for Giovanni Tornabuoni between 1485 and 1490 in the choir of Santa Maria Novella. The classical friezes in these decorations show an interest in antique motifs for essentially decorative purposes; but the principal charm of the frescoes lies in

the manner in which they hold up a mirror to contemporary Florentine society, and the figures that are most memorable are the gracefully attired ladies and bustling servant-girls that Ghirlandaio delighted to bring upon his stage. It was during the period in which these frescoes were being painted that Michelangelo, then a mere boy of thirteen, was enrolled among Ghirlandaio's pupils. But Michelangelo would have found little in the routine of Ghirlandaio's workshop to stir his imagination: the art of Ghirlandaio belonged entirely to the past, and it was from fresher soil that the new age – the Age of Michelangelo – was to rise.

On the other hand the art of Michelangelo is strikingly anticipated in Signorelli's heroic conception of the nude; and according to Vasari Michelangelo always praised the work of Signorelli in the highest terms. The Gentile youth at the centre of Signorelli's one fresco in the Sistine Chapel, the *Last Acts and Death of Moses (Ill. 84)*, would scarcely be out of place in one of the scenes on the Chapel ceiling, and it is clear that the group of nude athletes which Signorelli introduced into the background of his *Holy Family* in the Uffizi (1491) was the ultimate source of the similar motif in Michelangelo's *Holy Family*, known as the *Doni Tondo (Ill. 92)*. Signorelli's greatest work, the vast fresco of the *Last Judgment* in Orvieto Cathedral, painted between 1499 and 1502 in continuation of an unfinished decoration by Fra Angelico, likewise contains many figures that bring to mind the muscular nudes of the Sistine ceiling (*Ills. 85, 86*).

Luca Signorelli came from Cortona, and according to Vasari he was the pupil of Piero della Francesca; but although Signorelli would have responded from the first to the sublime dignity of Piero's art and to the grandeur of his vision of humanity, there are many qualities in his style that derive from his grounding in Florentine traditions and above all from his contacts with Verrocchio and the brothers Pollaiuolo. Signorelli was always in close contact with Florence, and the Uffizi *Madonna* and the *Triumph of Pan* (destroyed; formerly in Berlin) were both executed for Lorenzo de' Medici.

Of the various painters who helped to execute the Sistine Chapel frescoes, the least talented was Cosimo

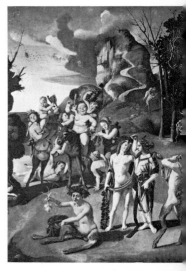

87. PIERO DI COSIMO (*c.*1462–1521?). *Discovery of Honey (detail)*, *c.*1500. *Tempera on wood* $31^1/_3 \times 50^5/_8$ *(80×128)*. *Worcester Art Museum, Worcester, Mass.*

88. ANDREA DEL VERROCCHIO
(*c.* 1435–88). *Portrait of Giuliano
de' Medici, c. 1478. Terracotta
24 × 26 × 11¹/₈ (61 × 66 × 28).
National Gallery of Art, Washington
D.C., Mellon Collection*

89. DESIDERIO DA SETTIGNANO
(1428/30–64). *Portrait of a Lady,
c. 1460. Limestone h. 18¹/₂ (47).
Staatliche Museen Berlin-Dahlem*

Rosselli, who is important chiefly as the head of an in-
fluential workshop and as the teacher of Piero di Cosimo
and Fra Bartolommeo. There will be occasion to consider
the work of Fra Bartolommeo in a later chapter, but it is
convenient to say a few words here about Piero di Co-
simo – a strange, neurotic recluse who is best known for a
group of panels devoted to the early history of mankind,
most of them commissioned by a rich Florentine wool
merchant. The themes of these pictures, which include the
Discovery of Honey (*Ill. 87*) and the *Battle of the Centaurs and
Lapiths* (National Gallery, London), were derived from
the accounts by Lucretius and Vitruvius of the origins
of Man and his relation to the animal creation; but some
of the remarkable free and fanciful details in the paintings
may have been suggested by the tales of travellers, with
their often exaggerated accounts of the life of primitive
peoples.

In his feeling for nature, Piero di Cosimo had much in
common with Leonardo, who deeply influenced him.
There is also something of Leonardo's intensity in his
treatment of portraiture – as, for example, in the bust-
length profile of *Simonetta Vespucci* at Chantilly, where
Piero di Cosimo introduces a stormy sky and a serpent
twined round the girl's neck, seemingly symbolic of her
early death. While many of his portraits adhere closely to
the traditions established by Baldovinetti, Antonio Pol-
laiuolo and Ghirlandaio, Piero di Cosimo was a pioneer
in the creation of that intimate portraiture of mood of
which Leonardo's *Monna Lisa* * (*Ill. 150*) was to be the
first great masterpiece. This development must have been
partly inspired by the work of such sculptors as Antonio
Rossellino, Andrea del Verrocchio (*Ill. 88*) and Desi-
derio da Settignano (*Ill. 89*), who were now mastering
the art of capturing in their portrait-busts the fleeting ex-
pression that reveals the hidden thought or sentiment.

* Incorrectly spelt *Mona Lisa*: *Monna* is a contraction of *Ma-
donna.*

The art of Sandro Botticelli has often been held to typify
the Renaissance ideal, and his most famous work, the
Birth of Venus, now in the Uffizi, has appealed to the
modern imagination as a symbol of the new spirit ushered
in by the growth of humanistic learning and the cult of
pagan antiquity. Yet in many respects Botticelli's develop-
ment ran counter to what we think of as the 'progressive'
tendencies of the age. In the *Birth of Venus* the Greek
statue upon which the figure of Venus was based has been
transmuted by Botticelli's poetic genius into an image of
wistful refinement in which an almost Gothic grace takes
precedence over the artist's understanding of classical
form, and no interpretation of the nude could present a
greater contrast to the vigorous ideal of Pollaiuolo and Ver-
rocchio, both of whom helped to mould Botticelli's early
development without modifying in any profound sense
his highly independent vision.

Botticelli's love of the sinuous outline and of decorative
pattern provides indeed a striking example of the persist-
ence of the Late Gothic ideal in Renaissance Italy. It is in
this tradition that his treatment of landscape also has its
roots: as in the work of such earlier masters as Gentile da
Fabriano and Paolo Uccello, the landscape backgrounds
in his pictures habitually provide a dark, tapestry-like foil
to the figures, and never reflect the changing moods of
nature. Botticelli, however, differs from the International
Gothic masters in the severe economy of his forms. This
quality appears in all its purity in the *Birth of Venus*, and
it is found again in his exquisite drawings illustrating
Dante's *Divine Comedy*, which were made to accompany
Landino's commentary on the poem.

Botticelli received his initial training under Filippo
Lippi, probably in the 1460s. A comparison between his

little panel of *Judith with the Head of Holofernes* (*Ill. 38*) and Filippo's fresco of the *Feast of Herod* at Prato (*Ill. 37*) will show the extent of Botticelli's indebtedness to this master. Not only did Botticelli take over from Filippo a specific convention for the representation of the human figure, but he also adopted the older painter's subtle method of suggesting tonal transitions and his characteristic way of activating a figure by means of fluttering draperies. Filippo's influence is still apparent in the great Madonnas of the 1480s, such as the *Madonna of the Magnificat* and the *Madonna of the Pomegranate* (*Ill. 91*), both in the Uffizi, but in these works of Botticelli's maturity the treatment of the subject has taken on an ethereal quality foreign to the spirit of Filippo's art. The sad, haunting beauty of the Virgin's face in the *Madonna of the Pomegranate* distils in one unforgettable image the tragic tone and tenderness of mood that characterize Botticelli's interpretations of this theme.

About 1475 Botticelli entered the service of the Medici. In the *Adoration of the Magi*, painted at this time, he gave his princely patrons such prominence – revealing his genius for portraiture – that the Holy Family are almost forgotten. In 1475 he painted a banner for a joust, at which Giuliano de' Medici (see *Ill. 88*) was declared victor. This event is the basis of a poem (*La Giostra*) by the humanist Politian, which celebrates the loves of Giuliano and Simonetta Vespucci by a combination of classical allusion, religious allegory and neo-Platonic theory; and this kind of allegory lies in turn behind Botticelli's great *poesie* painted for the Medici – the *Mars and Venus* of 1476-8, the *Primavera* of *c.*1478, and the *Birth of Venus* of *c.*1486.

90. SANDRO BOTTICELLI (*c.*1445–1510). *Mars and Venus, 1476–8. Tempera on wood 27¹/₄×68¹/₄ (69.5×173). National Gallery, London*

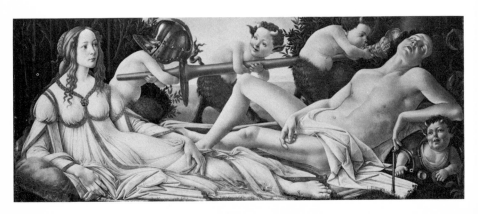

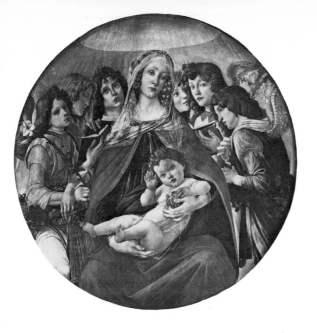

The precise circumstances surrounding the commission for the *Mars and Venus* (*Ill. 90*) are not known, but in the graceful Venus, as in the *Madonna of the Pomegranate* (*Ill. 91*) and the Venus of the *Birth of Venus*, we recognize the features of Simonetta Vespucci. In the sleeping Mars, undisturbed by the fauns playing with his armour or by the wasps that buzz around him, there is a clear allusion both to Giuliano de' Medici's triumph in the tournament and to his conquest by Venus in the person of Simonetta. The wasps are symbols of the sting of desire; and the Italian word for wasp, *vespa*, must also be a pun on the name Vespucci. No design by Botticelli is more perfect than this pictorial counterpart to Politian's graceful poem. Throughout the composition there weave those melodious arabesques of line that Botticelli made his own, and it is largely by means of outline, rather than interior modelling, that the figures are given substance. The whole of Botticelli's art seems to be contained in Mars's superbly rendered right hand, which hangs nerveless and limp from sleep.

The *Primavera*, or *Realm of Venus*, which was painted for the young Lorenzo di Pierfrancesco de' Medici, a pupil of the humanist Marsilio Ficino, is a far more complex work, both in design and content. Venus was regarded

91. SANDRO BOTTICELLI (*c.*1445–1510). *Madonna of the Pomegranate*, *c.* 1486–7. *Tempera on wood d. 57 (145). Uffizi, Florence*

not only as the goddess of earthly love, but also as the source of man's knowledge of the Divine. In a letter, Ficino urges Lorenzo to fix his eyes 'on Venus, that is on Humanitas; for Humanitas is a nymph of excellent come-liness, born of Heaven and more than any other beloved of God on high. Her soul and mind are Love and Char-ity, her eyes Dignity and Magnanimity, her hands Liber-ality and Magnificence, her feet Comeliness and Mod-esty ... Oh, what exquisite beauty!' Such ideas seem also to underlie the *Birth of Venus*, painted for the same patron.

Botticelli's subsequent development reminds us how insecure in reality were the foundations of Medicean hu-manism: the brooding darkness and nervous agitation that characterize his art from the 1490s must be connected with the revolutionary disturbances that followed upon Savonarola's arrival in Florence in 1489 (indeed, one of his brothers joined a group of Savonarola's followers known as the 'weepers'). Savonarola, elected Prior of San Marco, fired the people with his sermons in the Cathedral, in which he fiercely attacked the secular tendencies of the age, and prophesied divine retribution. He even foretold the death of Lorenzo de' Medici, and, as though in fulfil-ment of these prophecies, Lorenzo died in 1492. The Medici dynasty collapsed – albeit temporarily – and reli-gious frenzy, strongly anti-humanist, culminated in the notorious Burning of the Vanities, when books and works of art of a secular or pagan character were committed to the flames. Savonarola proclaimed that the artist's duty was to devote himself to sacred subjects and, above all, to scenes of Christ's Passion. Certainly such subjects as the Crucifixion and the Entombment become increasingly frequent in painting and sculpture toward the close of the century; and in this sense Botticelli's *Entombment* at Mu-nich and Michelangelo's *Pietà* (*Ill. 106*) in St Peter's in Rome, both executed in the years around 1500, may be said to have a common origin.

Savonarola was burned at the stake for heresy in 1498, but the emotional climate that he had created lingered on. It has been plausibly argued that Botticelli's strange *Mystic Nativity* in London (*Ill. 56*), which bears the date 1500 and an obscure inscription in Greek concerning the Last

Days, is directly related to Savonarola's prophecies. If any painting can be regarded as fully representative of Botticelli's late style it is this: no work illustrates more completely the abrupt change in his manner after his period in the service of the Medici. It is probably the most melancholy representation of the Nativity ever painted; and the relative serenity of Botticelli's earlier work has been replaced by a curious disturbance and agitation within the forms themselves. The grave expressions of the angels are not more surprising than the strange character of the abstract pattern that they make in their languid circular dance. What is particularly disturbing is that the far and near figures are so rendered that they seem to collide.

Similar tendencies reappear, in a slightly academic form, in the work of Botticelli's pupil Filippino Lippi. Filippino's early style is difficult to distinguish from that of his master, but by the middle years of the 1480s, when he executed for the Badia of Florence the beautiful panel of the *Vision of St Bernard,* he had developed his own personal manner, in which the grace of Botticelli is adapted to a more realistic idiom inspired partly by Flemish painting. At about the same time Filippino was entrusted with the important task of completing the frescoes left unfinished by Masaccio and Masolino in the Brancacci Chapel.

To assess Filippino's originality we must go to the Strozzi Chapel at Santa Maria Novella, which he decorated with scenes from the lives of St John the Evangelist and St Philip. Commissioned in 1487, the frescoes were not completed until the year 1502. During this period Filippino had paid a visit to Rome, where he had evidently been overwhelmed by all that he saw of the antique. The Strozzi Chapel is not merely filled with quotations from antiquity: it is a sort of archaeological extravaganza, combining decorative illusionism with fantastic architectural inventions reminiscent of designs for contemporary pageants. Whether on account of the obsessive fancy shown in the elaborateness of the ornamentation or of the frenzied agitation of the figures, it is difficult not to become aware in the Strozzi Chapel of certain presentiments of Mannerism (see Chapter Nineteen).

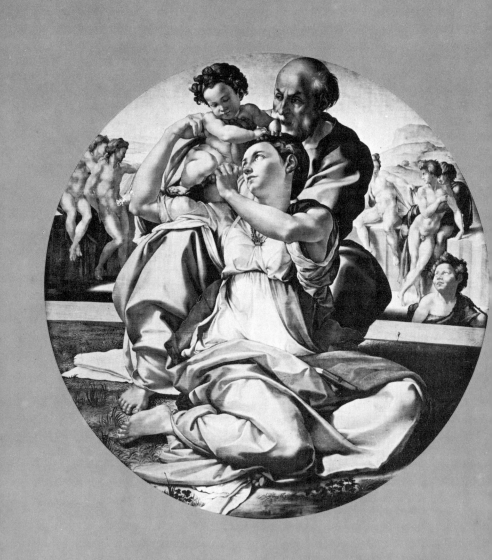

Leonardo and the origins of the High Renaissance

In Vasari's opinion the stimulus of the antique constituted the most vital of all the formative influences upon the art of his time. There is every reason to accept this judgment, and it is no exaggeration to say that the imitation of the antique now became more important than the imitation of nature. More and more ancient statues – many of them, such as the *Laocoön* and the *Farnese Bull*, works of major importance – had come to light in the first half of the 16th century, and these discoveries offered the painters and sculptors of the High Renaissance an ideal which they strove to realize in their own work and if possible to surpass. Yet it was an ideal consonant with the impulse of the Quattrocento towards naturalistic representation, especially as the efforts of such masters as Donatello, Verrocchio and Pollaiuolo to express movement in the human figure had themselves been partly inspired by classical sculpture.

The importance of this last consideration cannot be stressed too strongly: whether in Michelangelo's *Bacchus*, or in his Doni *Holy Family*, or in the *ignudi* of the Sistine Chapel ceiling, we distinguish a concern to represent movement in space which has a character and an intensity of its own. On a purely formal level the complexity of organization of the Doni *Holy Family (Ill. 92)* springs from a sharpened sensitivity to spatial harmonies. These forms, turning and twisting through a chiselled space, would be quite unexpected, if not unthinkable, in early Quattrocento painting: they belong to the language of the High Renaissance, and they descend through Leonardo from the more limited innovations of his master Verrocchio *(Ill. 93)*. In one word, it was in the use of *contrapposto* that the High Renaissance ideal of movement was

93. ANDREA DEL VERROCCHIO *(c.* 1435–88). *Putto with a Fish, c.* 1470. *Bronze h. 26³/₈ (67). Courtyard, Palazzo Vecchio, Florence. (Cast: original now kept inside the building)*

92. *(opposite)* MICHELANGELO (1475–1564). *Holy Family (Doni Tondo), 1504. Resin and tempera on wood d. 47¹/₄ (120). Uffizi, Florence*

94. ANDREA DEL VERROCCHIO
(*c.*1435–88) *assisted by* LEONARDO
DA VINCI (1452–1519). *Baptism of
Christ, begun 1470. Oil on wood
69⁵/₈×59¹/₄ (177×151). Uffizi,
Florence*

95. ANDREA DEL VERROCCHIO
(*c.*1435–88). *Doubting Thomas,
1481/3. Bronze h. 90¹/₂ (230).
Orsanmichele, Florence*

expressed most typically – that is to say, in the combina-
tion of two opposing movements in a single attitude, pro-
ducing a tension in the figure and hence the implication
of impending action, since it is only in action that such
tension can be released.

No 15th-century artist played a more decisive part in
the foundation of the new style than Leonardo da Vinci.
Although it is convenient to pair Leonardo and Michel-
angelo together as the two principal creators of the High
Renaissance in Florence, according to strict chronology
Leonardo belongs to the preceding age: he was born over
twenty years before Michelangelo, and at the turn of the
century he was already approaching fifty. We may see him
both as a transitional figure and as a pioneer: his early
work owes much to the example of his master Verrocchio,
but his originality and inventiveness were such that he
influenced the course of European painting as profoundly
as either Giotto or Masaccio before him.

Despite his lack of classical learning Leonardo was a
remarkable embodiment of the Renaissance ideal of the

uomo universale. He mastered every branch of the mathematical and physical sciences, and he therefore approached the art of painting with a knowledge of natural phenomena unrivalled by that of any previous master. His slightest drawing contains a profound understanding of the structure of things, from the articulation of the muscles of the human body to the mechanism of the flight of birds or the motion of water; he painted flowers with the eye of a botanist, and rocks and mountains with all the knowledge of a geologist; he applied himself to the study of the properties of light, and some of the observations on colour and reflected light contained in his voluminous notebooks foreshadow the findings of the Impressionists.

Leonardo was apprenticed to Verrocchio, whose workshop was the most soughtafter in Florence; and when he was about nineteen he painted the now famous angel on the left side of the large *Baptism of Christ* (*Ill. 94*) which had been commissioned from Verrocchio for the Convent of San Salvi. Leonardo's angel already intimates the complexity of his genius in its combination of intense realism, dreamy 'romanticism' and classic grace – qualities that we see again in the early *Annunciation.*

The *Annunciation* (*Ill. 99*) was probably painted about 1472, and although the picture contains many features

96. ANDREA SANSOVINO (*c.* 1460–1529). *Baptism of Christ, 1502. Marble, over lifesize. Baptistery, Florence (over east doors)*

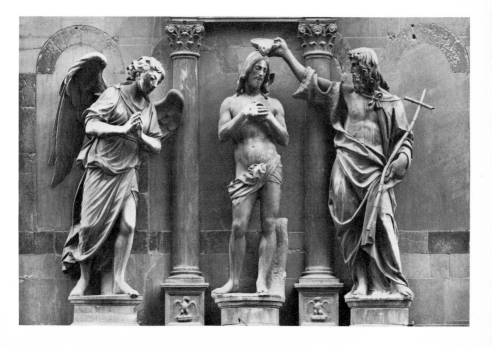

97. LEONARDO DA VINCI (1452–1519). *Virgin of the Rocks (detail), begun 1483. Oil on canvas (transferred from wood). Louvre, Paris*

98. ANTONIO (1427–*c.*79) *and* BERNARDO (1409–60) ROSSELLINO. *Tomb of the Cardinal of Portugal (detail), 1461–6. Marble. San Miniato al Monte, Florence*

that are borrowed directly from Verrocchio, and although certain aspects of the picture suggest the participation of another of Verrocchio's pupils, Lorenzo di Credi, there is much in it that is entirely new and which is attributable only to Leonardo. It is typical of Leonardo, for example, that he should have modelled the wings of the archangel upon those of a bird; and a study survives for the Virgin's draperies which shows how carefully he scrutinized the fall of light upon the folds of an actual piece of material. The mysterious beauty of all that is most ephemeral – from the accidental pattern of folds on a garment to the wayward rippling of hair or the eddying of a stream – seems to have held for Leonardo a special fascination. Like his love for shadow and half-light, this is all part of his 'romanticism'; and his celebrated *sfumato*, that method of modelling by means of subtly graded tones, descending into shadowy depths in which the outline of a form is often entirely lost, has as much to do with his poetic feeling for the mystery of things as with his concern with realistic representation.

In Verrocchio's workshop Leonardo would have absorbed all that there was to be learned about the Florentine 'science of picture-making': Verrocchio was the ideal teacher, a master goldsmith, sculptor and painter of inventive genius who at the same time was not one to impose his personality upon his pupils, and Leonardo was content to stay with him for many years. The art of Verrocchio stands on the threshold of the new age, and in his explorations of spatial movement and in the amplitude and majesty of his figures, especially in his sculptures, he anticipates the Cinquecento ideal. We have only to compare the head of the Saviour in Verrocchio's *Doubting Thomas* at Orsanmichele (*Ill. 95*) with Leonardo's own interpretation of Christ in his *Last Supper* at Milan to understand Leonardo's indebtedness to him.

Leonardo must have been attracted at an early age by the work of Filippo Lippi, and especially by the charm and dreamy wistfulness of Filippo's Madonnas and Angels, and he may well have preserved an equally vivid recollection of the similar qualities developed in sculpture by Antonio and Bernardo Rossellino, notably in the Tomb of the Cardinal of Portugal at San Miniato, where there

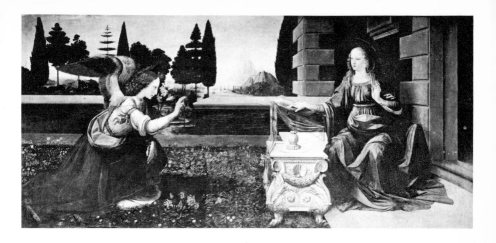

are smiling angels that come remarkably close to his own mysterious ideal (*Ills. 97, 98*). It is in the landscape backgrounds of some of Filippo Lippi's paintings that we discover the only true precedents for those character‑istic rock‑formations which Leonardo introduced into such pictures as the *Monna Lisa* (*Ill. 150*) and the *Virgin of the Rocks* (*Ill. 103*), while the Leonardesque *sfumato* is itself anticipated in the soft gradations of Filippo's mod‑elling. Again, if we compare the beautiful rendering of the draperies in Filippo's *Madonna* of 1437 (*Ill. 100*) with Leo‑nardo's very similar treatment in the Uffizi *Annunciation* (*Ill. 99*), we may conclude that Filippo Lippi was one of the most important formative influences upon Leo‑nardo's early development.

Leonardo was one of the first of the Florentine masters to explore the possibilities of the technique of oil‑painting, which in his hands became the vehicle for an unprece‑dented emphasis upon effects of chiaroscuro. He reverted to Masaccio's method of working from dark to light; but he carried this process much further, so that in such pic‑tures as the *Adoration of the Magi* in the Uffizi and the Paris *Virgin of the Rocks* (*Ill.103*) the figures seem to emerge from a crepuscular gloom which is itself suggestive of mystery.

Leonardo's major contribution to the development of portraiture was his insistence that the painter should be as much concerned with what he called 'the motions of the mind' as with the outward physiognomy of his sitter. This

99. LEONARDO DA VINCI (1452–1519). *Annunciation, c. 1472. Oil on wood 39⁵/₈ × 85³/₈ (98 × 217). Uffizi, Florence*

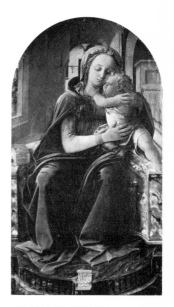

100. FRA FILIPPO LIPPI (c. 1406–69). *Tarquinia Madonna, 1437. Panel 59¹/₂ × 26 (151 × 66). Galleria Nazionale, Rome*

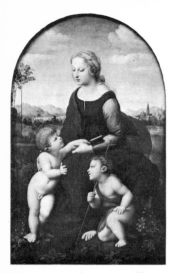

101. RAPHAEL (1483–1520). *La Belle Jardinière, c. 1507. Oil on wood 48×31 (122×79). Louvre, Paris*

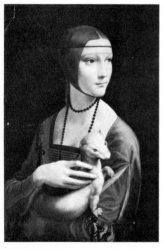

102. LEONARDO DA VINCI (1452–1519). *Cecilia Gallerani, c. 1483. Oil on wood 21⅝×16 (55×40.4). National Museum, Cracow*

intention is already manifest in the early portrait of *Ginevra de' Benci* (National Gallery of Art, Washington, D.C.); it is intensified in the half-length of *Cecilia Gallerani*, executed after Leonardo's arrival in Milan in 1483, when he entered the service of Ludovico Sforza; and it attains complete realization in that absolute masterpiece, the *Monna Lisa* (*Ill. 150*) in the Louvre, which he painted over a period of four years on his return to Florence in 1500.

Cecilia Gallerani (*Ill. 102*) is posed against a dark background. Evidently Leonardo followed a procedure which, in a famous passage in his notebooks, he recommended other painters to adopt: 'In the streets at twilight', he advises, 'note the faces of men and women when the weather is bad, how much attractiveness and softness is seen in them. Therefore, painter, have a courtyard made suitable with walls stained black ... If you do not cover your courtyard with an awning, make your portrait at twilight, or when there are clouds and mist. That is the perfect atmosphere.' Although this dark background is replaced in the *Monna Lisa* by an imaginative landscape, the chill light that falls upon these winding rivers and rocky wastes, and which flickers over Lisa Gherardini's serene but mobile features, is still the lingering light of evening. It is difficult not to think that Leonardo found in Lisa Gherardini the embodiment of a personal ideal; for, as we see her through his eyes, she conforms closely in feature to the type of his Madonnas; and when he placed her against that mysterious background of water and rock he was playing a variation upon the theme of the *Virgin of the Rocks*, which he had painted some fifteen years earlier.

In the Paris *Virgin of the Rocks* (*Ill. 103*) the noble proportions of the Virgin's features descend ultimately from the Greek ideal, but Leonardo's style is always so individual that the classical inspiration of his art is not at first apparent. Historically, the composition has the utmost importance: it was this pyramidal design that such masters as Raphael and Fra Bartolommeo, in the early years of the following century, adopted as the pattern for their own pictures of the Virgin and Child; so that with the Louvre *Virgin of the Rocks* the High Renaissance Madonna had been created.

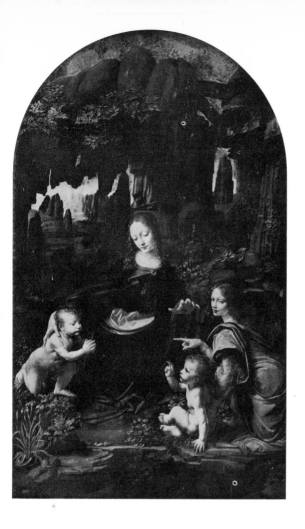

103. LEONARDO DA VINCI (1452–
1519). *Virgin of the Rocks,*
c. 1480? Oil on canvas (transferred
from wood) 77⅝ × 47¼
(197 × 120). Louvre, Paris

A later and slightly different version of the *Virgin of the Rocks* is in the National Gallery in London. The quality of the London picture seems to rule out the possibility that it was merely painted by pupils after Leonardo's own design; and yet the notion that Leonardo, who completed so few pictures, should himself have repeated a composition with such slight variations is equally puzzling. From the surviving documents we know that the altarpiece in San Francesco Grande in Milan of which it was to be the centre was commissioned in 1483, but still unfinished in 1506, and that two Milanese painters, Evangelista and

Ambrogio da Predis (or Preda) were also involved; two panels of Angels by the Predis brothers (also in the National Gallery in London) originally belonged to the altarpiece. Leonardo was paid, in 1507, for what appears to have been the London picture. The history of the Louvre panel is unknown, but its style is clearly that of Leonardo's early period – probably the 1480s – whereas the London version has all the amplitude of his late style. The problem remains unsolved.

No work shows more clearly what Leonardo meant to the masters of the Cinquecento than the heavily damaged wallpainting of the *Last Supper*, executed in the late 1490s in the refectory of Santa Maria delle Grazie in Milan, a church which Bramante was then remodelling. The static, formalized conception of the subject accepted by all earlier painters gives way in Leonardo's hands to a dramatic interplay between the dominant figure of Christ, at the centre, and the perplexed disciples, whose questioning gestures carry the pictorial movement back and forth across the measured spaces of the design. The individual figures are no longer isolated, but become participants in a momentous event of the utmost significance.

In the *Last Supper* Leonardo chose to depict the moment after Christ's words, 'Verily, I say unto you, that one of you shall betray me', when, in reaction to their Master's utterance, the troubled disciples had 'looked one on another, doubting of whom he spake'. He thus gave added depth to a subject which had previously seemed to offer so little to the painter that it had frequently become the excuse for the proliferation of inessential detail and decoration: not only did Leonardo inject into the subject a new dramatic tension, and with it a new unity of idea, but at the same time he emphasized its sacramental significance, since the disciples' perplexed self-questioning bears upon the ultimate meaning of Christ's sacrifice.

In Milan, Leonardo had begun to keep a record in his notebooks of his often unorthodox ideas. It was also at this time that he wrote his *Trattato della pittura*, in which all aspects of the art of painting are discussed and in which his imagination seems to leap ahead into the age of Rembrandt and even into that of Turner, as he sets out his ideas for the representation of night-scenes or cataclysmic

floods. During these years in Milan his scientific studies were so various that they must have left him little time for the practice of his art; and an ambitious project for an equestrian statue of the *condottiere* Francesco Sforza, the father of Leonardo's patron Ludovico, like a later commission at the time of Leonardo's second period in Milan for a monument to Gian Giacomo Trivulzio, was never realized. In Milan, furthermore, Leonardo seems to have turned his attention seriously to architecture, and although we know of no building commissioned from him, he prepared designs for the dome of Milan Cathedral, and indeed a number of architectural drawings survive from his hand. Some of these show the elevations and plans of more or less complex centralized buildings – an interest shared by Bramante, who, as we have seen, was also working in Milan at the time.

Bramante was born near Urbino, where he came under the influence of the architect Laurana and, almost certainly, of the artists Piero della Francesca and Francesco di Giorgio. He was himself trained as a painter. In his first major architectural work, the church of Santa Maria presso San Satiro in Milan (begun in 1482), a thoroughfare left no room for an apse at the east end: Bramante arrived at the brilliant solution of creating a feigned apse by means of a daring and ingenious use of perspective (*Ill. 104*).

When the French armies entered Milan in 1499, Bramante fled to Rome. There his Tempietto at San Pietro in Montorio, built in 1502 on the legendary site of St Peter's martyrdom, combines under a dome the circular form of an Early Christian *martyrium* with the colonnade of a Roman temple, and reflects in its severe dignity Bramante's increasing knowledge of ancient Roman remains. In 1503 Julius II – the future patron of Michelangelo and Raphael – gave Bramante the greatest of his commissions, the rebuilding of St Peter's and a large part of the Vatican. The two Vatican courtyards and the Palazzo Caprini, later bought by Raphael, have a Roman monumentality and restraint which is uniquely characteristic of the High Renaissance. Their influence on Italian architecture was profound: the House of Raphael, with its rusticated ground floor and upper storey decorated only with coupled half-

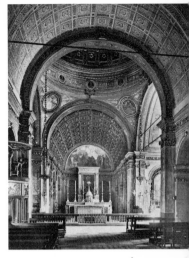

104. DONATO BRAMANTE (1444–1514). *Chancel, Santa Maria presso San Satiro, Milan, begun 1482*

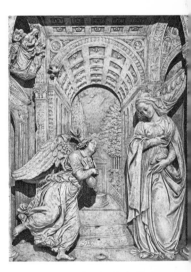

105. BENEDETTO DA MAIANO (1442–97). *Annunciation (centre of altarpiece), completed 1489. Marble. Mastrogiudici Chapel, Sant'Anna dei Lombardi, Naples*

columns, inspired countless palace designs even beyond the 16th century. Bramante's design for St Peter's, with its vast central dome and many complex spaces, was the culmination of all Leonardo's centralized church designs and his own classical knowledge; but its foundations were too frail and eventually, after Bramante's death in 1514, it was abandoned.

Leonardo, like Bramante, left Milan in 1499. During the rest of his life he wandered, staying in Florence for less than eight years, between 1500 and 1508, returning to Milan in 1506 and again in 1508–13, and living more or less unproductively in Rome from 1513 to 1517. Finally he accepted an invitation from François I to go to France, where he died in 1519.

During his second Florentine period, Leonardo executed three important works – the *Monna Lisa*, the unfinished fresco of the *Battle of Anghiari*, commissioned for the Grand Council Chamber of the Palazzo Vecchio, and a cartoon for an altarpiece representing the *Virgin and Child with St Anne* for the friars of the Annunziata. The altarpiece was never completed, but the cartoon – now lost – was publicly exhibited and aroused intense interest and excitement. In its design it must have closely resembled the painting of the same subject now in the Louvre; the cartoon in the National Gallery in London seems to represent a late stage in the evolution of the same idea. Variations upon the same theme were produced by several of Leonardo's pupils. The key feature of the composition in all these variants is the complexity of the relationships established between one figure and another: the Virgin, holding the Child, is seated on the lap of St Anne in such a way that the three figures are bound together within a unified, pyramidal design. Leonardo's ingenuity made a profound impression upon his contemporaries, and not least upon the young Michelangelo, whose Doni *Holy Family (Ill. 92)* must be seen in part as a reply to the older master.

The two painters were shortly to find themselves in direct competition: in 1503 Leonardo was commissioned to depict the *Battle of Anghiari* in the Palazzo Vecchio, and a few months later Michelangelo was asked to paint the *Battle of Cascina* in the same room. Michelangelo's com-

position never proceeded beyond the stage of the cartoon, which was subsequently destroyed, and although Leonardo began his fresco he used an experimental technique which made the colours run and then peel from the wall, so that eventually he abandoned his work in despair. The two compositions, however, are partly known from old copies, and, as we might expect, they present an absolute contrast: whereas Michelangelo sought to express his ideas through the medium of the male nude in action, Leonardo seized the opportunity to invent a stormy equestrian battle-piece which in the furious motion of the excited horses and in the violent expressions of the combatants may be said to have anticipated Rubens, who himself made a copy of it.

None of Leonardo's later works, among which the enigmatic *St John the Baptist* (in the Louvre) must have been painted not long before his death, has a comparable importance. He continued, however, to exert a strong influence upon his contemporaries, and in Milan he left behind him a large school of followers and imitators, who included Vincenzo Foppa, the Predis brothers, Bernardino Luini and Cesare da Sesto.

A brief word must be said finally about Leonardo's drawings. No Renaissance master drew more constantly than Leonardo: he was, perhaps, the greatest of all draughtsmen; and his drawings embrace all his interests, ranging from the most detailed studies of the human figure to sketches, some of them of animals, in which he sought to capture rapid movement in a few masterly strokes. There are scientifically accurate studies of human and animal anatomy; there are chalk drawings, of an astonishing delicacy, of flowers and plants; and others of a more scientific character, many of them illustrating the workings of some mechanical contrivance. It may be said in conclusion that in Leonardo's hands the Florentine ideal of *disegno* became an instrument that served the needs of art and science alike.

CHAPTER FOURTEEN

The young Michelangelo

Although Michelangelo received his earliest training un-
der Ghirlandaio, he was soon to devote himself principally
to sculpture; and in 1489, when he was in his fourteenth
year, he left Ghirlandaio's workshop for a far more stimu-
lating environment. Lorenzo de' Medici invited him to
work under his patronage in the Sculpture Garden, or
Casino Mediceo, which he had lately established in his
gardens near San Marco and which he had placed under
the superintendence of Bertoldo di Giovanni, a former
pupil of Donatello. Vasari tells us that the Casino Medi-
ceo was 'filled with antique and good sculptures', and
that 'the loggia, the garden-paths and all the rooms were
ornamented with figures and pictures such as were to be
found elsewhere neither in Italy nor outside Italy'. In ad-
dition to the paintings and sculptures, there were drawings
and cartoons by Donatello, Masaccio, Uccello, Fra Ange-
lico and other masters. It seems doubtful, however, wheth-
er there was any formal training at this somewhat myste-
rious establishment, which would appear to have been
rather a gallery of masterpieces than an academy of art;
and, strange as it may seem, the precise nature of Michel-
angelo's training as a sculptor remains obscure. What can
certainly be assumed is that, as he was actually living in
the Medici Palace, where he was to remain until Lo-
renzo's death in 1492, he would have come into imme-
diate contact with the great humanists who were attached
to the Medici Court. Thus Michelangelo must have been
familar from an early age with those neo-Platonic ideas
that run through his *Sonnets* and which seem to lie at the
heart of his practice as a painter and sculptor.

The ambitious relief of the *Battle of the Centaurs* in the
Casa Buonarroti must have been executed in this early

period, probably in emulation of a *Battle-Piece* by Bertoldo which is now in the Bargello. Bertoldo was an authority on the antique, and his *Battle-Piece* is a reinterpretation, of a somewhat literal and academic kind, of Roman relief-sculpture. In the *Battle of the Centaurs*, on the other hand, Michelangelo made a far more imaginative use of classical motifs; and there is something highly individual in the effect produced by the rhythmic, whirling movement embedded in the design of this work, which suggests an analogy between the tide of battle and the ebb and flow of natural forces.

Lorenzo de' Medici's death in 1492 compelled Michelangelo to return to his father's house; and although Piero de' Medici invited him back to the Medici Palace he proved himself to be an uncongenial patron. In this period Michelangelo fell increasingly under the spell of Savonarola, and in later life he was to say that he could still hear the friar's voice ringing in his ears. The great marble *Pietà* (*Ill. 106*) in St Peter's in Rome, with which he was shortly to establish his reputation, is certainly a work of which Savonarola would have approved. At the same time he engaged in an intensive study of human anatomy, although dissection itself was eventually to sicken him.

In 1494, as the French armies approached Florence, Michelangelo fled to Bologna. There he studied Jacopo della Quercia's reliefs at San Petronio (*Ill. 51*); he must have responded not only to Quercia's rhythmic yet nervous use of outline but in a more general sense to the emotional intensity of his art, and, above all, to the monumentality of his figures.

Michelangelo returned to Florence for only a short period. In the summer of 1496 he set off for Rome, where he was to stay for four years, and where he created those early masterpieces, both in marble, the *Bacchus* (now in the Bargello in Florence) and the *Pietà* at St Peter's. On his return from Bologna he had carved, in emulation of an ancient sculpture, a *Sleeping Cupid* which was sold by a dealer in Rome as a genuine antique. Thus he arrived in Rome with the reputation due to one who had proved himself capable of attaining to the perfection of the ancients. Shortly afterwards, the rich banker Jacopo Galli, an enthusiastic collector of antiquities whose garden was filled

with classical sculptures, gave him the commission for the *Bacchus*.

The sentiment expressed in the *Bacchus* seems ambigu-ous: in the hands of a Greek sculptor, the god's delight in the pleasures of the grape (a symbol of inspiration) would have been unequivocal; but one suspects here an element of disapproval on Michelangelo's part, a shadow at least of that deep sense of sin which was always with him. For all the qualities of genius that are manifested in it, the *Bacchus* remains a disturbing and ultimately unsatis-factory work, and a comparison with the *Pietà* at St Peter's only serves to remind us that Michelangelo was in the deepest sense a Christian artist, and that for him the high-est art was that which drew the beholder nearer to the Divine Presence.

The *Pietà* (*Ill. 106*) was commissioned for the Chapel of the Kings of France, on the south side of Old St Peter's. In its iconography it recalls a type of Northern Gothic *Pietà*, frequently carved in wood, in which the Virgin holds the dead Christ on her lap, seeming to recollect the days when she pressed him as a Child to her breast. But the anguish expressed by the Virgin in this tradition stands in the strongest possible contrast to the noble resig-nation of Michelangelo's Madonna. She is represented as still young, and evidently Michelangelo had in mind the neo-Platonic doctrine that physical perfection is the out-ward sign of an inner perfection of the spirit.

The Rome *Pietà* and the Bruges *Madonna* of about five years later are the most finished of all Michelangelo's works. In later life he was to permit himself a greater freedom, and the comparative roughness of his late style has particularly appealed to modern taste: but the grace and refinement of modelling that the young Michelangelo achieved in the polished surfaces of these two works still seem an almost miraculous achievement, and in the case of the *Pietà*, even on a purely technical level, his triumph was sufficient to establish his reputation as the greatest sculptor of his time. The supremely graceful figure of Christ has a quality that is almost Greek in its exaltation of the absolute perfection of the male nude. In addition to the influence of the an-tique, the *Pietà* indicates Michelangelo's response to the innovations of Leonardo and of his master Verrocchio, of

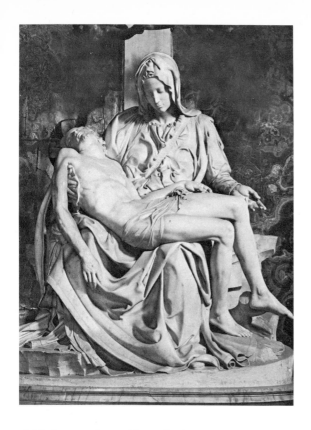

106. MICHELANGELO (1475–1564). *Pietà, 1498–9. Marble 68¹/₂ × 76³/₄ (174 × 195). St Peter's, Rome*

which there are clear evidences both in the treatment of the Virgin's draperies, recalling Leonardo (see *Ill. 99*), and in the type of the Christ, whose features conform to an ideal first developed by Verrocchio (for example in the Christ of the *Doubting Thomas* at Orsanmichele (*Ill. 95*), and subsequently by Leonardo in his *Last Supper* in Milan.

Whereas Leonardo placed painting above all the other arts, since it can depict all natural phenomena, Michelangelo gave it as his view that painting is 'the better the more it approaches relief, and that relief seems the poorer the more it approaches painting'. It was natural, therefore, that Michelangelo should have received his strongest aesthetic stimulus from the study of antique sculpture, and there were two ancient works in particular to which he constantly returned for inspiration, the *Belvedere Torso* and the *Laocoön*. The influence of the *Belvedere Torso* can al-

ready be seen in the nude Christ of the Rome *Pietà*, and it also lies behind the conception of the reclining Adam and many of the *ignudi* of the Sistine Chapel ceiling. Michelangelo is said to have referred to the *Belvedere Torso* as his 'Master'. On one occasion, when Cardinal Salviati discovered him kneeling before the *Torso* in rapt admiration, and attempted to engage him in conversation, Michelangelo was at first too absorbed to make any answer, but eventually remarked: '*Questo è l'opera d'un huomo che ha saputo più della natura*' ('This is the work of a man who knew more than Nature').

The marble group of the *Laocoön*, which had previously been known only from Pliny's description, was discovered in Rome early in the year 1506. Michelangelo was among those who were asked to advise on its restoration, and it was eventually set up in the Belvedere. The *Laocoön* came to be regarded as the supreme expression in sculpture of physical and spiritual agony; and its bursting energy underlies such figures by Michelangelo as the *St Matthew* for Florence Cathedral and the *Haman* of the Sistine ceiling.

The importance of Michelangelo's early visit to Rome cannot be exaggerated; he returned to Florence in 1501 with his mind stored with all that he had learned from his studies in that vast museum of antiquities. Florence was now prospering under its new republican government, and in order to glorify the virtues of the Republic the authorities now commissioned from Michelangelo the famous marble statue of *David* (*Ill. 107*).

Michelangelo abandoned the accepted tradition for the representation of David, the tradition still followed by Donatello (*Ills. 9, 18*) and Verrocchio. In medieval thought, David and Hercules were regarded as parallel symbols of Fortitude: Michelangelo went a step further, and united David and Hercules in one figure. In the *David* is to be found the first complete expression by Michelangelo of that quality of *terribilità* which was early associated with his name – that evocation of awe-inspiring power which was to be fundamental to the heroic language of the Sistine Chapel ceiling and the long-drawn-out project for the Julius Tomb. (Something of this quality is to be found in the famous *Horse-Tamers*, or *Dioscuri*,

of Montecavallo, one of the ancient works that Michelangelo is known to have admired in Rome.)

Shortly after the completion of the *David* in 1504, Michelangelo began to prepare his cartoon for the fresco of the *Battle of Cascina* in the Palazzo Vecchio, which, as we have seen, was commissioned as a pendant to Leonardo's *Battle of Anghiari*. He was thus placed in the position of being in open rivalry with the older master; but he also learnt from him, as is evident especially from his vigorous use of *contrapposto* in the Doni *Holy Family* (*Ill. 92*), which dates from the same period and which is Michelangelo's only certain painting on panel.

In the year 1505, while he was still at work on the *Battle of Cascina*, Michelangelo was suddenly summoned to Rome by Pope Julius II, who had decided to have an imposing marble tomb erected for himself in his own lifetime; and there now began what Condivi, Michelangelo's early biographer, was to call 'the tragedy of the Tomb'. In entrusting this task to Michelangelo, Julius II gave him an opportunity that must have seemed to fulfil all his ambitions, for it was to have been a work of impressive size, containing an enormous number of large figures. But for one reason and another the tomb was never to see completion: the Pope was continually changing his mind about it; there were further difficulties of other kinds; and all that Michelangelo ever completed, after nearly a lifetime of endeavour, was the huge figure of *Moses*, two subsidiary figures of *Rachel* and *Leah*, the so-called *Victory* and some further figures of *Bound Slaves*. The *Moses* now forms the centre-piece of a much reduced monument at San Pietro in Vincoli in Rome.

The first interruption had come very early on, in the spring of the year 1508, when the Pope had given Michelangelo a further task which was to occupy him in Rome for the next five years – the decoration of the ceiling of the Sistine Chapel. Loath to abandon his work on the tomb, Michelangelo began work in the Sistine with the utmost unwillingness, protesting that painting was not his profession; and defiantly, in his letters to the Pope, he insisted on signing himself *Michelagnuolo schultore*. It was under these paradoxical and unpropitious circumstances that one of the supreme masterpieces of painting was begun.

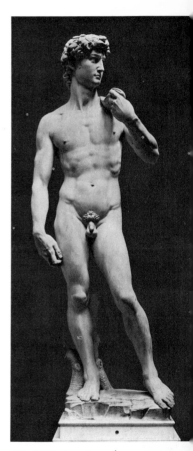

107. MICHELANGELO (1475–1564). *David, 1501–4. Marble h. 171 (434.5). Accademia, Florence*

125

The Sistine Chapel ceiling

Disappointed and frustrated by the delays over the Julius Tomb, Michelangelo transferred to the Sistine Chapel ceiling many of the ideas that he had conceived for that vast project. A number of drawings have been preserved which show the gradual development of Michelangelo's conception: the task of decorating so large an area was daunting in itself, and it was aggravated by the irregular shape of the whole central field, penetrated as it was by the ribs of the four large spandrels at the corners and the four smaller spandrels on either side of the low barrel-vault of the ceiling (*Ill. 108*). Michelangelo's solution was to super-impose upon the entire architectural structure a sort of trellis-work of illusionistically rendered architecture, sim-ulating marble, whose most important function was to define regular fields for the various narratives and figures.

The ceiling is divided by false transverse arches, group-ed in pairs, into four large fields and five small ones. Each pair of massive bases, themselves decorated by twin *putti*, forms a niche in which a gigantic figure – alternately a prophet or a sibyl – is seated. Upon each base Michel-angelo placed the figure of a nude youth: these celebrated *ignudi*, although seated, are all represented in strenuous poses, and form the counterpart on the Sistine ceiling of the so-called slaves intended for the Julius Tomb. In the nine rectangular fields Michelangelo painted narratives from *Genesis*, while the corner spandrels were reserved for four separate Old Testament scenes – *David and Goliath, Judith and Holofernes*, the *Punishment of Haman*, and the *Brazen Serpent*; above and around the windows are rep-resentations of the Ancestors of Christ. It will be recalled that the side walls of the Chapel were already decorated with two cycles, depicting the history of man under the

108. *(opposite) Sistine Chapel, Vatican, looking east. Side frescoes by various hands, c.1480; ceiling by* MICHELANGELO, *1508–12; Last Judgment wall by* MICHELANGELO, *1536–41*

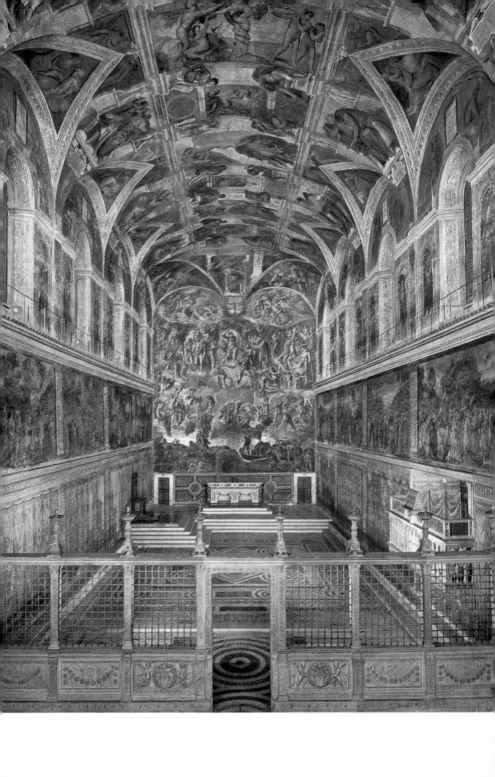

Law and the history of man under the new dispensation of Christ. Evidently Michelangelo's intention was to complete this scheme by showing, in the central narratives of the ceiling, the story of Creation and the history of man up to the giving of the Law.

In Michelangelo's time the chancel screen stood further towards the altar, dividing the Chapel into two equal parts – the room of the laity on the near side of the screen, and the *presbyterium* for the clergy on the far side. This original division, preserved in the mosaic-work of the floor, affected the scheme of Michelangelo's decorations on the ceiling. Above the *presbyterium* he painted the acts of God up to the Creation of Man, and above the room of the laity the story of man from his fall to the end of the flood. Between the two zones, over the chancel screen, Michelangelo placed the *Creation of Eve*, where God appears for the last time and man is still in an unfallen state. Above the papal throne, to the left of the altar, he depicted the most solemn of his Prophets – Jeremiah, who looks down in brooding contemplation as though meditating upon the spiritual destiny of mankind, as guided by the Vicar of Christ.

Michelangelo began work in 1508 at the entrance end of the Chapel, gradually moving, over the months and years, towards the altar: he thus executed the central narratives in reverse order, beginning with the *Drunkenness of Noah* (*Ill. 109*) and ending with the first act of the Creation, the *Separation of Light and Darkness*. It would seem that when, about half-way through his labours, he took down his scaffolding to study the ceiling from the floor, he saw that some of the figures were too small, and consequently gave the later frescoes a larger scale.

It is customary now to assume that Michelangelo intended the narratives to be read primarily in the order in which he painted them: the scenes as they unfold could then be interpreted as representing a spiritual progression, from the scene of Noah's drunkenness, in which man is shown in all his potential animality, towards an ultimate vision of the Creator. According to this interpretation, the ceiling sets forth the neo-Platonic idea of the ascent of the soul to the Divine. Various aspects of the decoration have been adduced in support of this argument. For example,

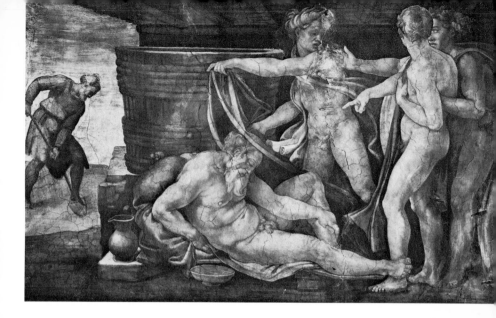

the scene of the *Sacrifice of Noah* is out of order, coming as it does before rather than after the *Deluge*: the whole point of Noah's sacrifice lay in the fact that it was a token of thanksgiving for his deliverance from the Flood. It is also argued that, as we move towards the altar, the Prophets show an ever-increasing spiritual awareness, until finally we come to Jonah, the symbol of absolute faith. And how shall we account for the fact that the narratives appear to end – with the *Drunkenness of Noah* – upon a note of despair? It has been contended finally that the nine histories cannot be read in their narrative order, for the reason that read thus they appear upside-down.

A different explanation of the meaning of the ceiling has been found in Franciscan theology, especially in the *Decachordum christianum* of Marco Vigerio, written in 1507. According to this argument, the programme of the ceiling is due not to Michelangelo, but to a theologian; and it is based on the use of typology, a principle as old as the New Testament and one that is fundamental to theological thinking throughout the Middle Ages and the Renaissance, whereby Old Testament events are seen as foreshadowing those of the New Testament. Thus everything in the ceiling refers to man's salvation through the sacrifice of Christ: hence the altar-like thrones of the prophets and

109. MICHELANGELO (1475–1564). *Drunkenness of Noah, 1509. Fresco. Sistine Chapel, Vatican*

110. MICHELANGELO (1475–1564). *Creation of Man (detail),* c.1511. Fresco. Sistine Chapel, Vatican

sibyls, supporting symbolic 'wafers'; hence the rams' skulls, found on ancient altars; hence the linen bands held by the *ignudi,* allusions to Christ's burial; hence the emphasis given to the figure of Jonah, the 'type' of the Risen Lord.

Interpreted in this light, such a scene as the *Drunkenness of Noah* (*Ill. 109*) no longer – except on a purely literal level – speaks to us of the degradation of sin: centuries before the time of Michelangelo, St Augustine had explained in his *Contra Faustum* that the story of Noah's drunkenness signified, in a mystical sense, the salvation of the human race by Christ. Similarly, all the stories represented in the corner spandrels had long been regarded as types or prefigurations of Christ's victory over Satan and of the triumph of the Church: the Ark itself was a symbol both of the Cross and of the mystical Body of Christ, the Eucharist; Christ was the second Adam; and so on.

To all this it may be added that there is in fact no reason at all to place any weight upon the circumstance that, as the visitor to the Sistine Chapel follows the narratives in their chronological sequence, walking (that is to say) away from the altar in the direction of the entrance, each scene will appear to him upside-down. The explanation of this apparent anomaly is surely quite simple: if we allow that the scenes showing God's creative acts were meaningfully placed over the *presbyterium,* the narratives could have been represented in no other way, since only

111. *Prometheus sarcophagus (detail, reversed). Louvre, Paris*

by turning their backs upon the altar could those present at a service or ceremony in the Sistine Chapel have seen the narratives correctly if Michelangelo had designed them the other way round.

No doubt the subject-matter of the frescoes will continue to be debated for many years to come; but here we must leave the problem, and turn to questions of style. It is probably the experience of most visitors to the Sistine Chapel that this vast decoration is not painting in the usual sense, but rather a translation of the art of sculpture into a two-dimensional language. So powerful is this impression that the figures seem to have been carved out of marble.

Not surprisingly, the Sistine Chapel ceiling contains a wealth of motifs adapted from the antique, and it is clear that some of Michelangelo's most original conceptions grew out of a vast store of memories and reformulations. To recognize this is in no way to commit the blasphemy of belittling Michelangelo: the reclining Adam in the *Creation of Man* (*Ill. 110*) is no less stupendous an invention because some of its probable sources can be traced, whether we point to the Adam of Uccello (in the Chiostro Verde at Santa Maria Novella in Florence), his far leg drawn back as in Michelangelo's figure, or antique representations of the creation of man by Prometheus (*Ill. 111*), showing a figure stretched out in a similar attitude, or whether we discern in the modelling and proportioning of Adam's body not only the fruits of Michelangelo's anatomical studies but also a melodious tribute to the *Belvedere Torso*. Even this list of the putative sources for the Adam is not exhaustive.

The *Creation of Man* sums up in one supreme composition the sublime power and beauty of the ceiling as a whole. Nothing in the entire decoration surpasses Michelangelo's conception of Adam's awakening to the presence of the Godhead, from whose outstretched hand he receives the divine spark; nor in the long history of painting has any artist ever approached the conviction of Michelangelo's own vision of the Supreme Being in this fresco and in the neighbouring scenes of primordial Creation. These mighty *concetti* seem the very paradigms of the terrible creative energy of his own genius.

112. PERINO DEL VAGA (1501–47). *Vertumnus and Pomona. Engraved by Giovanni Giacomo Caraglio.* $5^1/_8 \times 6^3/_4$ *(13 × 17). British Museum, London*

113. MICHELANGELO (1475–1564). *Libyan Sibyl, 1511. Fresco. Sistine Chapel, Vatican*

131

CHAPTER SIXTEEN

Raphael

A lofty gravity, a sublime austerity even, characterizes the art of Michelangelo from the beginning. The early paintings of Raphael, on the other hand, are all sweetness and grace, and although Michelangelo was to inspire him with a desire to emulate his grandeur of expression, these gentler qualities were too much part of his nature ever to be discarded. Michelangelo is the type of the individualist who goes his own way, the lonely genius tormented by interior struggle, and he had little time for the ordinary demands of society: Raphael, by contrast, was blessed with a serene temperament and a gracious disposition which made him virtually the ideal of Castiglione's *Courtier*, and it was fitting that Castiglione should have been his friend and patron. Reflecting these differences, the art of Raphael opposes to the 'divine despair' of Michelangelo an ideal of classical order and harmonious grace.

Raffaello Sanzio was born in 1483 at Urbino in Umbria. His father, Giovanni Santi, combined the offices of court painter and poet to Federigo da Montefeltro: when he died in 1494, the young Raphael entered the workshop of Timoteo Viti, a painter of minor devotional pictures who had just returned to his native Urbino from his studies under Francesco Francia, the Bolognese painter. At the age of seventeen Raphael came under a much more important influence when he was apprenticed in Perugia to the eminent master who takes his name from that city, Pietro Perugino. Within a short time Raphael had so absorbed all that Perugino could teach him that in this period the styles of the two painters, master and pupil, are almost indistinguishable. Probably no other painter has quite approached Raphael's extraordinary facility in following another artist's manner and making it part of him-

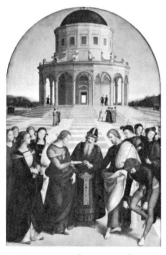

114. RAPHAEL (1483–1520).
Sposalizio (Marriage of the Virgin),
1504. Oil on wood 46¹/₂×66⁷/₈
(118×170). Brera Gallery, Milan

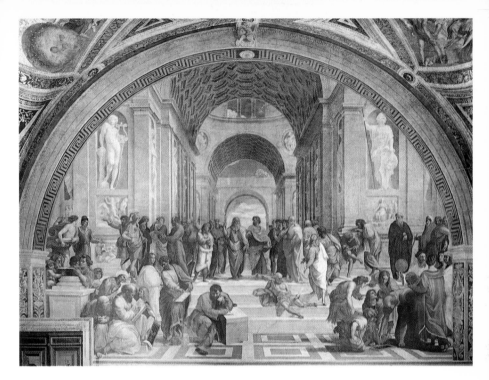

self; it might be said of him that he climbed to greatness on the shoulders of others. Yet when he accepted Perugino's vision of things as his own, he saw further than Perugino ever had; and so it is with the long list of other influences that crowd his brief but energetic life.

The Mond *Crucifixion* in the National Gallery in London, executed for the Dominican church at Città di Castello, and the *Sposalizio*, or *Marriage of the Virgin* (Ill. 114), painted in 1504 for the Franciscan church in the same city, show how conscientiously the young Raphael set himself to imitate Perugino's style. As Vasari observed, if Raphael's *Crucifixion* had not been signed, it 'would certainly have passed for Pietro's work'. Everything in the picture, from the limpid blue of the sky to the languid figures of the Beloved Disciple and the Virgin, derives directly from Perugino – everything, that is, except for a certain accession of virile strength, which can be seen especially in the graceful figure of the Crucified. The composition of the *Sposalizio*, although based upon Perugino's fresco of *The Giving of the Keys* (Ill. 83) in the Sistine

115. RAPHAEL (1483–1520). *School of Athens, 1510–11. Fresco. Stanza della Segnatura, Vatican*

133

Chapel, is far more compactly knit together: here Peru-
gino's melodious line takes on an ampler sweep, and the
sweetness of his colouring a new richness. This work may
be said to mark the beginning of Raphael's independence:
only he could have given expression to that harmonious
lucidity that elevates the subject to an ideal order of being.

The distance that separates the *Sposalizio* from Ra-
phael's supreme masterpiece, the *School of Athens* (Ill. 115),
painted some six years later, is a relatively small one: by
the time that he had begun the *School of Athens* Raphael,
admittedly, had not only passed through his Florentine
experience, but had also found himself in the position of
having to measure his powers against those of Michel-
angelo; yet a comparison between the two compositions
will show that in the Vatican fresco he returned to some
of the ideas that are first stated in the *Sposalizio* altarpiece.
Once again the figures are placed within a vast forecourt,
and the background is dominated by noble architectural
forms, no less reminiscent of Bramante, which blend har-
moniously with the sweeping arch of the framing. Ra-
phael now needed only the stimulus provided by Leo-
nardo's presence in Florence to evolve from the Virgin of
the *Sposalizio* the well-known type of the *Madonna del
Granduca* and the succession of Madonnas that followed,
all of the same spiritual family – divinely sweet, ideally
beautiful, yet not, like Perugino's, remote from life.

Raphael went to Florence in the year 1504. He was to
spend four years there, off and on, and he now came
into direct contact with the art of Leonardo, who had al-
ready begun his *Battle of Anghiari* and his portrait of Lisa
Gherardini (the *Monna Lisa, Ill. 150*). Raphael's imme-
diate understanding of Leonardo's genius is evident from
all that he refused to accept from him. While Leonardo's
pupils were content to echo his style and his mannerisms,
Raphael evidently understood from the beginning that the
most personal qualities of Leonardo's genius had nothing
in common with his own.

Shortly after his arrival in Florence, he was commis-
sioned by Angelo Doni – for whom, at about the same
time, Michelangelo was painting the *Holy Family*, now in
the Uffizi – to execute a pair of portraits of his wife and
himself. Both portraits are now in the Pitti Palace in

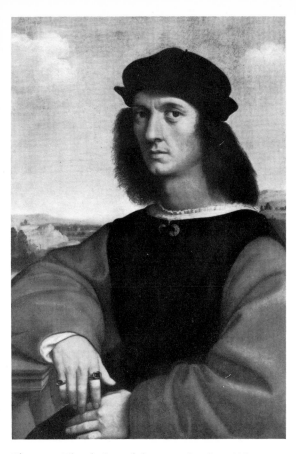

116. RAPHAEL (1483–1520).
Angelo Doni, c. 1505. Oil on wood,
24³/₄ × 17³/₄ (63 × 45).
Uffizi, Florence

Florence. The design of the portrait of *Maddalena Doni*
indicates clearly enough Raphael's study of the *Monna
Lisa*: yet there is nothing here of Leonardo's mystery, but
rather a calm objectivity and a cold grace that are the
reverse of Leonardesque 'romanticism'. The companion-
portrait of *Angelo Doni* (*Ill. 116*), which is the finer of the
two, displays in equal measure searching draughtsman-
ship, firm modelling and richness of colour. In effect,
Raphael grafts Leonardo's *sfumato* technique on to the
Peruginesque tradition: he does not lose the outline as
Leonardo does, but preserves in all his forms a complete
clarity. Here Raphael reveals for the first time that insight
into character which was to inform his masterly inter-
pretations of Julius II and Leo X.

135

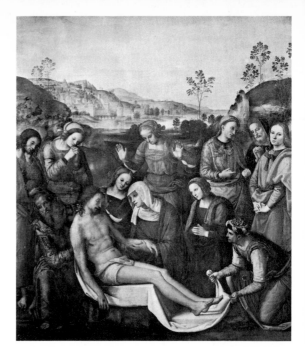

117. PERUGINO (1445/50–1523).
Entombment, 1495. Oil on wood
85×76³/₈ (216×194). Pitti Palace,
Florence

It was towards the beginning of his Florentine period
that Raphael painted the *Madonna del Granduca* in the
Pitti Palace, perhaps the most celebrated of his paintings
of the Virgin, which seem to embody all the qualities that
through its long history the subject has demanded of the
artist. These 'heads of such sweetness and grace' (to use
Vasari's words) derive ultimately from the type of femi-
nine beauty evolved by Perugino, and must have owed
little to living models. Raphael observed in a letter to
Castiglione on the subject of his *Galatea*: 'Since there is
a dearth ... of beautiful women, I avail myself of a certain
idea that comes into my mind.'

In the *Madonna of the Goldfinch* in the Uffizi and the
so-called *Belle Jardinière* (*Ill. 101*) in the Louvre, Raphael
adapted to the needs of his own style the type of pyramidal
composition which Leonardo had introduced in the *Vir-
gin of the Rocks* (*Ill. 103*) and in his variations upon the
subject of the *Virgin and Child with St Anne*, and which
after Leonardo's departure from Florence was to be devel-
oped by Fra Bartolommeo. But, once again, Raphael pre-
serves his characteristic lucidity of statement, and the Vir-
gin is seated in a pleasant meadow, under a serene sky.

Clear signs of the impact upon Raphael of the art of
Michelangelo appear only towards the end of his stay in
Florence, and they are particularly noticeable in the Bor-
ghese *Entombment* of 1507 (*Ill. 118*), a work commissioned
for a chapel in Perugia Cathedral. The picture is full of
echoes, and perhaps on no previous work had Raphael
expended greater pains: he must have regarded it as a
declaration on his part of the extent of his learning; and,
above all, it was a tribute to Michelangelo.

Raphael's source for the figure of the dead Christ was
Michelangelo's marble *Pietà* for Old St Peter's (*Ill. 106*),
and no less certainly the seated Mary on the right was
inspired by the Doni Virgin. Raphael drew other elements

118. RAPHAEL (1483–1520).
Entombment, 1507. Oil on wood
72¹/₂×69¹/₄ (184×176). Borghese
Gallery, Rome

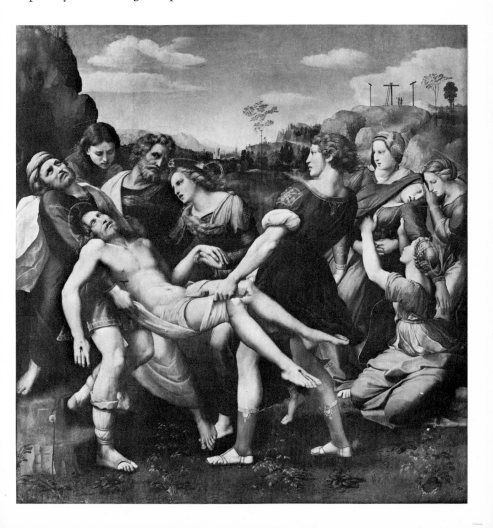

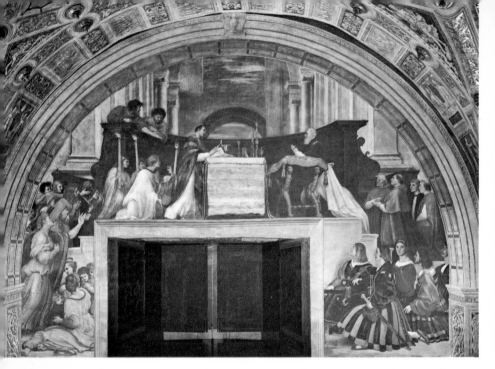

119. RAPHAEL (1483–1520). *Mass of Bolsena, c. 1512: Fresco. Stanza dell'Eliodoro, Vatican*

from an engraving by Mantegna and from an ancient sarcophagus-relief representing the *Funeral of Meleager*. It is possible that the influence of the *Laocoön* is detectable in some of the heads on the left. Moreover, there are still lingering echoes of Leonardo, especially in the rocky sepulchre in the distance and in the delicately rendered plants in the foreground. But the distant landscape – as was appropriate in a painting destined for Perugia – is entirely Umbrian in character, and has strong points of similarity with the landscape background of Perugino's Pitti *Entombment* of 1495 (*Ill. 117*).

In 1508 Raphael went to Rome, where he was to spend most of the remaining years of his life. It was partly through the interest of Bramante, who was his kinsman, that he now received from Pope Julius II the commission to decorate the papal apartments, or *Stanze*, in the Vatican. Raphael completed the first of these frescoes – those in the Stanza della Segnatura – towards the end of the year 1511, and thus his first major works in fresco were executed at the time that Michelangelo was painting the ceiling of the Sistine Chapel.

The visitor to the Vatican apartments passes first through the Stanza dell'Incendio. The second room is known as the Stanza della Segnatura, the third as the Stanza dell'Eliodoro, and the fourth as the Sala di Costantino. The decorations ordained for these four rooms are devoted to separate themes – in the first Stanza, the miracles of the Popes; in the second, the divine illumination of the human intellect; in the third, the divine guidance of the Church; and in the fourth the establishment of the Church after the conversion of Constantine the Great.

The Stanza della Segnatura had originally been planned as the Pope's private library, a circumstance that accounts for the subjects chosen for its decoration. The ceiling contains four large medallions in which are personified *Theology, Jurisprudence, Philosophy* and *Poetry,* together with four rectangular scenes, which in turn illustrate these four branches of learning. There is a similar correspondence between the four medallions and the frescoes on the four walls which form the principal part of the

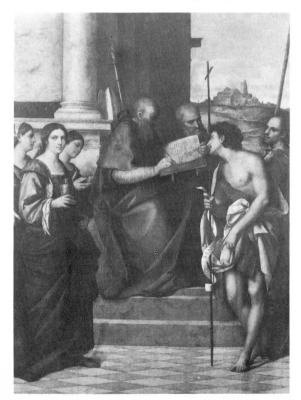

120. SEBASTIANO DEL PIOMBO (*c.* 1485–1547). *St John Chrysostom with other Saints, c.* 1509. *Oil on canvas* 78³/₄ × 65 *(200 × 165).* *San Giovanni Crisostomo, Venice*

decoration. Thus the fresco representing the *Apotheosis of the Faith* – traditionally known under the misleading title of the *Disputà* (or *Dispute of the Holy Sacrament*) – is placed under *Theology*; the *Three Cardinal Virtues* under *Jurisprudence*; the *School of Athens* – which would be better called the *Apotheosis of Reason* – under *Philosophy*; and the scene of *Parnassus* under *Poetry*.

In the so-called *Disputà*, Raphael was still feeling his way, modelling in small strokes of the brush more appropriate to tempera than to fresco, and the delicacy and grace of the composition belong essentially to his Umbrian past. In the *Parnassus* this meticulous style has given way to a broader and freer treatment. The exquisite colouring must owe something to Raphael's study of the examples of ancient painting that he could have seen in Rome. The *School of Athens* (*Ill. 115*) brings together in grave assembly the philosophers of antiquity, who are congregated beneath an imposing building of Bramantesque design, decorated with classical statues and low reliefs. In the centre, at the top of a flight of steps, stand Plato and Aristotle, the representatives of 'moral philosophy' and 'natural philosophy'. The group in the foreground on the right contains a number of portraits, including that of Bramante, represented (with a pair of compasses) as Archimedes, and a self-portrait of Raphael. The meditative figure of Heraclitus, seated in the left foreground, already reveals Raphael's assimilation of the heroic style of the Sistine ceiling.

The *Mass of Bolsena* (*Ill. 119*), in the Stanza dell'Eliodoro, reveals in a still more extraordinary manner the range of Raphael's interests and the receptivity of his mind; for the colouring in this fresco is neither Umbrian nor Florentine, but Venetian; and Venetian also is the rendering of the textures of the rich fabrics. This surprising development is to be explained by the presence in Rome of Giorgione's pupil Sebastiano del Piombo, whom Agostino Chigi had commissioned in 1511 to help with the decoration of the Farnesina. The subject of the *Mass of Bolsena* is the miracle which led eventually to the institution of the Feast of Corpus Christi, when a German priest who doubted the doctrine of the Real Presence saw blood flowing from the wafer at the moment of consecration.

The priest kneels at the altar, and opposite him Raphael introduced a portrait of Julius II, which has much of the 'senatorial dignity' (to use Sir Joshua Reynolds's phrase) of the later portraiture of Titian.

The *Mass of Bolsena* represents the spiritual triumph of the Church, the *Expulsion of Heliodorus from the Temple* its worldly glory. The *Heliodorus* (from which the Stanza dell'Eliodoro takes its name) illustrates the dramatic account in the Book of Maccabees of how the Syrian general Heliodorus, having invaded the precincts of the Temple to plunder the treasure reserved for the poor, was struck down and trampled underfoot by a heavenly rider who appeared accompanied by two men in dazzling apparel. The subject was chosen to commemorate the defeat of the French in 1512 by the forces of Julius II, who was now acclaimed as the saviour of Italy. In contrast to the calm and fundamentally static compositions in the Stanza della Segnatura, the fresco is remarkable for the violence of its action, foreshadowing that emphasis upon vehement movement which characterizes the work of the great Baroque decorators. In the same way, the exploration of light-effects in darkness in the *Liberation of St Peter from Prison* not only reveals an unexpectedly 'romantic' strain in Raphael's nature, but anticipates similar explorations by Caravaggio and even those of Rembrandt.

The static harmony of his earlier frescoes is even further abandoned in the Stanza dell'Incendio, painted after the unveiling of the Sistine ceiling. Here the influence of Michelangelo is yet stronger. In the *Fire in the Borgo* a young man carries an older man upon his shoulders: there is an allusion here to Aeneas' rescue of his father from the flames of Troy, a theme that was probably suggested to Raphael by a similar group in Michelangelo's fresco of the *Deluge*. More remarkable still is the composition, where the violent movement already present in the *Heliodorus* is further complicated by an asymmetrical setting. There is no middle distance: in the foreground figures flee from the fire; in the far distance the Pope appears on his balcony, miraculously quelling the fire. In this fragmentation some critics have detected the seeds of Mannerism.

By this time Raphael was overburdened with work, and he was compelled to entrust more and more of the

decoration of the Stanze to his assistants and especially to his chief pupil Giulio Romano. He was constantly receiv- ing other commissions, whether for altarpieces or portraits, and the penetrating portrait of Pope Julius II in the Pitti Palace in Florence dates from this period. In 1514 he painted his celebrated fresco of *Galatea* in the Villa Far- nesina; in the following year he began the cartoons (now in the Victoria and Albert Museum in London, on loan from the Royal Collection) for the series of tapestries in- tended to cover the wall-spaces below the Quattrocento frescoes in the Sistine Chapel; and in the same year he was appointed Inspector of Antiquities in Rome, an office taxing in itself, since it carried with it responsibility for extensive excavations and works of restoration. As though all this was not enough, in the previous year he had suc- ceeded Bramante as architect of St Peter's.

Raphael's achievement as an architect has never re- ceived the appreciation that is due to it, if only for the reason that few of the works undertaken by him have been preserved, while others that he designed – such as the Villa Madama and the church of Sant'Eligio – were completed by others in a different style. Among such losses, one of the most important is the destruction (to make room for Bernini's colonnade in the Piazza of St Peter's) of the Palazzo Branconio dell'Aquila, built for the Papal Cham- berlain. Here the façade combined something of the fla- vour of the style of Bramante with a complex decora- tiveness of great originality, which included painted pan- els and high-relief stucco ornament. As is evident enough from the beautiful Chigi Chapel in Santa Maria del Po- polo in Rome, with its magnificent use of the Corinthian order, Raphael's architectural style was founded upon a profound knowledge and understanding of classical ar- chitecture. His originality may be said to derive in great measure from his imaginative understanding of the use of licence in antiquity. This is confirmed by the Villa Ma- dama, begun in 1516 and never completed: its ambitious plan, centering on a circular courtyard, was inspired by the Golden House of Nero, and among its unique features are domed vaults of imposing dimensions and elaborate *grottesche* – fantastic decorations based on newly excavated Roman works – which are executed in low relief.

Much of Raphael's architectural work was undertaken in collaboration with others, such as Giulio Romano and the Sienese architect-painter Baldassare Peruzzi. It was Peruzzi who built the exquisite Villa Farnesina for Agostino Chigi (1508–11), and decorated it – in the company of Raphael, Giulio Romano, and others of that circle – with daring *trompe-l'œil* frescoes. He carried out Raphael's ideas in several buildings, among them the centrally planned church of Sant'Eligio degli Orefici, and succeeded him as architect of St Peter's. His last work, the Palazzo Massimi (1532–6), shows marked Mannerist tendencies.

Giulio Romano looked to the Villa Madama as a model when, in 1524, he accepted Federigo Gonzaga's commission to build the Palazzo del Tè in Mantua; but its strange details – among them dropped keystones, irregularly spaced columns, and exaggerated rustication – are far removed from Raphael's Roman dignity. Its interior was decorated by Francesco Primaticcio and by Giulio Romano himself; the most famous room, the Sala dei Giganti, contains Giulio's overpowering decorations representing the fall of the Titans at the hands of the gods of Olympus – a chaos of tumbling figures and crashing masonry, and a triumph of Mannerist illusionism and fantasy.

After the death of Julius II, his successor Leo X, the Medici Pope, continued to employ Raphael's services, and it was he who commissioned him, in the year 1515, to design the tapestries for the Sistine Chapel. A few years later Leo X sat for the portrait now in the Pitti Palace, in which he is represented together with his nephew Cardinal Giulio de' Medici and his secretary, Cardinal dei Rossi. Even Titian never surpassed the power and depth of characterization shown by Raphael in this portrait – a complex study of an epicurean prince of the Church whose sensuality was matched by his strength of intellect. In comparison with his early portraits, the *Leo X* reveals a new, almost relaxed confidence: the forms take on a greater amplitude; spatial problems are solved with a casual ease; and the colour is almost Venetian in its richness. This enlargement of Raphael's powers would seem to be directly related to his experience of fresco-painting.

The same mastery characterizes the great Madonnas of the period, of which the *Madonna della Sedia* in the Pitti Palace and the *Sistine Madonna* at Dresden are the finest. In many ways the *Madonna della Sedia* is Raphael's subtlest work, and it has always, and rightly, been hailed as the most masterly of all roundel designs. In the *Sistine Madonna*, which was executed for the Cistercians of San Sisto at Piacenza, the intimate qualities of the *Madonna della Sedia* are replaced by a majestic grandeur of conception that recalls the frescoes in the first two Vatican Stanze: here Raphael's long devotion to the theme of the Madonna and Child attains its most sublime expression.

Yet perhaps the most perfect painting executed by Raphael in these years is the fresco of *Galatea* in the Villa Farnesina. The commission appears to have had some connection with a pastoral drama composed by Castiglione for the Court of Urbino, during the performance of which the Duchess of Urbino had taken the part of Galatea. Just as Botticelli's *Birth of Venus* embodies much of the spirit of 15th-century Florence at the height of the Medici rule, the *Galatea* contains the essence of that High Renaissance classicism which belongs to the Rome of Leo X. The fresco contains numerous quotations from classical reliefs, and yet the conception is so fresh, the idea so completely realized, that it is difficult to believe that this masterpiece was not thrown off effortlessly in a momentary stroke of inspiration.

Raphael died suddenly in the year 1520, at the full height of his powers. We have evidence of the sense of shock and of deep loss with which the tragic news was received by his contemporaries, and the Venetian scholar and connoisseur Marcantonio Michiel wrote at the time that the Pope was 'plunged in grief'. It was an event that still seems of critical importance in the history of High Renaissance painting; for Raphael had so dominated the scene in the last twelve years of his life that his death left a hiatus that was impossible to fill, and the stylistic development known as Mannerism is to be directly related to this fact.

121. *(opposite)* ANTONIO (1427–c.79) *and* BERNARDO (1409–60) ROSSELLINO. *Tomb of the Cardinal of Portugal, 1461–6. Marble. San Miniato al Monte, Florence*

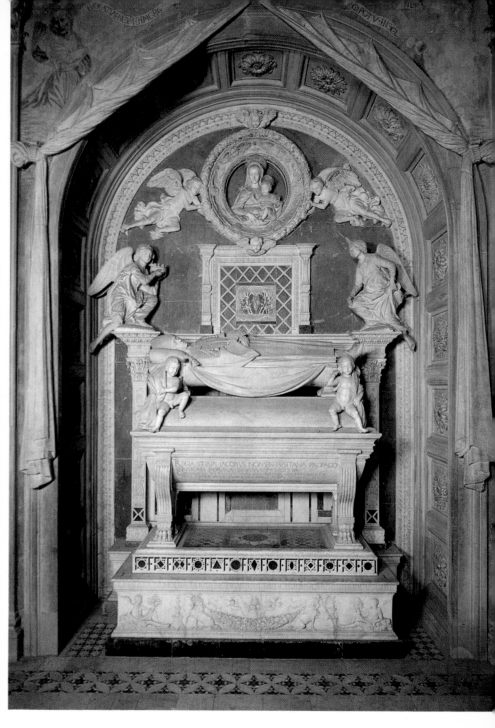

Michelangelo's contemporaries in Florence

The appearance, in the person of Michelangelo, of Italy's greatest sculptor happened to coincide with a period of decline in sculptural activity in Florence. The patronage of the guilds had ceased to be as effective as in the past, for their role had largely been taken over by such families as the Medici and the Strozzi; and at a time when increasing pride was being taken in collections of antiques the demand for works by living sculptors fell away. Lorenzo de' Medici seemed to show little interest in the sculptors of his own time; and Bertoldo was probably called into his service largely because of his extensive knowledge of antiquities.

In the last quarter of the century, the most popular sculptors working in Florence were probably Andrea della Robbia and Benedetto da Maiano. Andrea della Robbia fell heir to his uncle Luca's workshop, which under his direction continued the production of charming Madonnas in glazed terracotta (*Ill. 123*). Benedetto da Maiano, who at one time was employed by the Strozzi, developed the style of Antonio Rossellino in a series of religious works and portrait-busts. His *Melini Pulpit* at Santa Croce, bearing reliefs of Franciscan subjects, has a vigour that derives partly from Verrocchio and Pollaiuolo. His most impressive work is the altar for the Mastrogiudici Chapel at Sant'Anna dei Lombardi at Naples, completed in 1489, where in the central relief of the *Annunciation (Ill. 105)* a striking illusion of space is achieved by a contrasting use of low relief in the deep perspective of the background architecture and of high relief in the foreground figures. His intention was clearly to imitate a painted altarpiece, with its *predella*, and he applied colour to the marble; it is as though he was attempting to prove that in

the hands of a sculptor the figures in an altarpiece could take on an appearance of life denied to the skill of the painter, and could seem to be about to step from the frame.

Among the pupils of Pollaiuolo, Andrea Sansovino may well have received some additional training under Benedetto da Maiano. His major works in Florence, the *Corbinelli Altarpiece* at Santo Spirito, completed by 1490, and the later *Baptism of Christ* (*Ill. 96*) which stands over the east doors of the Baptistery, are representative of the purity and refinement of his style. These qualities bring him close to Raphael, with whom he was certainly acquainted in the early years of the new century. In 1505 he was summoned by Julius II to Rome, where in his elaborate tombs of Cardinal Ascanio Sforza and Cardinal Girolamo della Rovere, both at Santa Maria del Popolo, he created a type of sepulchral monument which was to provide a model for the Cinquecento just as Bernardo Rossellino's Bruni Monument (*Ill. 14*) had done for the Quattrocento. Sansovino's pupil Jacopo Tatti, known from his adoption of his master's name as Jacopo Sansovino, was to become the city architect of Venice.

122. GIANFRANCESCO RUSTICI (1474–1554). *Preaching of the Baptist, 1506–11. Bronze, over life-size. Baptistery, Florence (over north doors)*

123. LUCA DELLA ROBBIA (1400–82). *Madonna of the Rose Garden, 1420–30. Glazed terracotta*
$32^5/_8 \times 25$ *(83 × 64). Bargello, Florence*

An exact contemporary of Michelangelo, Gianfran-
cesco Rustici, modelled the bronze group of the *Preaching
of the Baptist* (*Ill. 122*) over the north doors of the Floren-
tine Baptistery. Vasari informs us that Rustici designed
this work with the assistance of Leonardo, and undoubt-
edly the response elicited by the Baptist's words from his
two listeners has something in common with the psycho-
logical insights of the Milan *Last Supper*. Similarly, Ru-
stici's marble *tondo* of the *Virgin and Child with St John*
(in the Bargello) recalls Leonardo in the softness of the
modelling, the rhythmic beauty of the draperies and,
above all, the Virgin's wistful smile; it is very possible
that Raphael remembered this work when he came to
paint his *Madonna della Sedia*. A group of statuettes of
horses made from designs by Leonardo is also attributed
by Vasari to Rustici.

A part from Leonardo and Perugino, the most dis-
tinguished painter to be trained under Verrocchio was
Lorenzo di Credi, who was entrusted early on with a
major share of responsibility for paintings commissioned
from the workshop. His early *Annunciation* in the Uffizi, in
which a doorway flanked by windows opens out upon a
distant landscape and effectively stabilizes the figures, in-
vites comparison with Leonardo's *Annunciation* in the
same gallery, in the execution of which Credi may well
have assisted. But while Leonardo possessed creative gen-
ius of the highest order, Lorenzo di Credi had no more
than a fine talent, which he improved by industry; and
whereas Leonardo was always advancing across the thresh-
old of new experience, Credi developed very little, and
his later work – of which the *Nativity*, also in the Uffizi, is
representative – belongs essentially to the Quattrocento
tradition, preserving the clear outlines, the bright colour-
ing and the crowded designs of late 15th-century practice,
and showing little response to the new ideals of monu-
mental simplicity and selectivity.

In addition to his religious works, Credi painted a
few portraits and mythological subjects. As a portrait-
painter, he is a proficient and pleasing minor master, and
the so-called *Portrait of Perugino* in the Uffizi has been var-
iously ascribed to Lorenzo di Credi himself, to Perugino
and even to Raphael. Of his mythological pictures, the

124. FRA BARTOLOMMEO (*c.*1474–
*c.*1517). *Pietà, 1515. Oil on wood*
62¹/₄×78³/₈ (158×199). Pitti
Palace, Florence

only one to have survived is the full-length *Venus*, also in
the Uffizi. Lorenzo di Credi had been one of the painters
most affected by Savonarola's fulminations against the
revival of pagan culture, and we are told that in the year
1497 he destroyed, wherever it was possible, all his secular
works.

The teachings of Savonarola exerted a still more deci-
sive influence upon the life of Baccio della Porta, known
as Fra Bartolommeo, who in response to the tragedy of
the friar's martyrdom chose to enter the Dominican Order,
temporarily abandoning the profession of painting. Along
with his friend and collaborator Mariotto Albertinelli,
Fra Bartolommeo had been trained in the workshop of
Cosimo Rosselli, and had subsequently come under the
influence of Perugino. In 1508 – eight years after taking
his vows – he visited Venice, where he studied the work
of Giovanni Bellini: the grandiloquent *Mystic Marriage of
St Catherine* (in the Uffizi), executed in 1512, derives in

part from Bellini's San Zaccaria altarpiece in Venice, with its imposing architectural setting and that motif so dear to Bellini and his contemporaries – the angel-musician seated at the foot of the Virgin's throne.

Fra Bartolommeo succeeded to Fra Angelico's position as head of the San Marco workshop, and his work has much of the purity and religious intensity of the art of the 'angelic painter'. It also shows, however, a tendency towards the grandiose, giving at times an impression of emptiness. This aspect of Fra Bartolommeo's style is to be explained by the impression made upon him by the work of Michelangelo, which is particularly in evidence, for example, in the *St Mark* in the Pitti Palace. He learnt much from Leonardo, and also, it would seem, from Andrea del Sarto. Both painters must have contributed

125. MARIOTTO ALBERTINELLI (1474–1515). *Annunciation, 1510. Oil on canvas 151⁵/₈ × 96⁷/₈ (385 × 246). Accademia, Florence*

to his mastery of subtle modelling and tonal harmonies; moreover, he successfully adapted to his own use Leonardo's experiments in pyramidal figure-composition, and in so doing helped to influence the course of Raphael's development during his Florentine period. Perhaps his most perfect work is the *Pietà* in Florence (*Ill. 124*), which contains the essence of his pensive and sensitive genius: no painting of the subject could be less pretentious, and the skill and inventiveness that went into this harmonious composition detract in no way from the touching simplicity of the sentiment that it lays bare.

Fra Bartolommeo's closest follower was his friend Mariotto Albertinelli, whose best-known work is the heroically conceived *Visitation* in the Uffizi. Altogether, Albertinelli was a quieter and less inventive painter than Fra Bartolommeo, as he was also very different from him in character. His style was largely based upon that of Fra Bartolommeo; at the same time, he was attracted by the placid grace of Perugino, which in his art becomes absorbed into the modern style of Cinquecento Florence. He used *contrapposto* with the utmost restraint, as in the rhythmic figure of Christ in the Florence Accademia *Trinity* or in the gentle Virgin in the angel-thronged *Annunciation* (*Ill. 125*) in the same gallery.

The attitude of Albertinelli's Virgin is very like that in a *modello* by Jacopo Sansovino for a marble *Virgin and Child* (*Ill. 126*). The pose is virtually repeated in Andrea del Sarto's San Gallo *Annunciation* in the Pitti Palace. These repetitions of the same image provide interesting evidence of the influence exerted upon early 16th-century painting in Florence by Sansovino, who on his return in 1511 from an early visit to Rome was to share a studio with Andrea del Sarto. Like his master Andrea, Sansovino upheld an ideal of restrained classicism, akin to that of Raphael in painting, wich eschewed the expressive *terribilità* of Michelangelo. The graceful harmony of the Sant'Agostino *Madonna* (*Ill. 127*), executed during a second period in Rome, before Sansovino finally settled in Venice, is typical of this important 'anti-Michelangelesque' current in Florentine High Renaissance art.

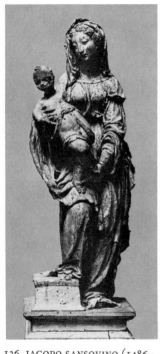

126. JACOPO SANSOVINO (1486–1570). *Virgin and Child (modello). Gilded wood covered with waxen canvas h. 24³/₄ (63). Museum of Fine Arts, Budapest*

No painter has suffered more unjustly from modern criti‐
cism than Andrea del Sarto, by far the greatest Florentine
painter of his generation, apart from Michelangelo. Sarto
has not been fortunate in his biographers. It was Vasari
who was responsible in the first place for the unhappy
legends that have surrounded Sarto's name, and which
were to be elaborated by Robert Browning in his famous
dramatic monologue. There has been handed down to us
a picture of a man of enormous gifts but of weak character
who allowed himself to be so ruined by a feckless wife
that he failed to fulfil his immense promise. Vasari's ac‐
count of him, however, can be shown to be false in many
particulars, and almost everything that he says about An‐
drea's life and personal circumstances must be treated with
the greatest reserve. Nor is Browning's judgment just, that
Sarto was a 'perfect painter' in the technical sense but an
artist without depth or spirituality. It is true enough that
Sarto was the most technically proficient painter working
in Florence in the second and third decades of the 16th
century – a brilliant draughtsman, the finest colourist of
his age outside Venice, and the absolute master of the
new technique of oil‐painting, – but he was no less an
artist of fertile imagination and profound humanity; and
his frescoes in the Scalzo take their place among the
supreme achievements of the High Renaissance.

Sarto received his early training under Piero di Cosimo
and Raffaellino del Garbo, but his figure‐style shows how
rapidly he responded to the innovations introduced by
Leonardo and Michelangelo, and also to the work of
Andrea and Jacopo Sansovino. His treatment of land‐
scape, which shows strong northern influence, indicates
his knowledge of the engravings of Lucas van Leyden and

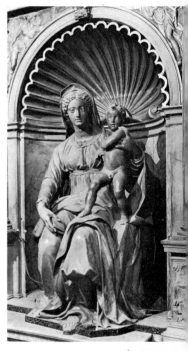

127. JACOPO SANSOVINO (1486–
1570). *Virgin and Child, 1520–21.
Bronze. Sant'Agostino, Rome*

153

Dürer. How close Sarto at times approached the realism of Flemish landscape painting can be seen, for instance, from the two *cassoni* (marriage-chest) panels in the Pitti Palace, representing scenes from the story of Joseph: these formed part of a decorative scheme in the Palazzo Borgherini which was entrusted to various masters, including Pontormo and Bacchiacca.

In 1509, when he was still only in his early twenties, Andrea del Sarto was commissioned to complete the frescoes begun by Cosimo Rosselli and Baldovinetti in the narthex of Santissima Annunziata. These scenes represent episodes from the life of San Filippo Benizzi, a 13th-century General of the Order of the Servi di Maria. There are no precedents in Italian painting for the qualities of these light and airy compositions (*Ill. 128*), informally yet effectively knit together by figures moving in a free space. The use of gesture in these early works is extremely impressive and gives the scenes an intense dramatic power. The San Filippo Benizzi cycle was finished in 1510. Sarto went on to paint two further scenes, both from the life of the Virgin – the *Journey of the Magi*, commissioned in 1511, and the *Birth of the Virgin*, which bears the date 1513. Certain aspects of the *Birth of the Virgin* reflect the influence of Fra Bartolommeo, and in particular of his *Mystic Marriage of St Catherine*, painted not long before, but the grace of movement and softness of modelling in the figures are entirely Andrea's own, as is also his uncanny ability to make tangible the very air within which the figures move.

These scenes are surpassed in imaginative power by the monochromatic frescoes executed intermittently between 1515 and 1526 in the Chiostro dello Scalzo, the cloister of the Barefooted Friars (or Scalzi). These comprise twelve scenes from the life of St John the Baptist, together with figures of the four Cardinal Virtues (one on each side of the two doorways). The lunettes over the scenes each contain an illusionistic representation of a balustrade opening upon a cloud-swept sky. The ornamentation in the borders is extremely elaborate, recalling the 'grotesque' decorations by Filippino Lippi in the Strozzi Chapel at Santa Maria Novella. The restraint shown in the use of *grisaille* – or *brunaille,* a better term for a monochrome which is predominantly of a deep golden tone – in preference to

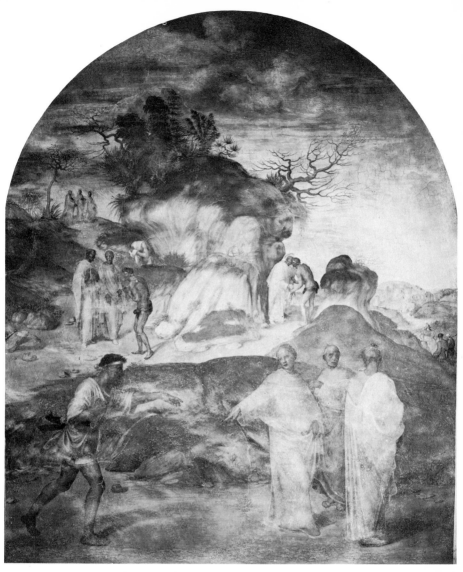

128. ANDREA DEL SARTO (1486–1531). *San Filippo Benizzi and the Beggar, 1509–10. Fresco. Narthex, Santissima Annunziata, Florence*

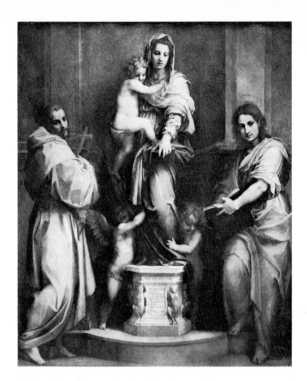

129. ANDREA DEL SARTO (1486–1531). *Madonna of the Harpies,* 1517. *Oil on wood 81¹/₂ × 70¹/₈ (207 × 178). Uffizi, Florence*

the bright colours admired in the previous century, typi-fies the austere ideal of the Cinquecento, with its emphasis upon the sublime rather than upon the merely pleasing. It has been pointed out that Serlio must have been think-ing of the Scalzo frescoes when in the Fourth Book of his *De Architectura Libri Quinque,* written in 1537, he com-mended those painters who employed monochrome in their decorations as a means of preserving the architectural unity of the setting.

During the long period of his work in the Scalzo, which was interrupted by his visit to France in 1518, An-drea del Sarto matured into an epic painter of tragic inten-sity. As we follow his development in these ten years, from the early *Baptism of Christ* of 1515 to the *Birth of the Baptist* of 1526, we observe a progressive extension of his dramatic powers and an increasing mastery of design. Where he uses an older prototype for a composition, as in the scene of *St John the Baptist Preaching,* which must have been largely based upon Ghirlandaio's fresco at Santa Maria

Novella, he transforms the subject by sweeping away everything that is inessential and by blowing upon the ancient iconography a breath of such freshness that we are almost deceived into forgetting that his subject-matter was not wholly new. There are also signs in the Scalzo decorations of a renewed assimilation of the antique, and it is possible that Sarto visited Rome shortly after his return from France; but he interpreted it with such freedom and independence that what he owed to classical sculpture is not immediately apparent: he imitated it rather in the spirit than in the letter, and many of the figures in the Scalzo decorations possess an antique flavour even where they cannot be associated with any identifiable statue or relief. This is true, for example, of the noticeably 'classical'

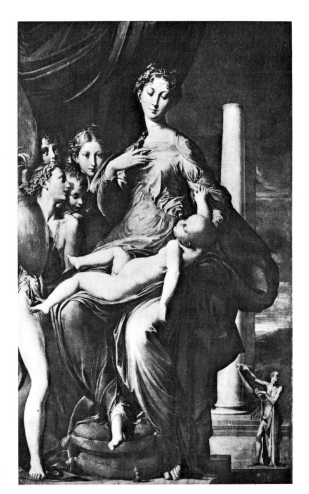

130. PARMIGIANINO (1503–40).
Madonna with the Long Neck, c.1535.
Oil on wood 85 × 52 (216 × 132).
Pitti Palace, Florence

157

treatment of the draperies in such scenes as the *Arrest of St John the Baptist* and the *Dance of Salome*.

In the scenes executed towards the end of this protracted undertaking, the figures tend increasingly to dominate the stage, and background detail is reduced to the barest indications. A fine example of these later compositions is the *Presentation of the Baptist's Head to Herodias* (*Ill. 16*), which compares in its expression of intense inward feeling with Donatello's *Feast of Herod* (*Ill. 15*) on the Siena Font. As in Donatello's relief, the focus of interest is Herod's reaction to the spectacle of horror that is placed before his eyes, and which freezes his every movement. How differently would Raphael have interpreted this subject! There is nothing here of his refinement, but a roughness, rather, which brings to mind the art of Rembrandt. The same kinship with Rembrandt is suggested by the dramatic light that plays upon the figures and upon the tablecloth, creating a slanting mass of shadow on the background architecture, and by the fluid tonalities that unify all the forms.

It may seem extraordinary that so inventive and, indeed, passionate a colourist as Sarto should have renounced colour entirely in what was undoubtedly his most important commission. The colouristic range that he was able to achieve in fresco is displayed in the famous *Madonna del Sacco* in the Chiostro de' Morti at Santissima Annunziata, which bears the date 1525, and in the serene *Last Supper* in the Refectory of San Salvi, completed shortly afterwards although begun much earlier. It is no wonder that Titian should have admired the *Madonna del Sacco*, for the relationships of colour found in this work and in other paintings by Sarto are inventions of the highest order of originality. The fresco is no less impressive in design: occupying a lunette over the doorway which leads into the north transept of the Annunziata, it must have been intended to take the visitor by surprise; the conception is as informal as it is intimate. It is as though, on leaving the cloister, we had stumbled accidentally upon a sacred mystery. According to iconographic tradition, the sack identifies the subject as the Rest of the Holy Family on the Flight into Egypt, and Sarto created out of the tradition a charming and yet solemn family group.

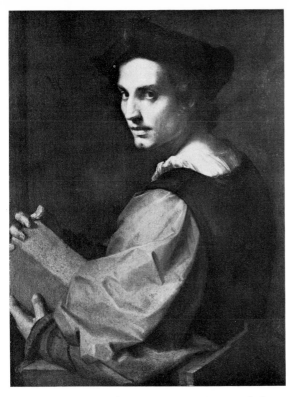

131. ANDREA DEL SARTO (1486–1531). *Portrait of a Young Man, c. 1517.* Oil on canvas $28^1/_2 \times 22^1/_2$ (72×57). National Gallery, London

Sarto's most important Madonna is the so-called *Madonna of the Harpies* (*Ill. 129*), painted in 1517 for the high altar of San Francesco in Florence. Properly speaking, the animals carved on the symbolic, pedestal-like altar, upon which the Virgin stands like a statue, are not harpies at all but sphinxes, such as appear, for example, on the throne of Donatello's Virgin at Padua: the precise nature of the symbolism is debatable, but the sphinx was an attribute of Minerva, who was not only the type of divine wisdom but also a virgin-goddess.

Like so many of Sarto's compositions, the *Madonna of the Harpies* is fundamentally symmetrical in design, but there is a calculated variety in the rhythmic and softly sculptured forms. The Virgin is more human and more tenderly portrayed than any Madonna by Raphael: according to tradition Andrea gave her the features of his wife Lucrezia, but this would not preclude the expression of

deep religious feeling. On the contrary, this is surely one of the most sincere and quietly moving, as it is also one of the most majestic, of religious paintings of the High Renaissance.

Andrea del Sarto was one of the great portrait-painters of his time. His masterpiece is the half-length of a *Young Man* (*Ill. 131*) in London, sometimes called *A Sculptor* and sometimes *An Architect*, from the fact that the object that he holds in his hands, and which is possibly an open book, has frequently been interpreted as a block of stone. The portrait seems to have been painted around the year 1517, but in a looser sense it occupies a position midway between the portraiture of Leonardo and that of the early Titian. The play of light and shade over the mobile features, seeming to shift with the turn of the head, represents an extension of Leonardo's method; while the simplicity and largeness of the conception, the silvery to-nalities and the emphasis upon the value of colour suggest possible connections with Venetian painting of the period. On the other hand there is nothing Venetian about the incisive drawing and chiselled modelling of this sculp-turesque figure. This is a work of considerable inventive-ness, and one that extends the range of traditional portrai-ture by introducing a dramatic element. The young man has been interrupted in a moment of study or contempla-tion, and one of the secrets of the compelling power of the portrait is that as we meet his eyes we are ourselves drawn into that moment, for it is we who have invaded his pri-vacy. One of the consequences of this invention is a new sense of informality, since the sitter is not obviously posing for the taking of his likeness.

Andrea del Sarto's influence upon his contemporaries was wide. He has an important place in the history of Mannerism, since such leading exponents of that style as Pontormo, Rosso, Salviati and Vasari were all his pupils.

The problems raised by the term 'Mannerism' are too complex to be considered in detail here. The term itself derives from the Italian word *maniera*. For Vasari, *maniera* was that quality of style, of 'stylishness', which resulted from 'the method of copying frequently the most beautiful things, combining them to make from what was most beautiful (whether hands, heads, bodies or legs) the best figure possible, and putting it into use in every work for all the figures – from this, it is said, comes *bella maniera*'. The word *maniera* had been employed by literary critics long before the time of Vasari to draw attention to positive virtues of style, and had also been applied in a similar way to social etiquette and deportment.

In modern times, art historians have used the word in a loose sense to describe aspects of post-Renaissance art in which they have detected not only a falling-off from the classical ideals of the High Renaissance but also a quality of nervous, even neurotic, disturbance: this mood has usually been connected with the unsettled conditions in Italy during the period of the Reformation, and, more particularly, after the Sack of Rome in 1527. On the one hand it would be surprising if the spiritual and political upheavals of the time were found to have cast no reflections in the arts: on the other hand this last interpretation of Mannerism would have been incomprehensible to Vasari, who expressed the utmost confidence in the state of the arts in his own time. Nevertheless we have also to admit that some of the leading exponents of Mannerism, such as Pontormo and Parmigianino, showed marked symptoms of neurosis.

If we remind ourselves of the impression made upon the age by the death of Raphael, who had seemed to unite

in his own person all its aspirations, we can understand not only the reasons for the sudden awareness of loss experienced by the artists and the patrons at that critical time, but also an attitude that reflected a consciousness of past achievement, and which saw no clear way towards the future development of the arts except through a process of refinement upon what had gone before: after the conquests, the booty; after the heat of battle, a desire for a relaxation of tension. And so there appears a new ideal, a kind of perfectionism in which facility, sophistication and eclecticism become primary virtues.

A tendency towards *maniera* is already evident in the later work of Michelangelo and Raphael. Even the Sistine Chapel ceiling contains figures – notably some of the *ignudi* – that are less remarkable for their *terribilità* than for an easy, almost indolent grace and self-display. Moreover, it was Michelangelo who developed the Leonardesque *contrapposto* into that graceful form which Lomazzo, in his *Treatise on the Art of Painting, Sculpture and Architecture*, published in 1584, was to commend under the term *figura serpentinata*. As Lomazzo observed, Michelangelo once advised a pupil always to make his figures pyramidal and serpentine. Lomazzo adds that if a figure has a pyramidal or conical form which resembles a flame, 'it will be very beautiful'. He recommends the painter to combine this pyramidal form with the *serpentinata*, like the twisting of a live snake in motion, which is also the form of a waving flame'.

Perhaps the first true example of the *figura serpentinata* is to be found in Michelangelo's marble *Victory*, executed about 1527 for the Julius Tomb but eventually set up by Vasari in the Palazzo Vecchio in Florence. But Michelangelo was too various an artist, not least in his later years, to be categorized as a Mannerist. We may say the same of Raphael, but in his last works he was moving towards Mannerism more consistently. This tendency crystallizes into an independent style in the work of Raphael's pupils. The germs of the new style can be seen not only in the later Stanze but also in such devotional pictures as the Louvre *St Michael*, of 1518, and his last painting, the Vatican *Transfiguration* (Ill. 134).

The circumstances under which the *Transfiguration* was painted are exceptionally interesting, for when Cardinal

132 *(opposite).* JACOPO PONTORMO (1494–1556). *Deposition, c. 1525. Oil on wood 123¹/₄ × 75⁵/₈ (313 × 192). Capponi Chapel, Santa Felicita, Florence*

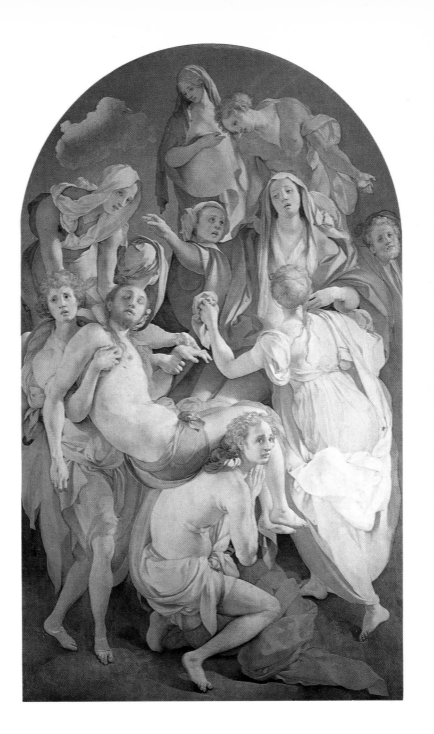

Giulio de' Medici gave Raphael the commission for this work it was known that he had also ordered an altarpiece on a similar scale from Sebastiano del Piombo: this was the *Raising of Lazarus,* now in the National Gallery in London (*Ill. 135*). This was a very different sort of contest from the competition held in Florence in 1401 for the bronze doors of the Baptistery, since Raphael and Sebastiano – who was supported and encouraged by Michelangelo – were not competing for employment, but for personal glory. The victory went to Raphael, and although he did not live to enjoy his success, in that victory Mannerism triumphed: the acknowledged prince of painters had uttered his final statement upon the nature of the highest art; and the *Transfiguration* remained in Rome to establish a canon of taste.

The composition contains a great deal of movement, especially in the lower field, in which Raphael represented the story of the healing of the demoniac boy. But the gestures, which might be misinterpreted at first as violent or agitated – are in fact moderated by a propriety that has as much to do with purely aesthetic considerations as with their intrinsic meaning in the dramatic action. The *Transfiguration* is a work of the utmost sophistication, and while it is a far more important painting than the Borghese *Entombment* of twelve years earlier (*Ill. 118*), it is no less a *demonstration*: therefore it contains an element of stylization, arising from the desire to bring known values to a state of perfection – whether we see it in the intricate ordering of the design, in the coherence given to figures in a wide variety of attitude, or in the sheer beauty of their deportment. The figures have a polished, marmoreal quality which is particularly noticeable in that of the young mother kneeling in the centre foreground, and even in the representation of the demoniac boy the ferment of psychic disturbance has been chilled by a process of idealization originating, it would seem, in conscious emulation of the *Laocoön*.

Shortly after Raphael's death the Mannerist style was firmly planted in Florentine soil by the arrival from Rome of Perino del Vaga, one of Raphael's closest associates. In 1522–3 Perino exhibited a cartoon for a fresco representing the *Martyrdom of the Theban Legion,* a work commis-

133. *(opposite)* GIOVANNI BATTISTA ROSSO (1494–1540). *Deposition, 1521. Oil on wood 148×77¹/₈ (375×196). Museum, Volterra*

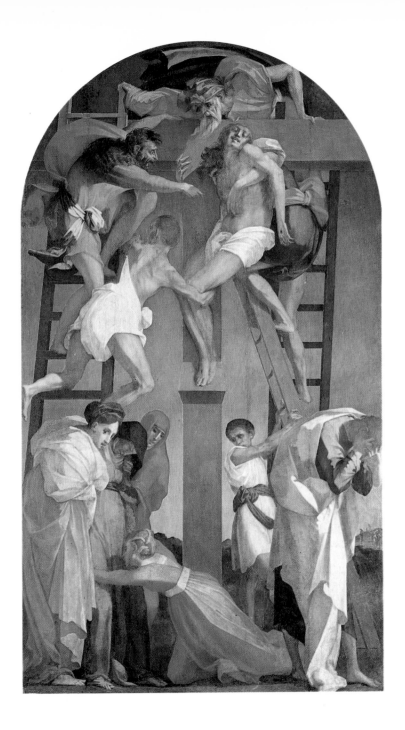

134. RAPHAEL (1483–1520).
*Transfiguration, 1517–20. Oil on
wood 157¹/₂ × 109³/₈ (400 × 279).
Vatican Museums and Galleries*

sioned by the Camaldolese church but never executed.
Perino's cartoon made an impression at the time comparable only with that made upon the previous generation
by Michelangelo's *Battle of Cascina*. The composition,
which is known from drawings, including Perino's preparatory study, has a curiously dreamlike quality, in that
the figures, which are exceedingly numerous, seem to be
adapting their attitudes to set, Raphaelesque patterns. How
this development within Mannerism is related to the art of
Michelangelo can be studied, for example, in an illustration to the idyll of *Vertumnus and Pomona* (*Ill. 112*) designed by Perino for a set of engravings of the *Loves of the
Gods*: the figure of Pomona in this intricate fantasy of
arms and legs is derived directly from the *Lybian Sibyl* on
the Sistine Chapel ceiling (*Ill. 113*).

It would be surprising if such elegance had not pleased, for Mannerism sets out to please. This is an art for the fastidious, and it avoids too close a contact with reality, on the grounds that reality contains imperfections. Far from expressing the torment of the soul, it seeks to conceal all anguish beneath an outward semblance of the motions of human life; and instead of exploring the intensity of human passion it freezes desire itself within the chaste outline and the statuesque form.

The impact of Perino's cartoon upon Sarto's pupil Jacopo Pontormo is evident from his own version of this subject in the Pitti Palace. Pontormo's most important early commission was for a series of scenes of the Passion in the Certosa di Galluzzo, outside Florence, which were painted between 1522 and 1525. The iconography of the frescoes, which are in a sadly damaged condition, derives in great measure from woodcuts by Dürer, but such borrowings do not disguise the originality of these heartfelt meditations upon the tragedy of the Cross. The Certosa

135. SEBASTIANO DEL PIOMBO
(c. 1485–1547). *Raising of Lazarus, 1517–19. Oil on canvas 149⁵/₈ × 87³/₄ (380 × 223). National Gallery, London*

167

136. AGNOLO BRONZINO
(1503–72). *Eleonora of Toledo and
her son Don Giovanni, 1545–6.*
Oil on wood 44×37 (111×94).
Uffizi, Florence

cycle stands rather apart from the new tendencies in Flo-
rentine painting, and it offers the greatest possible contrast
to Pontormo's later work, such as the astonishing *Depo-
sition* at Santa Felicita (*Ill. 132*), painted *c.* 1525. This is
Pontormo's masterpiece, the supreme monument to Flo-
rentine Mannerism among religious works of the period.
The figure of Christ is derived from Michelangelo's Rome
Pietà (*Ill. 106*), while other elements are inspired by the
same *Meleager* sarcophagus that Raphael had used in
designing his Borghese *Entombment*. Pontormo's compo-

sition is a strange one: the figures are strung out across the picture-space in a manner that takes more account of the intricacies of their formal relationships than of the plausibility of such a grouping. No less strange are the acid tonalities and eerie colours (exaggerated, it has been suggested, in a drastic early restoration), ranging from orange-red, deep yellow and a curious, chalky pink to strident greens and pallid blues. The figures have no weight, and the fair young disciple who supports Christ's body upon his shoulders, so far from conveying an impression of exertion, adopts a languorous posture of reverie.

The *Visitation* in the Badia at Carmignano is painted in a similar style and is stamped with the same originality. It would be interesting to know very much more about the reception of such works at the time that they were painted, for the artist's vision is so far removed from the normal that his interpretations of sacred legend take on a strange, almost hallucinatory quality. In Pontormo's case, it is difficult to suppose that the highly nervous character of his art does not reflect his own neurotic temperament, of which we have the evidence of the morbid, hypochondriacal diaries which he kept in his later years.

Pontormo's friend Giovanni Battista Rosso, known as Rosso Fiorentino, was also a product of the Sarto circle. In 1523 he left for Rome, where he both witnessed and suffered some of the horrors of the Sack. Thereafter he worked in various parts of Italy, visiting Perugia, Arezzo and Venice, before finally settling at the court of François I at Fontainebleau: there, with Primaticcio and others, he decorated the royal palace, so playing an important part in the foundation of the Fontainebleau School.

In his early years Rosso, like Pontormo, worked beside Andrea del Sarto in the Annunziata, contributing in 1517 an *Assumption of the Virgin* which reflects the influence both of Sarto and of Fra Bartolommeo. Even in this early work, however, there are traces of that tendency towards exaggeration and a somewhat forced heightening of the dramatic element which characterizes the stupendous *Deposition* executed in 1521 for Volterra Cathedral (*Ill. 133*). This extraordinary work, which combines motifs derived from Michelangelo and Pontormo with a quite

137. MICHELANGELO (1475–
1564). *Pietà, begun 1547. Marble
h. 89 (226). Cathedral, Florence*

surprising degree of simplification, exceeds any Florentine
painting of its time in the passionate expression of violent
emotion, which is conveyed as much by the painter's
employment of blazing contrasts of colour as by the stark
simplicity of the design. The very nakedness of the com-
position is moving, indeed overpowering; and so bare is
it of detail that attention is concentrated upon basic thrusts
and tensions of an almost abstract nature, with the conse-
quence that the most significant gestures – such as that of
the Magdalen, whose outflung left arm runs parallel to the
horizontal steps of the ladders brought to the Cross –
possess an elemental character, an armature-like strength
that conveys an impression of raw feeling laid bare.

 Such a work possesses little of the quality of *maniera* in
Vasari's sense; but hereafter a change takes place in Ros-
so's style: its effects are immediately apparent in the *Dead
Christ with Angels* (*Ill. 138*), which dates from Rosso's
Roman period. Nothing is left now of the strident, dra-
matic qualities that were present in the Volterra *Deposi-*

138. GIOVANNI BATTISTA ROSSO (1494–1540). *Dead Christ with Angels, c. 1524–7. Oil on wood 52¹/₂ × 41 (133 × 109). Courtesy Museum of Fine Arts, Boston, Mass., Charles P. Kling Fund*

tion; instead, the picture is notable for a suave elegance, especially in the figure of the nude Christ – which has been aptly likened to an Adonis, – and, although the influence of Michelangelo is more potent than ever, Rosso here sought not so much to imitate his style as to refine upon it. During the same period, Rosso made a considerable number of designs for engravings that exhibit a playful and capricious wit at times bordering upon mockery.

Outside Florence, the Sienese Domenico di Pace, called Beccafumi, and the Parmese Francesco Mazzola, known from his birthplace as Parmigianino, developed their own versions of the Mannerist style after decisive visits to Rome. In Beccafumi's case, this Roman experience came very early on, between the years 1510 and 1512. In the works which he painted shortly after his return in the latter year to Siena the Mannerist tendencies in his style are already well advanced. Beccafumi's mastery of brilliant colour descends from the old Sienese tradition, and like the Sienese painters of the 14th and 15th

centuries he is less intellectual than his Florentine con-temporaries. In his major works, such as the *Fall of the Rebel Angels* and the *Christ in Limbo*, both in the Siena Pinacoteca and both painted in the 1530s, he reveals his debt to Michelangelo; yet there is an intense and concen-trated emotionalism in such compositions that is entirely his own.

Parmigianino was in Rome between 1524 and 1527, the year of the Sack, and his enormous *Vision of St Jerome*, in the National Gallery in London, which dates from the end of his Roman period, shows how he absorbed into his own style elements borrowed from Raphael, Giulio Romano, Sebastiano del Piombo and his own country-man Correggio. In these days of his brilliant youth he impressed his contemporaries, much as Raphael had done before him, by his handsome presence, his elegant manners and his seemingly limitless gifts, and it was said of him that 'when Raphael died his soul passed into Francesco's body'.

On his return to Parma, he received a commission to decorate the church of Santa Maria della Steccata, but there were disagreements between the artist and his pa-trons, and the work was completed by others. During this unfortunate episode, which dragged on for some ten years, Parmigianino had even been confined to prison for breach of contract. Fleeing from Parma on his release in 1540, he took refuge in Castelmaggiore, where he died a few months later – at the same age as Raphael. In his last years, it seems, his whole personality underwent a curious altera-tion: he began to devote himself to alchemy, and, as Va-sari tells us, he 'changed from the delicate, amiable and elegant person that he was, to a bearded, long-haired and neglected and almost savage or wild man'.

Something of the strangeness of Parmigianino's char-acter as it developed in his later years is no doubt fore-shadowed in a circular self-portrait at Siena, painted with the use of a convex mirror which distorts the features and gives eccentric prominence to the 'close-up' of the hand. There is something disturbing also in the extremes to which he carried the Mannerist tendency towards elonga-tion of the human figure: a famous example is the *Ma-donna del collo lungo*, or *Madonna with the Long Neck* (*Ill. 130*).

The second, and culminating, phase of Mannerist painting in Florence centres upon the work of Pontormo's pupil and assistant Agnolo Bronzino and upon that of Giorgio Vasari and Francesco Salviati. Of the three, Bronzino was the most gifted, and he excelled especially as a portrait-painter. In his early years he had assisted Pontormo in the Certosa and at Santa Felicita, and in 1546 he had made the usual visit to Rome, where he stayed for two years. For most of his life, however, he remained in Florence, where he enjoyed the position of court-painter to Duke Cosimo I de' Medici.

In his major works, such as the panel of the *Resurrection* (of about 1552) at Santissima Annunziata, or in the grandiose fresco of the *Martyrdom of St Lawrence*, of the late 1560s, Bronzino reveals himself as a conscientious disciple of Michelangelo, and his variations upon *contrapposto* and the *figura serpentinata* seem endless. The icy purity of his style is well represented by the *Venus disarming Cupid* (now in the National Gallery in London), which was sent by Duke Cosimo as a present to the French king. But his most memorable works are his portraits, most of which are of members of the court of the tyrannical Medici Duke. His half-length of Cosimo in the Uffizi was modelled upon Michelangelo's statue of Giuliano de' Medici at San Lorenzo; and there is a certain quality of *terribilità* in this commanding figure, whose unbending mien is no less cold than the light that glints from his armour. The double-portrait of Cosimo's wife Eleonora of Toledo and her son Don Giovanni (*Ill. 136*) is even more typical of the calculating realism of Bronzino's portraiture. It has been well said that he approached his sitters' features as though they were a still life, and it was in the same spirit that he represented, with meticulous care, the labyrinthine patterns on the Duchess's velvet dress. No other portrait-painter ever approached his subject with greater detachment, or ever gave his sitters an aspect of such frigid *hauteur*.

It was as a portrait-painter that the young Vasari first established his reputation in Florence, when he was commissioned to paint the official portrait, now in the Uffizi, of Duke Cosimo's predecessor Alessandro de' Medici. Vasari's ambitions as a painter resound from his grandiose

frescoes in the Palazzo Vecchio, representing scenes from the history of Florence, in the execution of which he was assisted by Salviati, and from his rather empty decorations in the dome of Florence Cathedral. His activity as an architect was more important: it was he who began the building of the Uffizi, originally Grand Ducal offices. Vasari occupies a still more notable place in the history of the arts in Italy as the author of the celebrated *Lives of the Painters, Sculptors and Architects*, first published in 1550, and expanded eighteen years later. He was also the founder of the first academy of art, the Accademia del Disegno, which was set up in Florence in 1561 under the patronage of the Grand Duke. Vasari had already established himself as virtually the art dictator of Florence: unfortunately the effect was to stifle individual opportunity and expression almost as surely as, in a political sense, they were suppressed by the authoritarian regime of the Medici Court. The crystallization into a fixed canon of the principles that had been deduced from the art of Raphael and Michelangelo lent itself to a doctrinaire academicism of style, such as we find in Vasari's own paintings.

It was in these repressive circumstances that the great age of Florentine Mannerism burnt itself out; not, however, without a blaze of glory, for in Vasari's friend Francesco Salviati it produced its last major artist. Although he received his training under Andrea del Sarto, Salviati's style was chiefly formed in Rome, which he first visited with Vasari in the year 1531. His fresco of the *Visitation* at San Giovanni Decollato (1538) demonstrates his study of Raphael's Stanze and Tapestry Cartoons, while the impact of Michelangelo is evident in his figure-style. From the year 1539 he travelled widely, working in Venice, Bologna and his native Florence; in 1554 he was employed briefly at the French Court. His most important works are frescoes in the Farnese Palace in Rome, painted after his return in 1555. The sheer virtuosity of these decorations surpasses that of Parmigianino himself, and in their combination of extravagant ornamentation and bold illusionism they represent an ultimate declaration of the Mannerist ideal. It is fitting that this masterpiece of Florentine Mannerism should have been executed in Rome, the birthplace of the style.

The late work of Michelangelo in Florence and Rome

After the death of Julius II in 1513, the della Rovere family made serious efforts to have the Pope's tomb completed, even if it had to be on a reduced scale. Under the terms of the second contract, drawn up in 1513, the original conception of a free-standing mausoleum was abandoned in favour of a wall tomb: the scheme took on a more traditional religious character, underlined by the introduction of a Madonna and four figures of saints. The statues were to be fewer, but larger. Still more changes were made before the final completion of the tomb in 1545, when it was set up not in St Peter's (as originally planned) but in San Pietro in Vincoli. In the final monument the statue of *Moses* – originally intended as a subsidiary figure – occupies the central niche between the two supporting figures of *Rachel* and *Leah,* and the figures in the upper register were executed by other hands. Such an impoverishment of his original design makes it easy to understand Michelangelo's bitterness over the long-drawn-out 'tragedy of the Tomb' – and in all likelihood it was Michelangelo himself who first used the expression that Condivi immortalized.

The project for the Julius Tomb had occupied Michelangelo, off and on, for forty years. During this period he had received four other major commissions – for the decoration of the Sistine Chapel ceiling, for the construction of the Medici Chapel in San Lorenzo in Florence with its funerary monument to the Medici Dukes, for the building of the Laurentian Library, and for the fresco of the *Last Judgment* in the Sistine Chapel.

The Medici Chapel, although itself incomplete, remains as Michelangelo's supreme achievement in the

175

union of architecture and sculpture in the service of a lofty spiritual idea. San Lorenzo was the church of the Medici, and it was there that successive generations of the family had been buried. Now, in 1520, Michelangelo was put in charge of the building of a special funerary chapel and of the erection of imposing sepulchres, which originally were to have been four in number – a pair of tombs for the two *Magnifici,* Lorenzo and Giuliano de' Medici, and another pair for the two *Capitani*, Giuliano, Duke of Nemours, and Lorenzo, Duke of Urbino. Eventually, Michelangelo's ideas crystallized into a gigantic conception, according to which the tombs of the *Capitani* would each occupy one of the side walls, with a double-tomb for the *Magnifici* on the wall opposite the altar. Michelangelo's design comprehended the three arts of which he was the master: this union of architecture and sculpture was to have been completed by frescoes, including a *Resurrection* in the lunette over the altar, for which some preparatory drawings by Michelangelo survive. But the plan was successively changed: the frescoes were given up; and the tombs of the *Magnifici* were likewise abandoned, so that only the statues of the *Madonna and Child* and the patron saints of the Medici, *St Cosmas* and *St Damian* (the last two executed by pupils), were eventually placed in the position of honour opposite the altar.

The Chapel itself (*Ill. 43*) was designed to complement, on the north side of the church, Brunelleschi's Old Sacristy (*Ill. 42*) off the south transept, but Michelangelo's conception replaces Brunelleschi's static harmonies with an expression of dynamic movement, so that the eye is led from the lower zones into the freer spaces of the lunettes above, and thence into the coffered dome (an adaptation of the cupola of the Pantheon). As in the Old Sacristy, the cool dark-grey limestone (*pietra serena*) of the principal structural elements harmonizes with the broad expanses of white plaster on the walls; but the effect of colour is more intense and more varied, owing to the contrast produced by the elaborate marble decoration in the lowest register, culminating in the muted tonalities of the sculptures themselves. The altar faces inwards, so that the Chapel becomes, as it were, a vast altarpiece constructed in three dimensions around the central statue of the *Ma-*

donna and Child. It is a work profoundly imbued with
Christian sentiment.

The tombs on the side walls are dominated by idealized statues of the deceased *Capitani*. Beneath the statues, on sarcophagi, Michelangelo placed symbolic figures representing the four Times of the Day, while in the niches on either side of the two *Capitani* – now disturbingly empty – he may have intended to have allegorical figures of Heaven and Earth. The scheme would have been completed by river gods, representing the Arno and the Tiber, on the floor below the sarcophagi.

The two Dukes are given contrasting attitudes: Giuliano is shown as the man of action (although he was far from being that), accompanied by the figures of *Night* and *Day*; Lorenzo becomes a type of the *penseroso*, or melancholy man, associated with *Dawn* and *Dusk*. By an elaborate conceit, by a truly monumental indulgence of the pathetic fallacy, Michelangelo seems to be showing Nature in mourning for the departed Captains; thus Vasari describes *Dawn* as 'lamenting her continued beauty in token of her great sorrow' at Lorenzo's death, and *Night* as revealing 'the grief and melancholy of one who has lost a great and honoured possession' by the death of Giuliano. This effect is if anything enhanced by the fact that the Times of the Day were never completely finished: the rough-hewn character of certain passages adds to the impression that these are figures that have been turned to stone.

The figures of the *Capitani*, attired in classical armour, must have been inspired by Roman portrait-statues, and the influence of the antique upon the Times of the Day is no less evident. The attitude of *Night* derives from that of an ancient *Leda*; the figure of *Evening* betrays memories of the *Tiber* statue in Rome; and the mighty back of *Day* provides a further example of the endless inspiration that Michelangelo found in the *Belvedere Torso*. Yet there can be no denying the presence – if not in the figures themselves, at least in their relationship with the architectural framework – of an 'anti-classical' quality which can be associated with an impulse in Michelangelo's style towards Mannerism: there is certainly an expressive disturbance in the design of the Medici Tombs that is alien to the spirit

of classical art, and the licence of Michelangelo's treatment of architectural detail is itself extraordinary. The very tilt of the bases that support the recumbent figures of the Times of the Day might give the impression that these figures were about to slip from their sarcophagi, were it not that the dynamic tensions within their massive forms pull them inwards toward the centre. There is an additional con, flict of opposing forces, for, especially in the statues of *Day* and *Dawn*, the dominant turning and rising movement is counteracted by the sheer weight of the architectural forms in the background, which seem to press down upon the figures.

While he was still working on the Chapel, in 1524, the Medici commissioned Michelangelo to build a library off the cloister of San Lorenzo. The Laurentian Library, with its strange ante-room and stairway – whose spreading downward course has been likened to the flow of lava – carries still further the highly individual treatment of ar, chitecture which is noticeable in the Medici Chapel, and creates the impression of an almost wilful denial of accepted principles. In the ante-room the expected function of a given architectural detail is almost everywhere contra, dicted; normal proportions are upset; the illusion is given throughout of agitated movement. In this licence, this 'Mannerism', there lies a paradox: such innovations de, pend for their appreciation, which involves an element of surprise, upon a knowledge of the very principles which they deny.

Michelangelo's work on the Chapel and Library was interrupted by the alarming political events that began in 1527 with the Sack of Rome by the leaderless armies of the Emperor Charles V, a catastrophe which brought in its train the overthrow of the Medici and the institution of a Republic in Florence. Michelangelo served the Repub, lic, with whose aims he sympathized, in its struggle against his patrons the Medici; indeed he was given the task of strengthening the city's fortifications against their return. When in 1530 Florence surrendered to the papal forces, and Alessandro de' Medici resumed his tyrannical rule, Michelangelo's situation was a difficult one. Although he was encouraged to complete his work in the Medici Chapel, a combination of anxiety, ill-health and over,

work led to one delay after another, and he began to make protracted visits to Rome, returning only briefly to Florence.

In 1534 he finally settled in Rome, and he was never to set eyes again upon his native city. In the same year Clement VII died, to be succeeded by the Farnese Pope, Paul III (see *Ill. 147*). Not long afterwards Michelangelo received from the new Pope the commission for the fresco of the *Last Judgment* in the Sistine Chapel (*Ill. 108*).

A few years earlier, the altar wall of the Sistine Chapel had suffered damage from fire, and the entrance wall was also in disrepair. According to the original terms of the commission, Michelangelo was to have painted a representation of the Resurrection of Christ on the altar wall, to take the place of Perugino's *Assumption of the Virgin*, and on the entrance wall a fresco of the *Fall of the Rebel Angels*. In the end the plans for the fresco on the entrance wall were abandoned, and the *Resurrection of Christ* on the altar wall became a *Resurrection of the Dead*, or *Last Judgment*: moreover, the fresco was now to occupy the whole of the wall, necessitating the blocking-in of the windows and the destruction of all the earlier frescoes behind the altar.

Conceived as it was during the aftermath of the Sack of Rome, Michelangelo's fresco reflects – more powerfully than any other work of the period – the wounds inflicted by that overwhelming catastrophe upon the heart of Christendom. The Sack brought about not only the humiliation of Italy at the hands of a foreign power, but also the desecration of the Holy City of St Peter, a blasphemy against Christ uttered before the very seat of papal authority. The Sack was interpreted as a divine judgment upon the Church, and on the unveiling of Michelangelo's fresco the Pope prostrated himself before it in penitence. The fresco was intended not merely as a reminder of a greater judgment to come, but also as a reassertion of the spiritual power of the Church, which alone could save.

Yet Michelangelo's gigantic figures – the saved and the damned alike – express a profound spiritual unease, a deep pessimism that cannot be paralleled in previous representations of the subject. Michelangelo made radical modifications of the iconographic tradition: Christ the Judge is

no longer enthroned among his Apostles in a placid heaven, clearly distinguished from the regions of Earth, where the resurrected bodies of men and women ascend, some to be received into eternal light, others to be hurled by demons into the lurid flames of Hell: instead, amid a surging welter of nude figures, whose every gesture expresses an awareness of irrevocable doom, the gigantic Christ raises his right hand in a gesture that brings to mind some ancient representation of Jupiter about to hurl his thunderbolt. St John and St Peter plead for the execution of justice, while at the side of Christ the Virgin shrinks away from the awful scene. Above, the angels carry before men's eyes the Instruments of the Passion, reflecting in their own anguish the horror of Golgotha; below, the Blessed struggle upwards, not with the certainty of salvation set forth in earlier representations, but with apparent fear that they may yet fall, with the Damned, into everlasting darkness. On the right, the lost souls fall headlong in a writhing mass, dragged down by devils; never was their agony given more terrifying expression. In the lower right-hand corner of the composition, the infernal boatman – the Charon of classical myth – ferries the lost souls across the waters of another Acheron. Just as the scenes on the ceiling are visualized as lying beyond the fictive architectural framework, so here the impression is created that the Chapel opens up beyond the altar into the azure depths of heaven, to disclose the scene of Judgment. The effect of a sudden revelation is greater than on the ceiling, and the violence with which this vast spectacle is thrust before the beholder anticipates the method of the Baroque decorators.

Despite the change of style, Michelangelo was evidently concerned to relate his vast composition to the earlier scenes in the Chapel, including those on the side walls. The zones of Earth and Hell in the *Last Judgment*, for example, lie below the level of the *Moses* and *Christ* cycles. Similarly, the upper border of the Quattrocento frescoes coincides with the main horizontal division on the east wall – a division which, though not absolute as in traditional representations, separates the heavenly sphere from a middle zone where the dead rise heavenwards or fall sheer to destruction. Finally, in the curved spaces at the

top, formed by the pendentives, Michelangelo depicted the Instruments of the Passion: thus the adjacent scenes of *Esther and Haman* and the *Brazen Serpent* are made explicit as prefigurements of the Crucifixion.

Modern criticism, with its extreme sensitivity to style, has tended to draw an absolute contrast between the *Last Judgment* and the ceiling frescoes, seeing only disharmony and discord, as though Michelangelo had wilfully refused to take account of the final effect of what must have seemed to him to be the completion of his earlier work in the Chapel, or had strangely miscalculated. Whatever discord there may be is a matter purely of style, not of calculation or design, and it is worth remembering that the ceiling itself shows a stylistic progression producing, although within narrower limits, a not much less noticeable dissonance. Such stylistic changes are inevitable in the work of an artist of Michelangelo's originality, and in the *Last Judgment* he expressed himself with all the vehemence and freedom that characterize his last works as a sculptor.

Michelangelo's fresco was too original a conception to please everybody at the time, and on its unveiling in October 1541 it was the subject of much argument and criticism. Aretino was not alone in accusing Michelangelo of impropriety for having represented the saints in the nude: similar criticisms were made by dignitaries of the Church, and that this should have been so is a measure of the changed climate of thought that accompanied the Counter-Reformation. One of Michelangelo's pupils, Daniele da Volterra, was later given the task of adding draperies to some of the figures.

Shortly after the completion of the *Last Judgment*, Michelangelo began work on the two frescoes of the *Conversion of St Paul (Ill. 140)* and the *Crucifixion of St Peter* which had been commissioned from him for the Cappella Paolina, Pope Paul III's private chapel. Michelangelo commenced his new task unwillingly, and he worked slowly: the *Conversion of St Paul*, begun in 1542, took him nearly three years to complete, and the *Crucifixion of St Peter*, begun in 1546, nearly four years. Michelangelo was now a very old man, and when he laid down his brush on the completion of what were to be his last paintings, he was already in his seventy-fifth year.

The Cappella Paolina frescoes have been less studied than most of Michelangelo's works, and yet they contain, in terms of painting, many of the admired qualities of his last sculptures. The style, however, is severe, even hard, and the mood pessimistic and agonized. Raphael, in his tapestry of the *Conversion of St Paul* (Vatican), had rep-resented the Saint as a graceful young man transfigured by the radiance emanating from the visionary form of Christ. In Michelangelo's fresco, on the other hand, there is no such searching after exterior beauty: the Apostle is a venerable old man in whom, perhaps, Michelangelo saw himself, and he is presented as one whose spiritual darkness has been suddenly illumined by the light of revelation. He has been thrown sideways from his horse by a centrifugal movement that scatters his companions to right and left. The foreground forms seem to radiate

139. TINTORETTO (1518–94).
Presentation of the Virgin, 1551–2.
Oil on canvas 168⁷/₈ × 189
(429 × 480). Santa Maria dell'Orto,
Venice

from a central point of energy, this explosive mass of figures being placed in a dynamic relationship to the heavenly hosts that circle around the figure of Christ. The composition has been described as formless, but in fact it is based upon a carefully calculated geometry. What is important about the design is that it represents a new attempt to express movement in space: it contains even more powerful intimations of the Baroque than the *Last Judgment* itself, and there are passages that could be transposed to Tintoretto's great *Crucifixion* at San Rocco (*Ill. 171*) without any sense of discord.

The same tragic tone pervades the *Crucifixion of St Peter*: here there is no light from heaven, no beatific vision

140. MICHELANGELO (1475–1564). *Conversion of St Paul, 1542-5. Fresco. Cappella Paolina, Vatican*

to console the aged and infirm Apostle, awkwardly slung, head downwards, upon his cross. Nor does St Peter welcome his martyrdom with that preternatural joy which earlier painters would have been careful to show upon his countenance: instead, he stares out grimly towards the spectator, as though to remind him what it means to bear one's cross in the world and to persevere to the end through all the bitterness of life. Around the martyr there is gathered a sad assembly of men and women, some of them expressing horror as they commune among themselves, others isolated and wrapped in melancholy meditation. These grave representatives of humanity convey a sense of ineluctable oppression, of a weariness of the flesh into which it is difficult not to read some autobiographical significance.

It is known that in these years Michelangelo was in sympathy with a reforming party within the Church, led by Juan de Valdès and Fra Bernardino Occhino, which accepted the Lutheran doctrine of justification by faith rather than by deeds. This doctrine, which derives ultimately from St Augustine, has always encouraged a sombre view of human life and a profound sense of resignation, since faith itself is conceived as a gift from God, and no man can do anything of his own accord to ensure his salvation. There can be little doubt that both the *Last Judgment* in the Sistine Chapel and the frescoes in the Cappella Paolina reflect Michelangelo's meditations upon these fundamental questions. His sonnets themselves witness to the intensity of his religious faith in his last years; and the words uttered by Pope Paul III before the *Last Judgment*, 'Lord, charge me not with my sins when Thou shalt come on the Day of Judgment', could well have been on Michelangelo's own lips.

Before he died, Michelangelo embodied his deep religious longings in the great *Pietà* groups that crown his work as a sculptor. The complex *Pietà* in Florence Cathedral (*Ill. 137*), begun in 1547, was intended for his own tomb; we know from Vasari that Michelangelo gave his own features to the brooding Joseph of Arimathea. The group was never completed, for Michelangelo, frustrated by an imperfection in the marble block, broke it up in a fit of despair. An assistant pieced it together again, and

finished the somewhat lifeless figure of the Magdalen. The later Rondanini *Pietà* in the Castello Sforzesco at Milan seems to have been begun about 1552 and temporarily abandoned; but Michelangelo was observed by a pupil to be working on it only six days before his death. It is the very simplicity of this work that is so moving: the Virgin now supports the Crucified in a standing posture, and as she embraces him – it is the merest, most tender touch – the two figures of Mother and Son become virtually one form, one symbol of infinite pathos.

During the last thirty years of his life in Rome, Michelangelo received a number of outstanding architectural commissions, of which the first, begun in 1539, was for the remodelling of the Capitoline Hill. A worthy setting was to be given to the seat of Roman government, which had been overshadowed by the dominance of the Vatican; and it was Michelangelo's principal task to add imposing façades to the two palaces which already existed – the Palazzo del Senatore, on the east side of the piazza, and the Palazzo dei Conservatori, on the south side. In the latter, he introduced the highly influential combination of the 'giant order', where massive columns are used to link two storeys, with a smaller subsidiary order on the ground floor. In addition, Michelangelo designed a third palace, the 'Palazzo Nuovo', to close off the north side of the piazza, and a monumental staircase to provide the main ascent to the Capitoline Hill.

The old palaces had been built at a slightly acute angle to each other, so that the piazza widens out as one approaches from the stairway. For the piazza itself Michelangelo designed a splendid pavement, and at the centre of it he set up the Roman equestrian statue of Marcus Aurelius; other antique statues, including the famous *Dioscuri*, or *HorseTamers*, were incorporated elsewhere in the scheme. While Michelangelo's conception was never realized in all its purity, the impression that one receives on ascending into the piazza is still overwhelming: once again, one becomes aware of the sculptural function of Michelangelo's architecture and of his unique conception of the architectonic value of space itself.

His other commissions in Rome included the completion of the Palazzo Farnese, begun by Antonio da San

gallo and transferred to Michelangelo in 1546, and the erection, in honour of Pius IV, of the city gate known as the Porta Pia, finished a year after his death. But by far the most important of all his architectural works was one that, like the Palazzo Farnese, came to him on the death of Sangallo – St Peter's.

After the death of Julius II in 1513, and of Bramante in the following year, a reaction had set in against Bra-mante's centralized plan for St Peter's in favour of a basil-ican plan based on a Latin Cross and containing, there-fore, a long nave. When Michelangelo was put in charge of the completion of the church, he reverted to Bramante's conception. But he simplified and strengthened Braman-te's design, eliminating some of the subsidiary divisions in the interior, thickening the walls and supporting the dome upon four much more massive piers placed at the centre of a vast ambulatory. The projections produced alternat-ely by the three apses and four corners give variety and movement to the exterior: the effect is intensely sculp-tural, and it was evidently Michelangelo's purpose to oppose the ebb and flow of movement in the main fabric of the building to the still splendour of the great dome, whose colonnaded drum is harmonized with the giant order of Corinthian pilasters beneath. After his death, however, the fundamental idea that he had taken over from Bramante – the centralized plan – was to be adulterat-ed by the addition of the present nave extension and elabo-rate façade, with the consequence that when St Peter's is approached from the piazza Michelangelo's work is largely invisible, and the effect of the dome much diminished.

Michelangelo's architectural style has often been de-scribed as 'anti-classical'. Another way of putting it might be to say that he used the classical orders in an individual and creative manner, impelled as he always was to give expression to new concepts rather than being content to imitate.

Florentine sculpture after Michelangelo

Michelangelo had outlived Raphael by almost half a century, and he 'bestrode the age like a Colossus'. Among his most important followers, Bartolommeo Ammanati and Bernardo Buontalenti were both associated with Vasari. Buontalenti succeeded Vasari as the architect of the Uffizi, which he continued in a very similar style; and the extent to which Florentine architecture had departed, by the latter years of the 16th century, from Albertian classicism can be gauged from a comparison between the façade designed by Alberti for Santa Maria Novella and Buontalenti's disturbing façade for Santa Trinita, of 1593.

Ammanati had worked with Vasari on the Villa Giulia, commissioned by Julius III and executed by several architects, and it was he who built the lovely Santa Trinita Bridge over the Arno, for which Michelangelo possibly supplied the design. Between the years 1558 and 1570 he was engaged in additions to the Pitti Palace in Florence, adding the garden façade and two heavily rusticated wings, but he is better known as the sculptor of the *Neptune Fountain* in the Piazza della Signoria – a work that in his old age he wished to destroy, fearing that the nude figures might become a temptation to sin.

There was one Florentine sculptor who dared to consider himself a rival to Michelangelo: this was the envious Baccio Bandinelli, whose gigantic *Hercules and Cacus* in the Piazza della Signoria, completed in 1534, was carved from a block of marble originally reserved for a *Hercules and Cacus* commissioned from Michelangelo. Bandinelli was admired by Alessandro de' Medici, and was the exponent of a somewhat academic classicism; but in the *Pietà* which he carved in 1559 for his own tomb at Santissima Annunziata in Florence he demonstrated an imaginative

141. BENVENUTO CELLINI
(1500–71). *Perseus, 1545–54.*
*Bronze h. 126 (320). Loggia dei
Lanzi, Florence*

power which few of his other works hint at: the figure of
Christ possesses a stark pathos that makes this one of the
most memorable of all sepulchral monuments of the period.

The great Benvenuto Cellini, whose celebrated *Mem-
oirs* paint so vivid a picture of his times and of his own
tempestuous character, began as a medallist and gold-
smith, working in Rome, Florence and France before
settling in Florence in 1545. At the Court of François I
he established his reputation with his famous *Saltcellar*
(now in the Kunsthistorisches Museum at Vienna). His
return to Florence gave Bandinelli a new rival to think
about, for Cellini achieved immediate renown with his
figure of *Perseus* (*Ill. 141*), commissioned in 1545 by Co-
simo I to form a pair with Donatello's *Judith and Holofernes*.
Not only did Cellini exploit, in the *Perseus*, his gifts as a
craftsman in an unprecedented elaboration of intricate
detail, but there are few works of the period that are
stamped with such vitality.

The works commissioned for the Piazza della Signoria
from such artists as Cellini, Bandinelli and Ammanati
reflect the desire of the Florentine authorities to make this
central point of civic life still more imposing. We must
also take account in this period of that growing taste for
the decorative and the artificial which encouraged the cre-
ation both of the ornamental fountain and of the sculp-
ture-garden: some outstanding examples are Ammanati's
Neptune Fountain, Niccolò Tribolo's *Fountain of Hercules*
in the gardens at Castello, which anticipates Bernini,
Giovanni Bologna's *Fountain of Venus* in the Boboli Gar-
dens behind the Pitti Palace in Florence, Buontalenti's
Grotto, also in the Boboli Gardens, and the elaborate
garden which he designed for the Grand Duke Francesco
de' Medici's villa at Pratolino (outside Florence), and
Giovanni Bologna's *Neptune Fountain* at Bologna.

Giovanni Bologna (or Giambologna) had been born
in Flanders; he received his training first in the Low Coun-
tries and then in Rome, before being persuaded to make
his home in Florence. Between the death of Michelangelo
and the appearance of Bernini, he became the leading
sculptor in Italy, and he was to exert a powerful influence
on the development of the Baroque style. He was even
considered by some of his contemporaries to be Michel-

angelo's equal, and it was he who was given the commission in 1565 for a companion-group to the *Victory* in the Palazzo Vecchio. The subject chosen was *Florence triumphant over Pisa*. In this work Giovanni Bologna achieved an unprecedented complexity of movement – an aspect of his art that appears to have made an overwhelming impression upon his contemporaries, and one that is given still more dramatic expression in the marble *Rape of the Sabines* (Ill. 142), completed in 1582.

The *Rape of the Sabines* seems to have been directly inspired by the *Farnese Bull*, that dramatic masterpiece of Hellenistic sculpture which had lately been discovered in Rome, but in the rhythm and grace and even in the natural energy of its forms it surpasses its model. Giovanni Bologna's interest in antiquity is reflected no less in his statue of *Cosimo I de' Medici* in the Piazza della Signoria, which must have been partly inspired by the *Marcus Aurelius* newly set up by Michelangelo on the Capitoline Hill. In the subtlety of its portraiture the statue scarcely loses by a comparison with Donatello's *Gattamelata*: it may certainly be described as the supreme equestrian monument of Florence. Of his smaller bronzes, the delicately poised *Mercury* in the Bargello in Florence represents the quintessence of Mannerist elegance. With Giovanni Bologna the long history of sculptural achievement in Renaissance Florence, which began with Ghiberti and Donatello, comes to a close.

142. GIOVANNI BOLOGNA (1529–1608). *Rape of the Sabines, 1582. Marble h. 161³/₈ (410). Loggia dei Lanzi, Florence*

Giorgione, Titian and the origins of the High Renaissance

The achievement of Giovanni Bellini stops short at the threshold of the new age: with his pupils Giorgione and Titian, we enter the spacious mansions of the Venetian High Renaissance. While deeply indebted to Bellini, Giorgione possessed such originality that it was upon his style, more than on that of his master, that Titian was to found his own. So closely, indeed, does the early work of Titian resemble that of Giorgione that definite attributions are often extremely difficult, and the problem is complicated by the fact that a number of the pictures left unfinished by Giorgione at his death were worked over and completed by Titian: one example is the Dresden *Venus* (*Ill. 145*), Titian being responsible for the landscape in the background. The relationship of the two painters is, in many ways, comparable with that between Girtin and Turner – the one dying young after showing brilliant promise, the other maturing steadily during the course of a long life and exhibiting in old age a momentous renewal of his genius.

Little is known about Giorgione's life. He died in 1510, and, therefore, if Vasari was correct in saying that he was then in his thirty-fourth year, he must have been born in 1477. His birthplace was Castelfranco, in the hills north of Venice, and he spent his short working life entirely in Venice and its neighbourhood. He was a man of much charm and distinction of appearance, and – like Leonardo – a gifted musician. He is also known to have been a member of the humanist circle of Cardinal Pietro Bembo, the poet and historian.

Giorgione established his reputation with a series of decorations on the façade of the Fondaco dei Tedeschi in Venice (the Exchange of the German Merchants), a work

143. *(opposite)* GIORGIONE (1477?-1510). *Madonna enthroned with St Francis and St Liberale, c. 1504. Oil on wood $78^3/_4 \times 60$ (200 × 152). Cathedral of San Liberale, Castelfranco*

144. GIORGIONE (1477?–1510).
*Portrait of a Youth, before 1504. Oil
on canvas* 22⁷/₈ × 18¹/₈ (58 × 46).
Staatliche Museen Berlin-Dahlem

in which Titian also took part. Only pale fragments of these frescoes, which were completed by 1508, now survive, but the decoration is known to some extent from early engravings and contemporary descriptions, and it is clear that the scheme was an ambitious one which included a considerable number of nude figures, framed by illusionistically represented architecture.

There is every reason to accept Vasari's statement that Giorgione was profoundly influenced by Leonardo when the great Florentine master visited Venice in the year 1500. The small painting of *Christ carrying the Cross* at San Rocco, which derives from a design by Leonardo, itself provides proof of such influence. It seems clear that Giorgione adapted to his own poetic style the revolutionary *sfumato* of Leonardo and, more generally, his concern with tonal harmonies; and his interest in landscape may have been stimulated to an equal degree by Leonardo's visit.

Giorgione's feeling for light is already evident in the early *Madonna enthroned, with St Francis and St Liberale* (*Ill. 143*), painted about 1504 for the Cathedral of San Liberale at Castelfranco. There is much here of Bellini, but the mood is more lyrical than in any of Bellini's Madonnas, and a dreamy stillness reigns over the whole emblematic arrangement of divine and saintly figures. The *Tempest*, in the Accademia in Venice, is a more mysterious work, and its subject-matter has often been debated; as early as 1530, when it was in the collection of Gabriele Vendramin, an inventory describes it simply as 'A Village on canvas'. The most plausible solution to the problem is the recent suggestion that it is an allegory of *Caritas* (Charity) and *Fortezza* (Fortitude), symbolized respectively by the woman suckling her child and by the young man in the foreground. In his treatment of Nature in this picture, and especially of the gathering storm, Giorgione explored territory scarcely trodden before in European painting – what has been described as 'the landscape of mood'. Giorgione approached Nature with the eye of a pastoral poet, and his gentle but profound lyricism became the property of his many imitators. A similar poetic feeling is common to the portraits attributed to him, such as the *Youth* in Berlin (*Ill. 144*).

145. GIORGIONE (1477?–1510). *Venus. Oil on canvas 42¹/₂×68³/₈ (108×173.5). Gemäldegalerie, Dresden*

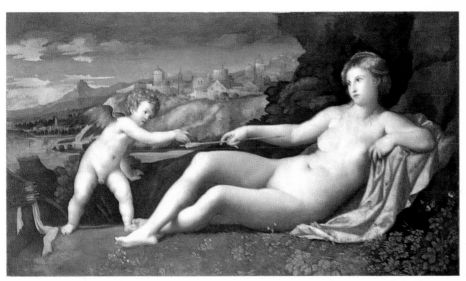

146. PALMA VECCHIO (1480–1528). *Venus and Cupid, 1520–25. Oil on canvas 46¹/₂×82¹/₄ (118×208). Reproduced by permission of the Syndics of the Fitzwilliam Museum, Cambridge*

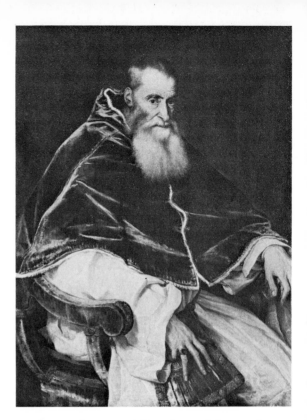

147. TITIAN (1487/90-1576).
*Pope Paul III, 1543. Oil on canvas
42 × 32 (107 × 81).
Museo di Capodimonte, Naples*

The Dresden *Venus* (*Ill. 145*) must belong to the very
end of Giorgione's career, and the fact that it was com-
pleted by Titian accounts for the difference between the
refined and delicate treatment of the figure of Venus,
which must be due entirely to Giorgione, and the broader
handling of the landscape. Titian not only reworked the
landscape, but also removed a Cupid from the right lower
corner. The composition was to become the model for
Titian's *Venus of Urbino* (in the Uffizi); but the chaste
sensuousness of Giorgione's *Venus* remains a world apart
from the more voluptuous ideal of Titian: Giorgione's
sleeping goddess raises the doubt whether we are not in-
truding upon her privacy; with Titian's Venus, we know
that we are meant to.

While most of the Venetian painters of the older gen-
eration, such as Vincenzo Catena, who shared a studio
with Giorgione in 1506, and Cima da Conegliano, whose
placid Madonnas are among the loveliest creations of the

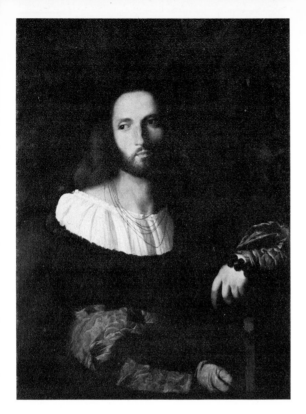

148. PALMA VECCHIO (1480–
1528). *Portrait of a Poet (Ariosto?),
1515–16. Oil on canvas (transferred
from wood) 33 × 25 (83 × 63).*
Courtesy the Trustees of the National
Gallery, London

Venetian Renaissance, remained faithful to the stylistic
principles of Giovanni Bellini, to the younger men the
beguiling manner of Giorgione was irresistible, and he had
numerous followers in Venice and the region. Even apart
from the minor figures, the list of those who were indebted
to him is a long one, including as it does the names of
Titian and Sebastiano del Piombo, from Venice; Palma
Vecchio, Giovanni Cariani and Lorenzo Lotto, from
Bergamo; Bonifazio de' Pitati, from Verona; Giovanni
Pordenone, from Friuli; Paris Bordone, from Treviso;
and the Brescians Girolamo Romanino, Giovanni Sa-
voldo and Alessandro Moretto.

On account of his probable influence upon Titian, a
brief word may be said here about Jacopo Palma, known
as Palma Vecchio. Palma settled in Venice at some time
prior to the year 1510, and he remained there until his
death in 1528. He was one of the creators of the High
Renaissance portrait in Venice, and he also responded

eagerly to the new taste for mythological subjects. His half-length female portraits and his Venuses tend to conform to the same voluptuous ideal of buxom, golden-haired femininity: a similar type was adopted by Titian, notably in such pictures as the *Flora* in the Uffizi and the *Sacred and Profane Love*. Palma lacked the vigour of Titian, and he was much less adventurous as a composer, but the gentle lyricism of his art has a unique flavour, and in his treatment of mythological subjects – of which the *Venus and Cupid* (*Ill. 146*) in the Fitzwilliam Museum in Cambridge is a splendid example – he created an ideal of opulent beauty which is borrowed neither from Titian nor from Giorgione, although, like Giorgione and the young Titian, he reflects in his art something of that longing for a world of indolence and innocent pleasure which is to be found in contemporary literature, notably in the *Arcadia* of Jacopo Sannazaro.

As a portrait-painter, Palma is well represented by his putative portrait of *Ariosto* (*Ill. 148*) in the National Gallery in London, which offers us not merely the likeness of an individual but also, in a more universal sense, the image of a poet: the soft light that slants across the pensive brow, throwing one half of the face into shade, helps to suggest the poet's reverie, not least through the contrasted treatment of the two eyes – the one half-hidden by shadow, the other active and receptive to the light. There is nothing here of Titian's power: rather are we reminded of the wistful 'romanticism' of the portraits attributable to Giorgione (*Ill. 144*), although the interpretation is entirely personal to Palma Vecchio.

In attempting to define Titian's debt to Giorgione, we think, perhaps, of Giorgione's rich orchestrations of colour; but his method of composing in broad tonal areas was also new. Even in his earliest known works – such as the *Gypsy Madonna* at Vienna – Titian carried this process a stage further, and by the time that he painted the Borghese *Sacred and Profane Love* he was able, by the use of contrasting tonal masses, to give his composition an unprecedented breadth and a new harmoniousness. Whereas a picture by Michelangelo is still, in essence, a coloured drawing, in the hands of Giorgione and Titian the art of painting assumes a new independence: the artist no longer

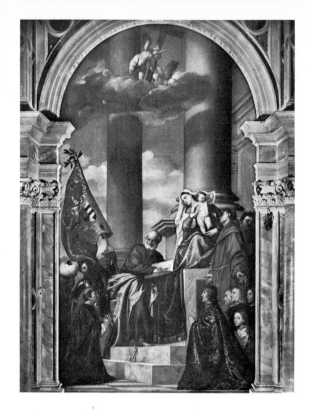

149. TITIAN (1487/90–1576).
*Madonna and Child with Saints and
Donor (Pesaro Madonna), 1519–26.
Oil on canvas 152 × 108 (488 × 274).
Santa Maria Gloriosa dei Frari, Venice*

applies his colours to an outline, but brings drawing into
the act of painting. The consequence is that drawing, as
such, no longer plays the dominant role, and an equal
emphasis is placed upon tonal and colouristic values.

Titian was, however, as great a draughtsman as Ra-
phael himself, and in many ways a more inventive one:
the figure of Bacchus in the *Bacchus and Ariadne* (*Ill. 152*)
in London is a miracle of drawing which in no sense
compares unfavourably with Raphael's *Galatea*, and if
we look at Titian's treatment of hands in such portraits
as the early *Man with the Glove* in the Louvre and the
much later *Pope Paul III* (*Ill. 147*) at Naples, we discover
a subtlety of observation that perhaps only Andrea del
Sarto among his Florentine contemporaries ever ap-
proached.

As we have seen, Titian was a pupil of Bellini, and
his earliest known work, the votive portrait at Antwerp of
Jacopo Pesaro, Bishop of Paphos, shown in supplication

150. LEONARDO DA VINCI (1452–1519). *Monna Lisa (portrait of Lisa Gherardini), c. 1500–c. 1504. Oil on wood 30$^1/_4$×20$^7/_8$ (77×53). Louvre, Paris*

before St Peter, to whom he is being presented by Pope Alexander VI, contains passages that are closer to Bellini than to Giorgione. The picture is connected with the defeat of the Turks at the naval battle of Santa Maura in 1502, when Jacopo Pesaro had commanded the papal galleys. Many years later, in 1519, the same patron ordered

from Titian another votive picture, the famous *Pesaro Madonna* (*Ill. 149*) in the Frari Church at Venice, a work that marks an important stage in the development both of the *sacra conversazione* and of portraiture itself.

It is evident from a glance at this picture that Titian was not content with the formality of arrangement of Gior-

151. TITIAN (1487/90–1576). *La Bella di Tiziano, c. 1536. Oil on canvas 39 1/2 × 29 1/2 (100.5 × 75). Pitti Palace, Florence*

gione's *Madonna* at Castelfranco (*Ill. 143*), where the design is basically symmetrical and where the holy figures and saints are represented in isolation. Already in the *St Mark enthroned, with Saints* (*Ill. 75*) at Santa Maria della Salute, an *ex voto* picture painted in celebration of the end of the great plague of 1510, Titian had brought a new informality into the tradition of the *sacra conversazione*: the four saints standing beneath St Mark's elevated throne are represented as though they had chanced to meet in this place, and three of them engage in animated, if pious, conversation, so that the whole group presents a unity absent from earlier representations: this is achieved not only by the use of natural gesture but also by a skilful massing of tone which binds one figure to another. The use of silhouette and of cast shadow contributes to the breadth of treatment and to the coherence of the composition, and such devices

152. TITIAN (1487/90–1576).
*Bacchus and Ariadne, 1522. Oil on canvas 67³/₄×72³/₈ (172×185).
National Gallery, London*

constantly recur in such masterpieces of the second decade as the *Assunta*, or *Assumption of the Virgin*, painted for the Frari Church, the *Bacchanal of the Andrians* in the Prado, and the *Entombment* in the Louvre. In the *Assumption* and in the *Entombment*, silhouette and tonal contrast are employed both as a means to purely pictorial ends and as the vehicle of dramatic expression. But in the *Pesaro Madonna* (*Ill. 149*) such contrasts, although still very much in evidence, have been muted so that they no longer shout from the canvas.

The Frari *Assumption*, commissioned in 1516 and finished two years later, was at first received with misgivings by the Franciscan friars, and it is understandable that this should have been so: the Virgin's assumption into

153. GIOVANNI BELLINI (*c.* 1430–1516). *Feast of the Gods, c. 1514; partly overpainted by* TITIAN. *Oil on canvas 67 × 74 (170 × 188). National Gallery of Art, Washington D.C., Widener Collection*

heaven is represented as a sudden and violent event that astonishes the Apostles gathered below, one of whom, with outstretched hand, seems to be attempting to stay her swift passage from the earth. Our experience of the Baroque, with its calculated exploitation of the emotions of surprise and wonder, has, no doubt, lessened for us the shock that those who first set eyes upon the altarpiece must have experienced.

The *Pesaro Madonna*, begun in 1519, occupied Titian for seven years. During this time he made various alterations to his original design, the most important of which was his abandonment of a setting within a church and the introduction of the two imposing columns which dominate the upper area of the composition. On a raised podium beneath the right-hand column, Titian placed the Virgin and Child, and at a lower level, below the other column, the impressive figure of St Peter, seated upon the upper step leading to the Virgin's throne. Below, Jacopo Pesaro, on the left, and other members of the family on the right, kneel in prayer, facing inwards; behind the bishop an ensign, bearing the same splendid standard embroidered with the Pesaro arms that is to be seen in the earlier picture at Antwerp, leads in a Turkish captive; on the right, St Francis, the patron saint of the church, stands upon the marble stair on the other side of the Virgin from St Peter, turning in supplication towards the Christ-Child, as with one hand he indicates the members of the house of Pesaro grouped together below him; far above, on a little cloud, two cherubs support Christ's Cross.

A number of points may be noted about this complex composition. In the first place, the design enabled Titian to preserve the necessary hierarchical distinctions between the Virgin and Child, placed on the uppermost level, and the two saints, who occupy a lower level, and between these sacred figures and those of the donor and his family. Secondly, Titian boldly dispensed with the symmetrical arrangement common to the Castelfranco *Madonna* (*Ill. 143*) and to the Madonnas of Bellini, transferring the Virgin and Child to a position far to the right of centre. He compensated for this asymmetrical placing by providing, on the left, a counterweight in the form of the banner with the Pesaro crest and also by inclining the Virgin's head into the

central field of sky between the two columns. The kneeling members of the Pesaro family themselves support the pyramidal design of the sacred figures, but at the same time the long diagonal that leads up to the Virgin from the donor, through the figure of St Peter (who leans slightly inwards), is counterbalanced by the opposing angle of the banner. Above, variety is given to the columns by shad-ows that break across them; but only in the upper regions of the composition, where some activity was necessary to avoid an effect of emptiness, is the lighting quite as drama-tic as it is in the *Assumption*.

The originality of this oblique composition cannot be stressed too strongly. There is little in Titian's very early works, such as the Giorgionesque frescoes of the *Life of St Anthony* at the Scuola del Santo in Padua, which he completed in 1511, to prepare us for such inventiveness; and even the *Sacred and Profane Love*, one of the most harmonious of all Titian's early compositions, exhibits a tender quietude of feeling that is not far removed from the sentiment of Palma Vecchio.

The decade that opens with Titian's first great altar-piece for the Frari Church, the *Assumption*, and closes with the completion of the second, the *Pesaro Madonna*, wit-nessed an astonishing flowering of his genius. It was during this period – in the years around 1520 – that he was employed by Alfonso of Ferrara to paint three mytholog-ical subjects for his *camerino*, a small room in the Estense Palace – the *Feast of Venus*, the *Bacchanal of the Andrians* (both now in the Prado), and the *Bacchus and Ariadne* (in London; *Ill. 152*). The three pictures were to hang to-gether, along with Bellini's *Feast of the Gods* (*Ill. 153*) and a bacchanalian scene by Dosso Dossi.

It is probable that the three paintings by Titian were intended to form a group on their own, and they have been plausibly connected with the three stages of Love as defined by Bembo in his *Asolani* – 'chaotic love', 'harmo-nious love' and 'transcendent or divine love', represented in turn by the infant passions of the *Feast of Venus*, by the harmonious courtship and dancing of the *Bacchanal of the Andrians*, and by the fatal love of a mortal for a god which is the subject of the *Bacchus and Ariadne*. The mood of the *Bacchanal of the Andrians* is tender and relaxed, but the

Bacchus and Ariadne (Ill. 152) strikes a note of urgency and dramatic tension, as Bacchus leaps from his cheetah-drawn car to greet the doleful Ariadne. The harmonious music of the Andrians is here replaced by the clamorous revelry of Bacchus's retinue of satyrs and cymbal-clashing bacchantes.

Titian composed the picture in terms of a dramatic conflict of opposing movements: the main movement is from right to left, being first stated in the processing revellers accompanying Bacchus, and it culminates in the leaping form of the god himself. This movement is reversed by the figure of Ariadne, the twist of whose body seems to direct it upwards towards the symbolic stars of her constellation; it is further counteracted by the static forms of the cheetahs and by that of the dog in the foreground, which has turned to face the little faun leading the bacchic procession. Other stabilizing factors in the design include the use of strong verticals and horizontals in the landscape and the pyramidal arrangement of the figures of Ariadne, Bacchus and a third figure – that of the serpent-wreathed satyr (reminiscent of the *Laocoön*) in the right foreground. The apex of this pyramidal organization is formed by the extremities of Bacchus's fluttering draperies, and various other passages in the composition contribute to it. The spatial organization of the composition was no less intellectually devised; and the interval that separates Ariadne from her divine lover opens out into a broad vista of distant hills and sea such as only Titian could paint, while the relationships established between one figure and another create rhythmic patterns of interweaving forms. Most marvellous of all is the treatment of the central figure of the young Bacchus, perfectly balanced in mid-air; a figure derived ultimately from an ancient relief, but transmuted by Titian's imagination into a new and far more vital image. Titian never surpassed this masterpiece. Only in the *poesie* painted in his old age for Philip II of Spain was he to produce works comparable with the *Bacchus and Ariadne* in their imaginative evocation of classical mythology.

154. *(opposite)* CORREGGIO (1489/94–1534). *Ganymede, c.1531.* Oil on canvas 64¹/₄ × 27³/₄ (163 × 70.5). *Kunsthistorisches Museum, Vienna*

CHAPTER TWENTY-THREE

Correggio

A remarkable feature of Cinquecento painting in north-
ern Italy was the proliferation of vital local schools, nota-
bly in such centres as Milan (where Leonardo's influence
was decisive and long-lasting), Ferrara and Bergamo
(which were particularly receptive to the art of the Vene-
tians), Parma (which produced both Parmigianino and
Correggio) and even humble Bassano (the birthplace of
that original and independent genius Jacopo da Ponte).

By far the greatest of all the provincial masters of north-
ern Italy was the short-lived Antonio Allegri, called Cor-
reggio after the town of his birth, which lies about thirty
miles from Parma. Definite information about Correggio's
artistic origins is scanty, but the tradition that he was the
pupil of Mantegna, presumably in Mantua, is probably
correct. It may also be assumed that it was at Mantua that
he painted his earliest independent works before settling in
Parma. His first documented work is the *Madonna of St
Francis* (*Ill. 156*), which was completed in 1515 for the
Franciscan community in Parma. This altarpiece tells us
a good deal about the early influences upon Correggio's
development. In the first place there are clear echoes of
Raphael's *Madonna di Foligno* (*Ill. 155*), which are espe-
cially marked in the figures of St Francis and St John the
Baptist. Indeed, the figure of the Baptist is virtually Raph-
ael's figure in reverse: the gesture of the Virgin, on the
other hand, suggests a reminiscence of Mantegna's *Ma-
donna of Victory* (in the Louvre) and a still profounder debt
to Leonardo's *Virgin of the Rocks* (*Ill. 103*). The hard
linearism of Mantegna's style has been forsaken for a soft,
Leonardesque *sfumato*, and the Virgin's wistful features
and tense right hand are virtually copied from Leonardo's
composition.

Parma belonged to the Duchy of Milan, and it is more than possible that at an early age Correggio had visited Milan, where he would have been able to study the work of Leonardo and his pupils at first hand. The Leonardesque smile of the Dresden Virgin is no accident, and it persists as one of the most easily recognizable characteristics of the distinctive facial types in Correggio's pictures, distinctive because of a subtle transmutation whereby an expression that is coldly enigmatic in Leonardo takes on, in Correggio, an aspect of radiant and joyous yearning.

It has been argued that Correggio must at some stage in his career have seen the works of Michelangelo and Raphael in Rome. But while several of his figures certainly recall the Sistine Chapel, he may not have known it at first hand. The most direct source for his dome paintings is unquestionably the ceiling of Mantegna's Camera degli Sposi in Mantua (*Ills. 70, 71*).

Of Correggio's three great works in fresco, all at Parma, those in the Camera di San Paolo are the most charming and consciously decorative; those at San Giovanni Evangelista the most heroic and Michelangelesque; and those in Parma Cathedral, in which the influence of Mannerism is apparent, the most adventurous in their anticipations of Tintoretto and of Baroque illusionism. In the Camera (*Ill. 157*), decorated in 1518 or 1519, the chief emphasis is laid upon a beguiling, almost rococo elegance. Painted ribs fan out from the centre of the ceiling, dividing the whole vault into sixteen sections, and enclosing within each of these fields, at successive levels, a swag of fruit, a wreath-framed opening which discloses, against a vista of sky, a pair of playful *putti*, and, below, in the lunette in which each division terminates, an allegorical figure or group of figures executed in grisaille – such as *Minerva, Chastity*, the *Punishment of Juno* and the *Three Graces*. The lunettes show an extensive knowledge of the antique, and many of the figures are derived from representations on ancient coins. The decorative trellis-work, festooned with fruit and foliage, that covers the vault is taken directly from Mantegna's *Madonna of Victory*.

The subject of the frescoes in the cupola of San Giovanni Evangelista, painted in the early 1520s, is the *Vision of St John upon Patmos* (*Ill. 71*). As St John gazes up-

155. RAPHAEL (1483–1520). *Madonna di Foligno, 1512. Oil on canvas 126×76³/₈ (320×194). Vatican Museums and Galleries*

156. CORREGGIO (1489/94–1534). *Madonna of St Francis, 1514–15. Oil on wood 117³/₄×96¹/₂ (299×245). Gemäldegalerie, Dresden*

207

157. CORREGGIO (1489/94–
1534). *Vault decorations, 1518/19.*
Fresco. Camera di San Paolo, Parma

wards in rapture, the heavens open to reveal a vision of
Christ in glory, surrounded, upon banks of clouds, by
nude figures of Apostles and angels. The four pendentives
contain figures of the Evangelists, each paired with one of
the Doctors of the Church. A number of Old Testament
figures, such as Jonah, Elijah and Moses, all of them pre-
figuring the redeeming work of Christ, are represented
below: these are among the most powerful of all Correg-
gio's creations, as they are also among the most sculptural.
In the cupola itself, the visionary form of Christ has a
conviction comparable with that of the Jehovah of the
first scene on the Sistine ceiling, by which Correggio may
well have been influenced: in feature, however, the ide-
alized head recalls rather the type of Raphael's Christ in
the Vatican *Transfiguration* (*Ill. 134*). The joyous angels
have their prototypes in the *Madonna di Foligno* (*Ill. 155*)
and in Titian's *Assumption.*

The boldness of Correggio's conception requires little
comment: his use of violent foreshortening to convey an
impression of the movement of the celestial figures through

limitless space represents an astonishing development from the more static exercises of Mantegna. In the *Assumption of the Virgin* on the cupola of Parma Cathedral, executed between 1526 and 1530, illusionism is carried still further: the domed vault appears to dissolve in a vortex of swirling forms which rise ever higher as the Virgin is borne aloft into the very eye of heaven; and the vast spaces of the dome are thronged, tier upon tier, with the heavenly hosts – ecstatic, gesticulating, Ariel-like figures of insubstantial lightness.

The attitude of one of these angelic figures is repeated exactly, with a curious appropriateness, in the *Ganymede* at Vienna (*Ill. 154*), one of a group of mythological sub-jects illustrating the 'Loves of Jupiter' which were com-missioned about 1530 by Federigo II Gonzaga – the other pictures in the series being the *Jupiter and Io*, also at Vienna, the *Leda* at Berlin and the *Danaë* in the Borghese Gallery in Rome. Correggio interprets the ancient fables with an exquisite lightness of touch – epitomized by the soaring, light-dappled Ganymede, a creature of beguiling grace who is only too conscious of his charm – and at the same time with an unashamed sensuousness which is given its most overt expression in the voluptuous playfulness of Leda's companions in the Berlin picture. It is not to force historical analogies to see in Correggio's delicate eroticism a foretaste of the rococo painter Boucher.

Correspondingly, Correggio reveals himself in his altarpieces as the most amenable of religious painters. Such works as the *Madonna of St George* at Dresden and the more celebrated *Madonna of St Jerome* in the Galleria Nazionale at Parma may be said to put the seal upon the development in the early 16th century of a more intimate and credible treatment of the *sacra conversazione*; and it is as though the attendant saints – and even the lion of St Jerome – were participating in a long-desired family reunion. No painter ever expressed the joy of Christ's coming with such tender delight. The same mood prevails in the *Nativity* ('*La Notte*') at Dresden of the early 1530s, an imaginative antic-ipation of the 'tenebrism' which was to be increasingly explored in the Cinquecento, notably by such northern masters as Savoldo, Titian, Tintoretto and Bassano.

CHAPTER TWENTY-FOUR

The later work of Titian

158. TITIAN (1487/90–1576).
*Death of St Peter Martyr, 1530
(destroyed). Engraving by Martino
Rota. British Museum, London*

We left Titian's career in the 1520s: we must now return to follow the works of his maturity and old age. Of all the great Venetian masters of the Cinquecento, none was more saturated in the art of antiquity, or made a more tasteful or effective use of it, than Titian; and from the 1530s he was increasingly to apply classical motifs to the illustration of Christian legend. A representative example is the large painting of the *Death of St Peter Martyr*, executed in 1530 for the church of Santi Giovanni e Paolo in Venice and known to us since its destruction in the 19th century from a full-scale copy and an engraving (*Ill. 158*): here the most prominent of the figures, the Saint's companion who flees away in terror in the left foreground, must have been based directly upon the ancient group known as the *Ludovisi Gaul* (in the Museo Nazionale in Rome), which exhibits the same violent *contrapposto*. The vehemence of the style of this impressive work must also owe much to Michelangelo. Once again, we are in the presence of the mysteriously fructifying influence of the marriage of art and life, as images culled from both art and life work upon the imagination of a supreme master. The *Death of St Peter Martyr* is in this sense a particularly apposite example, for the majestic trees that arch over the violent scene below were surely studied directly from Nature, and when Constable, in a famous lecture delivered in London in 1833, traced the rise of landscape painting from ancient times, he singled out Titian's composition as a work of particular importance in the development of the naturalistic tradition. After his visit to Rome in 1545, the classical influences upon Titian's style became still stronger, and helped to mould the character of the great mythologies painted for Philip II.

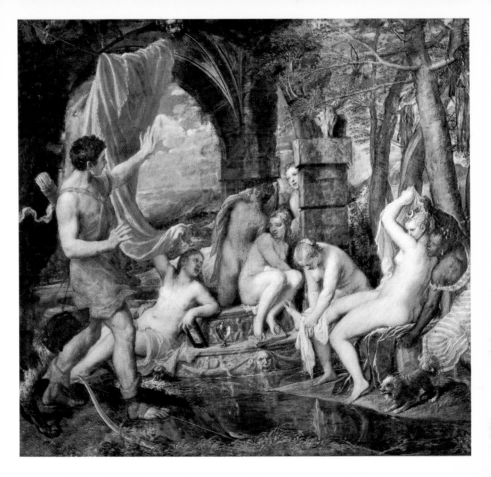

Meanwhile, Titian's supremacy among Venetian painters was unchallenged. In the early 1530s he attracted the attention of the Emperor Charles V, who commissioned him to make a version of a full-length portrait of himself by his court painter Jacob Seisenegger. Titian's portrait (now in the Prado) closely follows the original, but it is treated more broadly, and possesses a dignity and distinction lacking in Seisenegger's faithful but uninspired likeness.

The full-length portrait was virtually a German creation, and had become the rule for State portraiture. There was no such tradition in Italy, where almost all portraits had been restricted to the half-length (the only exceptions are in Brescian painting: see p. 228). The Duke of Ur-

159. TITIAN (1487/90–1576). *Diana and Actaeon, 1559. Oil on canvas 75 × 81³/₄ (191 × 213). Duke of Sutherland Collection, on loan to the National Gallery of Scotland, Edinburgh*

bino, painted by Titian in 1536, seems to have rejected the idea of the full-length. It was used with majestic effect, however, both for Titian's second portrait of Charles V (at Munich), painted at Augsburg in 1547, and for that of Philip II in the Prado.

Before going to Augsburg Titian had painted his masterly three-quarter-length of *Pope Paul III* (*Ill. 147*), both technically and psychologically one of the greatest portraits in the world, and a no less powerful, if less studied, portrait of *Pietro Aretino* (Pitti, Florence), which the poet sent as a present to Cosimo de' Medici.

These important commissions should not, however, distract our attention from his portraits of humbler sitters, and especially those voluptuous and yet sensitive representations of Venetian women, of which the most celebrated is that in the Pitti Palace known as *La Bella di Tiziano* (*Ill. 151*). This painting was executed at the same time as the portrait of Francesco della Rovere, and it is close in feeling and treatment to the companion-portrait of the Duke's wife Leonora (also in the Uffizi). The Duke, indeed, was so struck by *La Bella* that he gave orders to his agent in Venice that Titian should finish the picture for him. The contrast between this opulent tribute to feminine beauty and Leonardo's *Monna Lisa* (*Ill. 150*) or Michelangelo's austere sketch of Vittoria Colonna is almost amusing. Not here, by any means, the Florentine ideal of womanhood, pale, grave and intellectual: Titian's *Bella* was obviously born for love and pleasure. Perhaps she was one of the beautiful women who attended those 'bacchanalian feasts', as Titian called them, which he held in his house at San Casciano. There, after sunset, the tables would be spread in a garden overlooking the lagoons, which 'soon swarmed', as a contemporary tells us, 'with gondolas full of fair women, and resounded with the music of voices and instruments'.

Much the same delight in external beauty characterizes the large *Presentation of the Virgin*, painted in 1538 for the refectory of the Confraternity of the Carità in Venice. The Confraternity was housed in the building that has since become the Accademia, and the picture can still be seen in its original setting. Occupying the length of one wall of a room, it is deliberately decorative in intention; it is Car-

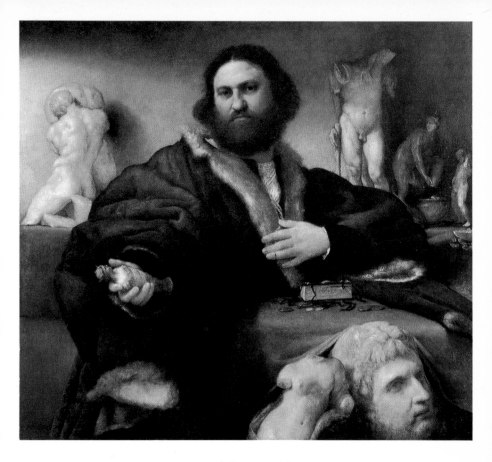

paccio writ large. Although the principal elements of the iconographic tradition, including the fifteen steps mentioned in the Gospel of Mary, have been preserved, what is emphasized is the splendour of the occasion, and the scene takes place against a magnificent architectural setting which opens out into a splendid vista of mountains and sky.

In 1545 Titian made his long-delayed visit to Rome, on the invitation of the Farnese Pope, Paul III. Two years earlier, during a visit to Bologna, the Pope had sat to Titian for the great portrait at Naples (*Ill. 147*), and he now commissioned him to paint the group-portrait, also in Naples, in which he is shown in conversation with his nephews Ottavio and Cardinal Alessandro Farnese. The picture was never finished, possibly because Titian took

160. LORENZO LOTTO (*c.* 1480–1556). *Andrea Odoni, 1527. Oil on canvas 44¹/₈×39³/₄ (114×101).*

no pains to disguise the senility of the Pope, possibly be-
cause of criticisms of Titian's style that may have been
made by Michelangelo, then engaged in the decoration of
the Cappella Paolina. Titian's guide in Rome was none
other than Giorgio Vasari, who conducted him on a tour
of the ancient monuments, and also took Michelangelo to
see him: it is known that on this occasion Michelangelo
expressed himself in polite terms about a mythological
picture which he saw on Titian's easel, but that after-
wards he became more guarded, saying that although he
admired his style 'it was a pity that good *disegno* was not
taught at Venice'.

The fruits of Titian's study of the antique in Rome are
apparent immediately in the classicizing style of the *Danaë*
in the Capodimonte Museum at Naples, a painting ex-
ecuted for the Farnese family before his return to Venice
in the Spring of 1546.

To the 1550s and 1560s belong the great series of *poesie*
commissioned by Philip II, who on the abdication of
Charles V had inherited his father's Spanish dominions.
One picture, a *Danaë*, was based on the earlier version
painted in Rome, but with an old woman replacing the
Cupid. The other paintings in the series are the *Venus and
Adonis* (Ill. 162) in the Prado (of which there are other
versions elsewhere), the *Perseus and Andromeda* in the Wal-
lace Collection in London, the *Rape of Europa* in the
Gardner Museum at Boston, the *Diana and Callisto* and
the *Diana and Actaeon* (Ill. 159) in the collection of the
Duke of Sutherland (on loan to the National Gallery of
Scotland in Edinburgh), and the *Death of Actaeon* in the
collection of the Earl of Harewood (on loan to the Na-
tional Gallery in London). The series is documented by
some interesting correspondence between the king and
the painter, which shows that Titian was fully in accord
with his patron's wishes respecting the erotic content of
the pictures. Thus in explaining to Philip II his inten-
tions in the *Venus and Adonis* (Ill. 162), Titian writes:
'Since the Danaë which I sent your Majesty fully reveals
the front of the body, I have tried in this other *poesia* to
vary it, and to disclose the other side, so that the room
where they are to hang may present a more pleasing aspect.
Soon I shall be sending you the *poesia* of Perseus

161. *'Letto di Policleto'. Marble relief
after an antique composition known in
Renaissance times (detail). Palazzo
Mattei, Rome*

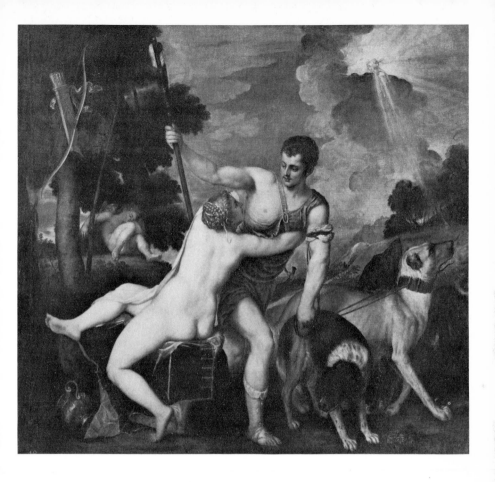

and Andromeda which will have yet another angle, dif-
ferent from these two.' So wholehearted a delight in phys-
ical beauty sheds an interesting light upon the personality
of that ambiguous monarch Philip II, and it also reminds
us that the reaction during the period of the Counter-
Reformation against the representation of the nude in
works of art, which is typified by the criticism levelled at
Michelangelo's *Last Judgment*, was by no means universal.

Certainly in Titian Philip II found a painter perfectly
fitted to do justice to the ancient fables of the loves of gods
and mortals that he desired him to evoke upon canvas. On
Titian's side, it cannot be doubted that the patronage of
Philip II was as important to him as his earlier employ-
ment by Alfonso of Ferrara: it was as though his youthful

162. TITIAN (1487/90–1576).
*Venus and Adonis, 1554. Oil on
canvas 73 $^1/_2$ × 81 $^3/_4$ (187 × 208).
Prado, Madrid*

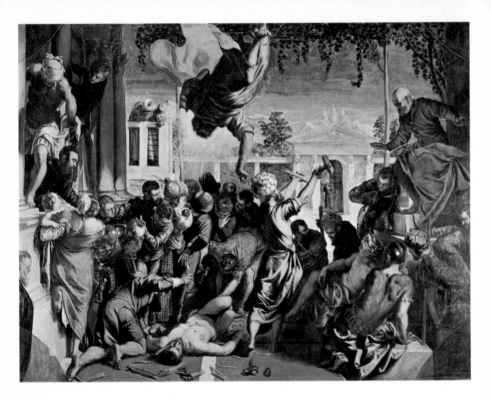

163. TINTORETTO (1518–94).
*Miracle of St Mark rescuing a Slave,
1548. Oil on canvas 163³/₈×214
(415×543.5). Accademia, Venice*

powers had been renewed in old age, and the *Danaë*, the
Venus and Adonis, the *Rape of Europa* and the *Diana and
Actaeon*, which most critics would probably accept as the
finest of the group, are to be numbered among his supreme
masterpieces.

The chief literary sources for the series were the *Meta-
morphoses* and the *Fasti* of Ovid, but, as in his earlier
mythologies for Alfonso d'Este, Titian's imagery was
even more profoundly affected by the antique: the *Venus
and Adonis* (Ill. *162*) recalls a famous relief, known as the
Letto di Policleto (Ill. *161*), of which a version was owned
by Ghiberti; and similar classical borrowings are to be
found in the other canvases in the series.

Vasari, commenting upon the *poesie*, drew attention to
the change that had taken place in Titian's technique.
'His mode of proceeding in these ... works', he wrote, 'is
very different from that pursued by him in those of his
youth, the first being executed with a certain care and
delicacy, which renders the work equally effective, whether

seen at a distance or examined closely; while those of the
later period, executed in bold strokes and with dashes, can
scarcely be distinguished when the observer is near them,
but if viewed from the proper distance they appear perfect.'
In his early works Titian had painted on a white ground,
which helped to give luminosity and brilliance to his
colours, and was not averse to working up a passage in
some detail, but a few years before the commission for the
poesie he began to employ a heavily primed canvas, paint-
ing from dark to light, applying his colours with brush-
strokes of unprecedented breadth, and making increasing
use of scumbling (dragging a brush loaded with stiff,
opaque pigment over a passage in a painting). As the
occasion arose he would also dab on spots of colour with
his fingers, a fact noted in an interesting account of his
technique written by his pupil Palma Giovane.

As Vasari observed, the late works, when seen close
at hand, are a medley of apparently chaotic colours; and
only at a distance does this chaos resolve itself into har-
mony. This revolutionary technique is of great historical
importance, for it signifies a new recognition of the specific
qualities of the oil-medium. What is of equal importance
is that the late works of Titian show a fundamentally new
approach to colour orchestration. In his early period Titian
delights in dazzling effects of brilliant and varied colour
and in often violent contrast, whether of colour or of tone.
In the late paintings, on the other hand, these luminous
contrasts give way to a fusion of related colours and silvery
tonalities: Titian the colourist develops into Titian the
harmonist; and, while his palette is not more restricted, he
employs colour with greater reserve, playing upon the sub-
tlest modulations, so that the stronger notes sing out with
added vibrancy.

There is no more beautiful example of Titian's late
style than the *Diana and Actaeon* (*Ill. 159*), the most magni-
ficently composed of all the *poesie*, and a work even grander
in conception than the early *Bacchus and Ariadne* (*Ill. 152*).
Ovid's story of Actaeon's intrusion upon the privacy of
the chaste goddess and her startled companions was a sub-
ject supremely suited to Titian's genius: the surprise and
alarm of Actaeon, offset by the affronted modesty of
Diana, produce a dramatic tension which is conveyed to

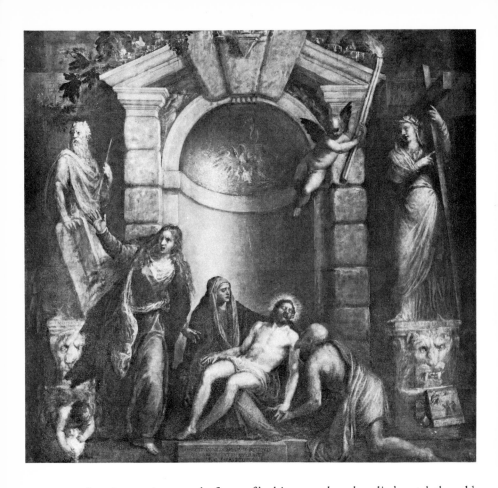

164. TITIAN (1487/90–1576).
Pietà, 1573–6. Oil on canvas
137³/₄×153¹/₂ (350×415).
Accademia, Venice

the flutter of bathing nymphs, whose limbs catch the gold of the sun or reflect the pearly light filtering through the shade. Throughout the composition, colour contrasts, where they occur, are softened by the conjunction of related tones: the deep crimson of the curtain which hangs from the archway, behind the figure of Actaeon, and the dark blue of the distant hills glimpsed beyond have similar tonal values; and the superb conception – anticipating Manet's *Olympia* – whereby the dusky form of Diana's Ethiopian servant is played against the goddess's white radiance produces a contrast that is muted by the interposition of silvery half-tones where Diana's naked body is shaded from the sun. Well might Titian's contemporaries conclude that

his late style 'showed the way to true painting'. Yet through the *poesie*, beneath all the delight in physical beauty, there runs a tragic tone that removes them from the category of mere feasts for the senses of sight and touch, imbuing them with a noble and meditative gravity.

This quality becomes still more intense in the great religious works of Titian's final period, such as his last picture, the *Pietà* in the Accademia in Venice (*Ill. 164*). This painting was intended by Titian for his own tomb in the Frari Church in Venice, although it never reached its destination. It still remained unfinished in 1576, when he was struck down by the plague, and certain details were completed by Palma Giovane. The lamentation of the Virgin, St Mary Magdalen and the kneeling Joseph of Arimathea – a portrait of Titian himself – takes place in front of a massive pedimented niche of grey stone, containing an apsidal recess which is decorated with gold mosaic work. The simplicity and informality of the central group of figures are intensely moving: the power to lay bare such deeply felt emotion is a gift that comes only to the greatest masters, like an accession of wisdom, in the evening of their lives; and in this last testament to the world Titian declares himself one of the great tragic artists. The Accademia *Pietà* crowns the achievements of the final decade, in which Titian no longer seeks to captivate the senses but rather to penetrate to the depths of the human soul: the range of Titian's genius was never in doubt; but in the works of the final period we recognize its profundity.

CHAPTER TWENTY-FIVE
Titian's contemporaries

During Titian's lifetime, Venice ceased to be the largely Gothic city that he would have known as a boy, and put on a new face. The assimilation of High Renaissance forms in architecture was chiefly due to the work of Jacopo Sansovino, whose activity as a sculptor has already been mentioned, and to Michele Sanmicheli.

Although a Florentine, Sansovino became chief architect to the Venetian Republic two years after his arrival in 1527, and for the next forty years he was to dominate Venetian architecture much as Titian dominated Venetian painting. His most important building is probably the Library of San Marco, opposite the Doge's Palace (1532–1554). Its design is a variation on the Colosseum, with two superimposed rows of arches flanked by attached columns; there are in addition smaller colonnettes, flanking the upper windows. The relief is deep, and the sculptural quality is increased by a lavish display of figure carving in the spandrels of the arches, and garlands and oval openings in the frieze. The influence of this design was immense. It reappears in modified form in Sansovino's Palazzo Corner della Ca' Grande and in his Loggetta at the base of the Campanile; Palladio soon took it up – in chaster form, – and it was pushed to a sculptural extreme in the seventeenth century by the Venetian Baroque architect Longhena. It even appears in painting, particularly in the works of Veronese. Sansovino made one excursion into another mode: the Mint (*La Zecca*) next to the Library, of 1535–45, is an astonishing display of angular rustication, combined with the unorthodox details of Mannerism.

Michele Sanmicheli came from Verona and received his training, like Sansovino, under Sangallo. He was

originally a military engineer, responsible for the great ramparts of Verona, and his palace architecture owes much, in its weight and solidity, to this experience. For the most part his palace façades have the orthodox rusticated ground storey and classical orders on the upper floor formulated by Bramante, but on this theme he played several consciously sophisticated variations. The Palazzo Bevilacqua at Verona, for instance, has spirally fluted columns as well as an alternating rhythm based on a triumphal arch. His great Venetian palaces – the Palazzo Grimani and the Palazzo Cornaro Mocenigo – were designed in the same vein, but are still more impressive in scale.

Two of the most celebrated landmarks of Venice, the churches of the Redentore and San Giorgio Maggiore, are the work of another great non-Venetian architect, Andrea Palladio. Their plans are superb exercises in rational invention; their elevations employ the classical orders at their purest and grandest; and their façades are highly ingenious combinations of motifs taken from Roman temple fronts. Even more important are the villas built by Palladio in his native Vicenza and the surrounding country, inland from Venice. Of these the Villa Maser – which Veronese was to decorate (see Chapter Twenty-six) – is perhaps the epitome of the Palladian type of symmetrical villa, fronted by an imposing classical portico; but the most famous is the Villa Rotonda (*c.* 1550), conceived as a cubic structure built around a circular domed room: here, in addition to the main portico, there are similar porches on the other three sides of the building. This style was to be applied to the eighteenth-century country house by the English 'Palladians'. Palladio's influential treatise, the *Quattro libri dell'architettura*, contains a detailed exposition of his architectural principles, which were founded upon mathematical theory, like Alberti's, and upon a profound knowledge of classical antiquity.

The Roman influence which is apparent in Venetian architecture of the Cinquecento is paralleled by a similar development in Venetian painting of the same period; and Titian's three greatest contemporaries, Sebastiano del Piombo, Giovanni Pordenone and Lorenzo Lotto, all made decisive visits to Rome, where they were deeply im-

pressed by the work of Michelangelo and Raphael. Sebastiano, indeed, was to remain in Rome for the rest of his life, apart from a short visit to Venice in 1528.

We have seen that it was from Sebastiano that Raphael had learnt the secret of Venetian colouring. Subsequently, Sebastiano became the protégé of Michelangelo, who often supplied him with designs for his pictures, including the *Raising of Lazarus* (*Ill. 135*) painted in competition with Raphael. Although in that contest Sebastiano had been the loser, his reputation as the first painter in Rome was unchallenged after Raphael's death. In 1531 Clement VII appointed him to the sinecure of the *Piombo*, or Keeper of the Papal Seal; hence the name by which he is known.

Sebastiano's most important commission before he settled in Rome was for an altarpiece for San Giovanni Crisostomo in Venice (*Ill. 120*), representing the patron saint of the church and other saints. The figures are grouped in front of an imposing temple. St John Chrysostom, seated at the centre upon the temple steps, is engaged in writing a book of homilies, and his concentration upon his task helps to give the scene its air of uncontrived informality. Sebastiano must have made a thoughtful study of the *St Mark* (*Ill. 75*) at Santa Maria della Salute, and set out to surpass the naturalness of Titian's grouping.

Sebastiano arrived in Rome in 1511, where his first commission was for nine lunettes in the Villa Farnesina. Their sumptuous and sensuous colours attracted the attention of Raphael, decisively affecting his style and inspiring the rich harmonies of the *Mass of Bolsena* (*Ill. 119*). In his turn, Sebastiano was receptive to the art of Raphael, whose influence is especially evident in his Madonnas and portraits, in which, however, he retained a Venetian splendour of colouring. But the impact of Michelangelo's personality was to prove still stronger; and all the major works of Sebastiano's later years – such as the emotionally charged *Pietà* painted for San Francesco at Viterbo, the London *Raising of Lazarus* executed in direct competition with Raphael, and the *Flagellation of Christ* commissioned for San Pietro in Montorio – were the fruits of this association.

The Michelangelesque inspiration of the *Raising of Lazarus* (*Ill. 135*) is particularly clear, since several of the

figures are variants upon some of the most famous *concetti* of the Sistine ceiling. The majestic Christ combines the gestures of the Godhead in Michelangelo's frescoes of *God Blessing His Creation* and the *Creation of Man*; Lazarus, freeing himself from the grave-clothes, is reminiscent of one of the *ignudi*; and Martha, who recoils from the ghastly apparition, raises her hands and turns her head aside in the gesture of the Eve of the *Expulsion from Paradise* (a pose deriving from a *Medea* sarcophagus): but the effect of these powerful poses is weakened by the overcrowding of the composition with so many figures. The landscape in the *Lazarus* is that of the Tiber valley, and contains, in the ruins on the left, a reminiscence of the Basilica of Constantine: the sentiment, however, remains Venetian, and the sunlight that falls upon the distant village (representing Bethany) beyond the shadowed bridge, picking out the variegated greens of the trees and meadows, is rendered with a bravura worthy of Titian himself.

Sebastiano was not by nature a dramatic artist, and consequently his interpretation of Michelangelesque form is sometimes a little forced. But in the prolific Giovanni Pordenone northern Italy produced a painter whose style matches the *terribilità* of Michelangelo in its vehemence and energy. Pordenone's origins were provincial: he was born in Pordenone (to the north-west of Venice), whence he took his name. He soon came under the influence of Giorgione, Palma Vecchio and Titian in Venice: subsequently he was to be no less profoundly affected by the work of Michelangelo, Sebastiano and Raphael, and it is probable that about 1516 he made a visit to Rome. He died in 1539, at the age – according to Vasari – of fifty-six, so that he would appear to have been an almost exact contemporary of Sebastiano.

In 1520 Pordenone accepted a commission to paint a number of scenes from the Passion in the Cathedral at Cremona, four of which had already been executed by Romanino. These frescoes are among Pordenone's masterpieces, and – still more than any work by Sebastiano – they anticipate the art of Tintoretto in their furious energy and forcefulness of expression. There are echoes here of Mantegna and yet stronger influences from the Sistine ceiling and the later Stanze. All is movement and activity,

reaching a climax in the *Crucifixion* (*Ill. 166*), in which the agony of Golgotha is laid bare with a directness comparable with the stark expressionism of Grünewald's Isenheim Altarpiece.

Pordenone was by now established as the major fresco-painter working in northern Italy, and in 1528 he was called to Venice to undertake decorations in the church of San Rocco. In 1535, he made Venice his home, setting himself up as a rival to Titian. The moment, in a sense, was propitious, for Titian had neglected his commitments to the Venetian Republic, giving priority to his work as Court Painter to Charles V. The knighthood now conferred upon Pordenone by King John of Hungary was a deliberate reply to the Emperor's ennoblement of Titian; a mark of prestige that was immediately followed by important commissions for fresco-decorations from the Venetian State, none of which, however, has survived. Pordenone also executed ambitious façade decorations at this time for three of the great Venetian palaces – Palazzo Mocenigo, Palazzo d'Anna and Palazzo Morosini,–but these too have perished.

The success enjoyed by Pordenone in Venice was denied to his contemporary Lorenzo Lotto, despite Titian's professed admiration of him; and after an early Venetian

165. ROMANINO (1484/7–1562). *Christ before Pilate, c. 1520. Fresco. Cathedral, Cremona*

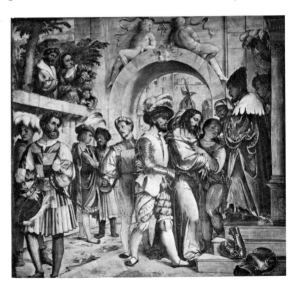

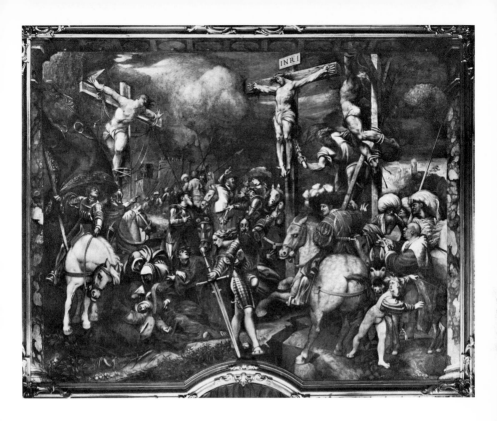

166. GIOVANNI ANTONIO
PORDENONE (1483/4–1539).
*Crucifixion, 1521/2. Fresco.
Cathedral, Cremona*

training Lotto was compelled, for the most part, to con-
fine his activity to such northern cities as Treviso and
especially Bergamo, where he established a high reputa-
tion. Lotto's origins in the Bellini School are apparent
from the composition of the *Madonna of St Dominic* (1508),
at Recanati in the Marches, although a certain restlessness
in the design – due partly to illumination from below –
and a tendency towards congestion are peculiar to his
nervous and highly individual temperament. In Venice
Lotto had become the friend of Palma Vecchio, and an
early *sacra conversazione* in the Borghese Gallery in Rome is
almost entirely in Palma's manner. Inevitably, like Palma,
he was touched by the poetry of Giorgione, who must
have helped to awaken his gift for landscape.

Lotto's originality as a landscape-painter can be judged
from the *St Jerome in the Desert* (*Ill.* 77), which also dates
from his early period. This subject had traditionally be-
come the excuse for a concentration upon a detailed rep-

resentation of landscape forms, from rocky escarpments – suggestive of the desert places of the saint's meditations – to more homely reminiscences of local scenery; but in the Louvre picture Lotto reduces the scale of the saint's figure still further, almost hiding him within the fabric of nature, and produces what is almost pure landscape. The impression is given that one has ascended to a high altitude among alpine forests; one thinks even of Altdorfer and of the fascination that Nature in her wilder moods held for the German masters of the 16th century, examples of whose work Lotto had possibly seen in Venice.

Lotto was receptive to a wide diversity of influences, ranging from Leonardo and Raphael to Correggio, but his bold experiments with spatial organization and his interest in lighting show a highly personal inventiveness: there seems always to have been in him an urge to surprise the beholder with some novel effect. It is this quality, together with his profound interest in the psychology of his subjects, that gives such an individual character to his portraits: the *Young Man* in the Kunsthistorisches Museum in Vienna, an early work, startles by its very directness and informality, and there is an unexpectedly modern look about the sitter's nervous, questioning expression. Still finer is the portrait of the connoisseur *Andrea Odoni* (*Ill. 160*), a work that was evidently painted in Venice in 1527, and which anticipates Titian's *Jacopo Strada* of over forty years later. But where Titian habitually preserves his sitter's distance, Lotto invites intimate acquaintance; and it is this impulse to penetrate beneath the mask that has made him, as a portrait-painter, particularly admired today.

The cities of Bergamo, at the western extremity of the Venetian territories, and Brescia, not far to the south-east, had close cultural connections, and between them they produced a school of painting in the 16th century second only, in northern Italy, to that of Venice itself. Its three most important painters were Romanino and Savoldo (both of whom – like Lotto – were formed in Venice under the influence of Giorgione and Palma Vecchio) and Alessandro Bonvicino, known as Moretto.

Romanino worked almost exclusively at Brescia, but his first masterpiece is the altarpiece executed for the Bene-

dictine Church of Santa Giustina in Padua, where he took refuge after the sack of Brescia in 1512 by the French forces commanded by Gaston de Foix. In 1519, he received the commission, already mentioned, to paint four scenes from the Passion in Cremona Cathedral (*Ill. 165*). Like the slightly later frescoes there by Pordenone, these compositions seem to reflect a northern influence, and the expression is intensely realistic and at times brutal.

His contemporary Savoldo continued the Giorgio-nesque tradition in a style at once lyrical and naturalistic. In his major altarpieces, such as the *Virgin in Glory* painted for San Domenico at Pesaro and now in the Brera Gallery in Milan, he could design on a monumental scale in the manner of Titian; but most of his pictures are small in scale, and he had a predilection for representations of the Nativity and the Adoration in which the scene is illu-mined by the dying glow of sunset or by moonlight. The same delight in the poetry of light can be seen in the wrongly named *Gaston de Foix*. This picture, representing a knight in armour whose figure is reflected by two mir-rors, is of particular interest because of its connection with the ancient dispute, which was argued with renewed intensity in the 16th century, as to the relative merits and potentialities of painting and sculpture: the painters con-tended that their art was capable, by the use of mirrors, of rivalling the sculptor's ability to present more than one aspect of a three-dimensional form.

When Romanino returned to Brescia, after painting the Cremona *Passion* scenes, he found Moretto already established as the leading painter; and the two artists now worked together on the decoration of the Chapel of Cor-pus Christi at San Giovanni Evangelista, where in the *St Matthew and the Angel* the effect of candle-light antici-pates Caravaggio. Moretto's style descends ultimately from Mantegna and Foppa, but he was no less decisively in-fluenced by Palma Vecchio, Pordenone and Titian, and (as Vasari observed) he responded also to the graceful ideal of Raphael. He was content to remain permanently in Brescia, where he was extensively employed in the painting of altarpieces and portraits. His glowing colour and rich effects of chiaroscuro were largely derived from Titian, although he was inclined to dwell too much upon

descriptive detail, and lacked Titian's invention and va-
riety. In two great compositions – the *Feast in the House of
Simon the Pharisee* (*Ill. 168*) and the *Marriage at Cana* in
San Fermo at Lorigo – Moretto anticipates Veronese (see
Ill. 167): the Biblical narratives are made the excuse for a
display of gorgeous pageantry and decorative splendour.

As a portrait-painter Moretto had great distinction;
indeed it was he who introduced the full-length portrait
into Italy, with his *Unknown Man* of 1526, now in the
National Gallery in London. While his portraits lack
Titian's humane breadth and authority, and never ap-
proach the insight characteristic of Lotto, they assert an
ideal of casual elegance and refinement which must have
greatly appealed to his aristocratic clients. A fine example
is the three-quarter-length of a *Young Man* (*Ill. 169*), in
which the unknown sitter, sumptuously attired in green
satin and fur cloak, rests his head musingly upon one hand
in the wistful attitude of the disconsolate lover. It was this
genial style of portraiture that Moretto passed on to his
pupil Giovanni Battista Moroni, a master of the informal
likeness whose refined clarity of vision is well represented
by the famous *Portrait of a Tailor*, also in London.

Much the same Venetian influences that determined
the development of painting in Brescia and Bergamo were
felt in Ferrara – not itself a Venetian dependency. The two

167. PAOLO VERONESE
(*c.*1528–88). *Supper at Emmaus,
c.1559. Oil on canvas 114^1/$_8$ × 176^3/$_8$
(290 × 448). Louvre, Paris*

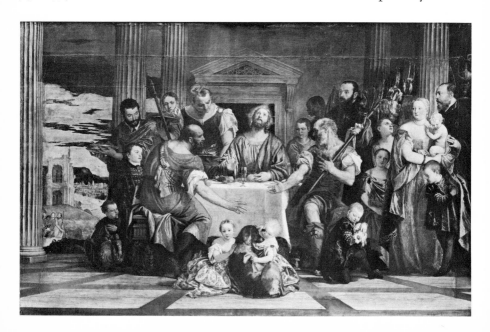

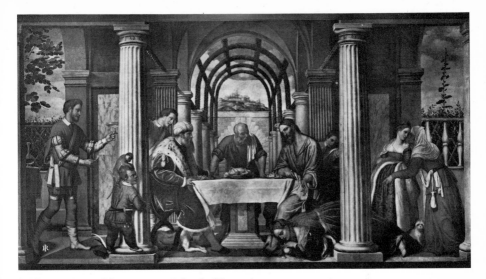

168. MORETTO OF BRESCIA
(*c*. 1498–1554). *Feast in the House of Simon the Pharisee, 1544. Oil on canvas* 119¹/₄ × 234⁵/₈ *(303 × 596). Santa Maria della Pietà, Venice*

leading masters of the Ferrarese School of the 16th century, Benvenuto Tisi, known as Garofalo, and Dosso Dossi, had their artistic origins in the circle of Giorgione (of whom, according to Vasari, Garofalo was a personal friend), but both later came under the influence of Raphael in Rome. Garofalo's large *Pagan Sacrifice* (National Gallery, London) is representative of his elegant eclecticism, in which the sensuousness of Giorgione and Titian is blended with a refinement derived from Raphael and the antique. Dosso's most characteristic works are mythological subjects, of which the *Circe* at Washington is perhaps his materpiece; and, as we have seen, he contributed a *Bacchanal* to Alfonso d'Este's *camerino*. In his interpretations of ancient legend he shows an inventive fancy infused with a lyricism not much less inspired than that of Giorgione himself.

A special place in the history of landscape painting must be reserved for Jacopo da Ponte, known from his birthplace near Venice as Jacopo Bassano. After an early visit to Venice, where he absorbed the new manner introduced by Giorgione, Palma Vecchio and Titian, Bassano retired to his native town to develop, from about the middle of the century, that 'rustic' manner for which he was most celebrated, and which was to play an important part in the creation of *genre* painting. Whether in his char-

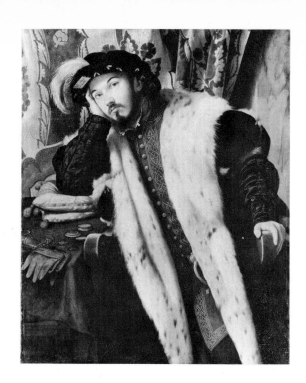

169. MORETTO OF BRESCIA
(*c*. 1498–1554). *Portrait of a Young Man, 1526. Oil on canvas 78 × 35 (198 × 88). National Gallery, London*

acteristic Nativities and Adorations, or in his pastoral landscapes – such as the superb picture in the Thyssen Collection (*Ill. 170*) – he portrays the simple life of the peasantry with a passionate and touching sympathy. His four sons, of whom Francesco and Leandro were the most gifted, continued his manner, notably in a number of small canvases representing the Seasons, which mark a further stage in the development of the *genre* subject. Thus in the hands of the Bassani the artificial Pastoral introduced into Venice by Giorgione – the haunt of legendary divinities and pensive nymphs – became receptive to the realities of rustic life.

In the last twenty years of his life Jacopo Bassano devoted himself to dramatic effects of lighting, often in nocturnal scenes of a grave and meditative splendour: these pictures are among the most poetically intense of those explorations of the world of night which were to become a characteristic preoccupation of the Baroque painters, and they bring him close at times to Tintoretto.

170. JACOPO BASSANO (1510/18–92). *Pastoral Landscape, c. 1560. Oil on canvas* $55^1/_2 \times 51^5/_8$ *(141 × 131). Thyssen-Bornemisza Collection, Castagnola*

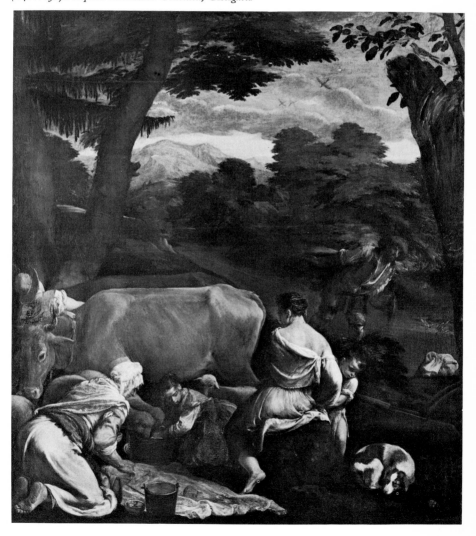

CHAPTER TWENTY-SIX

Tintoretto and Veronese

The great period of Venetian painting draws to an end upon a note of unprecedented grandeur and magnificence: the development that opened with the gentle cadences of Giorgione closes in the splendid harmonies of Veronese and the vibrant chords of Tintoretto. Both masters founded their style upon that of Titian, but they also opened the way to entirely new possibilities – Tintoretto to El Greco, Caravaggio and the Baroque; Veronese to the Carracci, Poussin, Rubens and Tiepolo.

The nickname 'Tintoretto' given to Jacopo Robusti simply means 'little dyer', being an allusion to his father's profession. Tintoretto was born in Venice, where Titian is said to have taken him for a brief period as his pupil: Titian was certainly the strongest influence upon his early years. There are also stylistic connections between Tinto-retto and the Trevisan painter Paris Bordone, who on settling in Venice had developed a personal and intimate version of Titian's manner, combining rich colouring with a genial realism that anticipates Bassano. The heroic temper of Tintoretto's mind drew him no less inevitably towards Michelangelo, although there is no record of a visit to Rome. The motto which the young painter is said to have placed over his studio door, 'The colouring of Titian and the drawing of Michelangelo', accurately de-fines his eclectic intentions; and his life's work was to be a successful fulfilment of this ideal.

In his first major work, the *Miracle of St Mark* (*Ill. 163*), painted in 1548 for the Scuola di San Marco, the figure of the saint hurtling downwards from the heavens must have been inspired both by the energetic Jehovah of the Sistine ceiling and also by the Christ of Michelangelo's *Conver-sion of St Paul* (*Ill. 140*), and there are other figures that

are no less Michelangelesque in character. Yet in the richness of its tonal harmonies the composition is profoundly Venetian, and, more specifically, Titianesque.

The shifting play of light; the deep pools of shade suppressing the forms within them to dusky vagueness or flat silhouette; the intense, predominantly warm colours that blaze in the light or glow from the shadows – of these brilliant effects, activated by energetic movement projected through a grandiose space, is the heroic rhetoric of Tintoretto's art compounded. One of his principal innovations – and again there is a precedent in Michelangelo's *Conversion of St Paul*, completed only about three years before the *Miracle of St Mark* (which, indeed, was executed while Michelangelo was still working in the Cappella Paolina) – was to organize his compositions in such a manner that the principal pictorial movement is directed into, or out of, the depths of the space, rather than flowing laterally from one side of the picture to the other. This new attempt to explore the potentialities of spatial composition is only nascent in the *Miracle of St Mark*, but the *Presentation of the Virgin* (*Ill. 139*) at Santa Maria dell'Orto in Venice, of 1551–52, marks its triumphant fulfilment. In this startling composition Tintoretto opposed to the serene splendour of Titian's version of the same subject in the Scuola della Carità (now the Accademia) an interpretation that is as austere in its avoidance of the decorative as it is violent in its insistence upon the thrust and counter-thrust of dynamic movement.

In the *Discovery of the Body of St Mark* in the Brera Gallery in Milan, another work commissioned (along with two further scenes from the Apostle's life) by the Scuola di San Marco, the obliquely receding perspective of a high-arched hall, whose chilly vastness almost makes echoes visible, tunnels out a cavernous space narrowing towards a distant rectangle of light. On the left St Mark, in his spiritual body, identifies his sepulchre from among a row of tombs that line the far wall: his imperious gesture counterbalances the thrusting orthogonals of the architecture. Space itself seems to be charged with drama and miracle. The use of a bold diagonal as the basis of a composition occurs frequently in Tintoretto's work, and it was to become a characteristic feature of Baroque painting. In

the *Presentation of the Virgin* (*Ill. 139*) he had discarded convention in the representation of sacred legend, and in his great series of canvases at the Scuola di San Rocco, which occupied him for twenty-three years, he was no less impatient with tradition in his interpretation of the Life of Christ.

This vast enterprise, upon which Tintoretto began work in 1564, had been inaugurated by a competition for a ceiling painting of *San Rocco in Glory*, his competitors being Veronese, Salviati and Taddeo Zuccaro. Such was Tintoretto's eagerness to obtain this commission that he stole it by a trick: when the other artists brought their sketches to San Rocco for the inspection of the judges, they found to their dismay that Tintoretto had already transferred his ideas to canvas and the canvas itself to the appropriate place on the ceiling. It was equally character-istic of Tintoretto that, in order to make no mistake, he painted certain passages in the manner of his rivals, in an attempt to prove that he was at least their equal upon their own ground.

The San Rocco decorations, vast in scale and sublime in conception, are worthy of comparison with the frescoes of the Sistine ceiling itself: yet the impression that they make is very different. Tintoretto's genius was less intellectual than Michelangelo's, and depended more upon the sud-den, visionary illumination; he had the power to invent a striking image that became, as it were, the central thought of a design, the essence of his general idea. Where that power failed him his expression could become almost ordinary and even vacuous; where it was at its height, his soaring imagination defied all precept in its boundless creativeness; and in interpreting the ancient Biblical themes he invented a whole new iconography, seeing each subject afresh and imposing upon it the authority of his own vision.

The decorations in the Scuola di San Rocco fill three rooms. Tintoretto began the vast work by painting for the small Sala d'Albergo three episodes from the Passion – the immense *Crucifixion* and the paired scenes of *Christ before Pilate* and the *Road to Calvary*. The adjacent Upper Hall, decorated between the years 1576 and 1581, con-tains, on the four walls, a series of large canvases, each

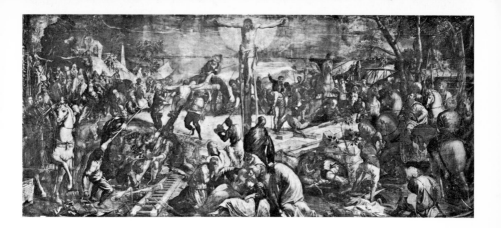

seventeen feet high, illustrating the Life of Christ, and, on
the ceiling, a number of Old Testament miracles pre-
figuring Christ's redemptive work. The slightly smaller
canvases in the Lower Hall, on the floor below, which
were painted between 1583 and 1587, are devoted to the
Life of the Virgin.

The gigantic *Crucifixion* (*Ill. 171*) in the Sala d'Al-
bergo rivals Michelangelo's frescoes in the Cappella Pao-
lina in the overwhelming power of its design and in its
heroic austerity of expression. The starkness of Tinto-
retto's presentation of the agony of the Cross brings to
mind Pordenone's *Crucifixion* (*Ill. 166*) at Cremona; but
Tintoretto eschews Pordenone's descriptiveness, and every-
thing in his composition contributes to a universal idea.
Christ, hanging from the Cross at the centre of the picture,
looks down with compassion upon the grief-stricken group
of the holy mourners huddled at its foot. On either side
an ever-widening circle of human beings, participants and
onlookers, has its centre in the same still figure of Christ,
the focus of the dominant radiating movement of what is
a basically symmetrical design. Suspended above the earth
against a threatening sky, a nimbus of light defining the
more strongly the silhouette of his bowed head and heroic
frame, Christ is represented as both victim and Redeemer,
as one 'rejected of men' and yet 'glorified': 'And I, if I be
lifted up from the earth, will draw all men unto me.' It is
a staggering conception, and perhaps no painter – not
even Rembrandt – ever gave profounder expression to the
cosmic significance of the Crucifixion.

171. TINTORETTO (1518–94).
*Crucifixion, 1565. Oil on canvas
211 × 482 (536 × 1224). Scuola di
San Rocco, Venice*

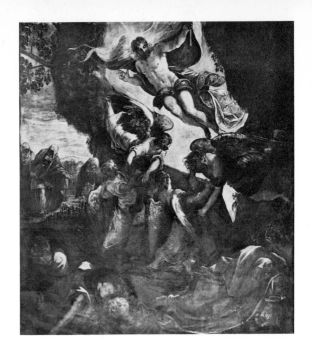

172. TINTORETTO (1518–94).
*Resurrection, 1576–81. Oil on canvas
208×191 (528×485). Scuola di
San Rocco, Venice*

The composition can be related in many ways to Michelangelo's *Conversion of St Paul* (*Ill. 140*), a work that would appear to have been a source of continual stimulation to Tintoretto's imagination. Although it lacks the explosive movement of Michelangelo's design, it is similarly organized around two focal points, one in the upper area of the composition and the other in the lower, from which the surrounding forms radiate to right and left. The design is severely geometrical; and yet so varied are the attitudes of the figures, and so continually surprising the conflicts of light and dark and the effects of contrasted colour, that the structural elements, while giving coherence to the whole, in no way obtrude upon the dramatic expression.

The austerity of Tintoretto's style is such that many of the San Rocco pictures, including the *Christ before Pilate* and the *Road to Calvary* in the Sala d'Albergo, contain vast areas of unrelieved canvas, impenetrable fields of dark against which the rough-hewn figures are picked out by the modelling light. Such contrasts are nowhere more effective than in such compositions as the *Raising of Lazarus* and the *Temptation of Christ* (in the Upper Hall) and

the *Annunciation* and *Flight into Egypt* (in the Lower Hall), where the conflict between light and dark is particularly intense and dramatic. In the sensually beautiful Satan of the *Temptation* scene (*Ill. 173*), a figure of epicene luxury and deceit that perhaps only a Venetian could have conceived, Tintoretto created an image of sheer evil that has been justly compared for its imaginative power with the Satan of Milton's *Paradise Lost*: the dialogue between Christ and the Tempter was never presented more dramatically or with equal plausibility.

173. TINTORETTO (1518–94).
Temptation of Christ, 1576–81. Oil on canvas 212×130 (539×331).
Scuola di San Rocco, Venice

174. TINTORETTO (1518–94).
*Flight into Egypt, 1583–7. Oil on
canvas 165³/₄ × 228 (421.5 × 579).
Scuola di San Rocco, Venice*

At San Rocco Tintoretto invented a world of heroic
conflict in which all experience is elevated to the sphere
of the sublime, so that the spectator ceases to be concerned
with appearances for their own sake but at once grasps the
deeper significance of the drama that is set before his eyes.
It is this power to lay bare the spiritual meaning of the
Gospel narratives that makes such scenes as the *Resurrec-
tion* and the *Annunciation* so overwhelmingly convincing.
In the *Resurrection (Ill. 172)*, Christ is impelled upwards
as he breaks free from the sepulchre, an heroic figure of
light emblazoned against the darkness, and if the mind
suspends its disbelief it is because it is compelled, not to
dwell upon the miracle as a terrestrial event, but to ap-
prehend its larger meaning.

During the long period of his labours on the San
Rocco cycle Tintoretto's style developed in the direction
of a still greater freedom of handling, until in the *Flight
into Egypt (Ill. 174)* and in the two separate representations
of *St Mary Magdalen* and *St Mary of Egypt*, all of which
have as their settings nocturnal landscapes that dwarf the

figures, his brush suggests instead of defining the forms, and flickering whites, laid on thickly, evoke the brittle gleam of moonlight glancing upon shallow streams and upon the dark foliage of silhouetted trees. If the scale were not so vast, or the handling so broad, we should be re-minded at once of Giorgione, so profound is this poetry of mood; but Tintoretto's interpretation of nature pos-sesses nothing of the still quietude of Giorgione's land-scapes: his vision is altogether harsher and more tempes-tuous, and these brooding night-thoughts have an epic rather than an idyllic quality.

In the course of his work for San Rocco Tintoretto found time for many other commissions – altarpieces for Venetian churches, large-scale decorations for the Doge's Palace, some portraits, notable for their grave dignity, and a few mythological paintings. Many of the earlier decora-tions in the Doge's Palace were destroyed by fire in the year 1577, and Tintoretto and Veronese were entrusted with the task of replacing them. Tintoretto's four *Alle-gories of Venice*, painted in the following year, are probably the finest of his contributions to this extensive project, and it is a measure of the range of his genius that at the same time that he was creating the tragic world of the San Rocco cycles he was able to produce compositions that vie with the work of Veronese in their sumptuous beauty. Never-

175. TINTORETTO (1518–94). *Last Supper, 1592–4. Oil on canvas 143⁷/₈ × 224 (365.5 × 569). San Giorgio Maggiore, Venice*

theless, Tintoretto was primarily a religious painter, and in his last years he returned to the spirit of the San Rocco decorations – first in the stupendous *Paradise* in the Sala del Maggior Consiglio in the Doge's Palace (famous to tourists as the largest oil painting in the world) and, subsequently, in three great compositions for San Giorgio Maggiore – the *Gathering of the Manna*, the *Last Supper* and the *Entombment.*

In the *Last Supper* (*Ill. 175*) Tintoretto again employed the dramatic, diagonal perspective that he had used in the *Discovery of the Body of St Mark*: the long table no longer runs across the picture, as in Leonardo's fresco in Milan, but projects from the depths of the space, with the consequence that the element of formality that still survived in Leonardo's composition is totally destroyed. In its place Tintoretto evokes an atmosphere of mysterious inquietude, as of an event that is enacted in a flickering half-light and which the bewildered disciples have no power to comprehend. In the *Entombment*, painted in the last year of his life (1594), all the profundity of Tintoretto's genius as a religious painter is given final expression in a composition comparable in its tragic intensity with the great *Pietà* painted by Titian for his own tomb.

Since every period of history is a complex of conflicting tendencies, it oftens happens that the more pronounced characteristics of a particular age find fulfilment in the work of men of diverse and perhaps opposing ideals. Venice, in the second half of the 16th century, produced two such representative figures in Tintoretto and Veronese; the one driven by a genius that was at once austere, energetic and tragic; the other a brilliant virtuoso whose element was the festive and the spectacular.

Veronese, as his name implies, was born in Verona, but about 1553 he settled in Venice, where he soon became Tintoretto's principal rival. Although he was unsuccessful in the San Rocco competition of 1564, he had already received extensive employment upon the decoration of the Doge's Palace, and in 1556 he had won a competition, which was judged by Titian and Sansovino, for ceiling decorations for the Library of St Mark's. Indeed, by the middle 1550s, he was established as the most popular decorative painter in Venice.

176. PAOLO VERONESE
(c. 1528–88). *Feast in the House of
Levi (originally Last Supper), 1573.
Oil on canvas* $50^3/_4 \times 216^1/_2$
(128 × 550). Accademia, Venice

In the year 1560 he made a visit to Rome. While Tin-
toretto's sympathies lay with the heroic style of Michel-
angelo, Veronese was attracted more by the grace and
charm of Raphael and by the daring inventiveness of Giu-
lio Romano. However, like Tintoretto, he was still more
fundamentally indebted to Titian. Among the other in-
fluences upon his early development, that of Correggio
was one of the most decisive; and it must have been partly
from Correggio that he acquired his light and radiant
palette, although in his great ceiling decorations at San
Sebastiano and at the Doge's Palace he never fully accept-
ed Correggio's ideal of spatial composition, preferring to
retain the virtues of surface decorativeness. That Veronese
knew Moretto's *Feast in the House of Simon the Pharisee*
(*Ill. 168*), at Santa Maria della Pietà, seems clear from
his early *Supper at Emmaus* (now in the Louvre; *Ill. 167*),
which must date from his first years in Venice. This
crowded canvas recalls Moretto both in its careless display
of visual delights at the expense of the religious subject-
matter and in the vibrant orchestration of the colour, in
which effective use is made of black as a foil to rich reds
and golds. A striking feature of the painting is the prom-
inence given to the donors and their family: it is as though
the children had been taken out to witness a religious
spectacle, although the youngest among them pay more
attention to their pet dogs than to the solemn scene that
is being enacted before them.

Notwithstanding this secular approach to religious
subject-matter, Veronese is known to have been a man of

strict piety. Yet his flaunting of the proprieties in his reli-
gious paintings was to lead him into trouble with the In-
quisition. The occasion was a commission given to him
in 1573 by the Dominican friars of Santi Giovanni e Paolo
for a large picture of the *Last Supper*. Veronese not only
proceeded to give the scene (*Ill. 176*) the aspect of a secu-
lar banquet in palatial surroundings, but also introduced
such seemingly irrelevant figures as jesters and carousing
soldiers, as well as the familiar dogs. Veronese's bold
defence before the Inquisitors of the artist's freedom to
paint as his fancy prompted him is now famous. Never-
theless, he was compelled to rename the picture, which
now became (and it mattered little) the *Feast in the House
of Levi*. This is the great painting now in the Accademia in
Venice, one of a series of similar subjects taken chiefly
from the New Testament which are made the excuse for
a vast scenographic spectacle. These splendid pageants are
in the first place glorifications of the new Venice – the
Venice of Sansovino and Palladio – but they are also
compositions of intricate inventiveness, and Veronese here
broke entirely new ground in the range and subtlety of his
orchestration of colour. The nobility of human life and

*177. Villa Barbaro, Maser. Frescoes
by* PAOLO VERONESE (*c.* 1528–88)
begun c. 1560

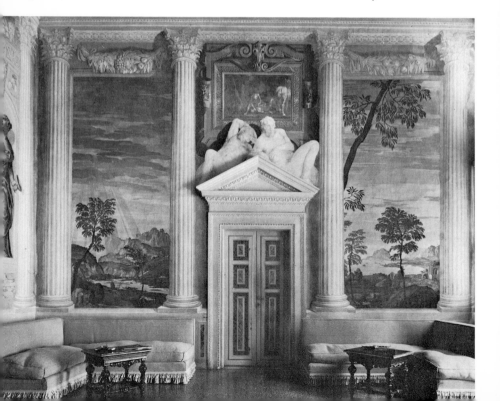

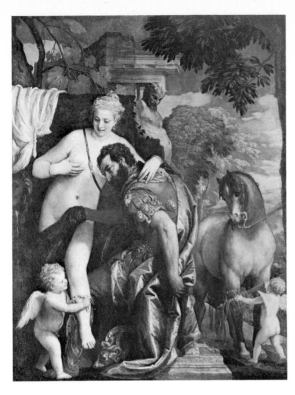

178. PAOLO VERONESE
(*c.* 1528–88). *Mars and Venus
united by Love, after 1576. Oil on
canvas* $80^3/_4 \times 66^1/_8$ *(205 × 168)*.
*Metropolitan Museum of Art,
New York, Kennedy Fund 1910*

the dignity of civilization find expression in colour itself;
colour that matches the cultured refinement of his drawing
and his unerring gift for the telling shape or arrangement.

It was appropriate that on the completion of the Villa
Barbaro at Maser, one of the finest of Palladio's country
houses, the Barbaro family should have entrusted the task
of decorating its rooms to Veronese. The brothers Daniele
and Marcantonio Barbaro were distinguished Venetian
patricians and diplomats; they were both learned men
who were deeply versed in the arts; and it was their inten-
tion in availing themselves of the services of Palladio and
Veronese that both architect and painter should recreate
something of the atmosphere of an ancient Roman villa,
such as the famous Sabine retreat of Horace. Vitruvius
had described Roman wall-paintings representing 'varie-
ties of landscape gardening, harbours, headlands, shores,
rivers, springs, straits, temples, groves, cattle, hills and
shepherds'. And it was in much the same spirit that Ve-
ronese, availing himself of recently produced sets of en-

gravings of topographical views and Roman ruins, gave a special prominence in his decorations in the Villa Barbaro to illusionistic landscapes (*Ill. 177*), whose function, evidently, was not only to enchant the eye but also to summon up memories of the glories of ancient Rome.

The other decorations in the Villa Barbaro include a light-filled ceiling-fresco representing the fable of *Bacchus's Revelation to Mankind of the Mysteries of Wine*, a composition that opens out into a vista of cloud-flecked sky. Veronese was a painter ideally fitted for the interpretation of classical mythology, and yet such subjects by him are mostly to be numbered among his minor works. Of these, two of the finest are the charming *Rape of Europa* and the *Mars and Venus* (*Ill. 178*).

Veronese was principally a great decorator, a painter of splendid pageants, and he was at his best when his subject-matter allowed him free scope to indulge his taste for sumptuous textures and opulent colours and for those melodious arrangements of intricately varied shapes that guide the eye with such ease across the eloquent surfaces of his compositions. Appropriately enough, his last major work, executed in the late 1580s – the vast oval canvas which decorates the ceiling of the Sala del Maggior Consiglio in the Doge's Palace, – has for its subject the *Triumph of Venice*. Unlike the late work of Tintoretto, it discloses no new insight, but only a final perfecting of immense gifts. Here the illusionism of Giulio Romano and Correggio is made decorous and elegant, but the grandiose architectural perspectives serve primarily to provide a fittingly magnificent setting for the symbolic figures glorifying the Republic of Venice: the illusion of space is denied by the primary, decorative intention.

The deepest impulses of the Renaissance are not to be looked for in the art of Veronese; but in him there triumphed that most vital discovery of the Venetian genius – the pictorial value of tonal and colour orchestration. And at a time when, under the pressures of the Counter-Reformation, the age of the Renaissance in Italy was drawing to its close on a note of gloom and renunciation, it was a happy circumstance that the painter who so confidently defied the Inquisition should have been this supreme purveyor of luminous colour.

The following list of books recommended for further reading is confined to works available in English. Periodical literature is not included. For more information, especially on articles in the leading art-historical journals, the student is recommended to consult the quarterly volumes of the *Art Index*, in which new publications are listed by author and subject. Peter and Linda Murray's *Dictionary of Art and Artists* (illustrated ed. 1965) is without peer among works of reference, and contains a comprehensive bibliography. For an excellent introduction to the complexities of Renaissance culture and for a discussion of problems of historiography, see Peter Burke's *The Renaissance* (1964). An excellent new study is Frederick Hartt's *History of Italian Renaissance Art* (1969, 1970).

I GENERAL

Architecture P. Murray, *The Architecture of the Italian Renaissance*, rev. ed. 1969; N. Pevsner, *An Outline of European Architecture*, Jubilee ed. 1960; T. W. West, *A History of Architecture in Italy*, 1968; G. Masson, *Italian Villas and Palaces*, 1959; R. Witt-kower, *Architectural Principles in the Age of Humanism*, 3rd ed. 1962.

Sculpture E. Panofsky, *Tomb Sculpture*, 1964; J. Pope-Hennessy, *Italian Gothic Sculpture*, 1955, *Italian Renaissance Sculpture*, 1958, and *Italian High Renaissance and Baroque Sculpture*, 1963; C. Seymour, *Sculpture in Italy, 1400 to 1500*, 1966; W. R. Valen-tiner, *Studies in Italian Renaissance Sculpture*, 1950; B. H. Wiles, *Fountains of Florentine Sculptors and their Followers from Donatello to Bernini*, 1933.

Painting B. Berenson, *Essays in the Study of Sienese Painting*, 1918, *Italian Painters of the Renaissance*, 1953, *Italian Pictures of the Renaissance: Florentine School*, 1963, and *Italian Pictures of the Renaissance: Venetian School*, 1957; E. Carli, *Sienese Painting*, 1956; J. A. Crowe and G. B. Cavalcaselle, *A History of Painting in Italy*, 1903–14, and *A History of Painting in North Italy*, 1912; M. Davies, *The Earlier Italian Schools* (catalogue of the National Gallery, London), 1951; S. J. Freedberg, *Painting of the High Renaissance*

in Rome and Florence, 1961; C. Gould, *An Introduction to Italian Renaissance Painting*, 1957, *The Sixteenth-Century Italian Schools (excluding the Venetian)* (catalogue of the National Gallery, London), 1962, and *The Sixteenth-Century Venetian School* (catalogue of the National Gallery, London), 1959; R. van Marle, *The Development of the Italian Schools of Painting*, 1923–6; F. Jewett Mather, *Western European Painting of the Renaissance*, 1939; B. Nicolson, *The Painters of Ferrara*, 1950; J. Pope-Hennessy, *Sienese Quattrocento Painting*, 1947; E. Sandberg-Vavalà, *Uffizi Studies*, 1948, *Sienese Studies*, 1953, and *Studies in the Florentine Churches*, 1959; L. Venturi and R. Skira-Venturi, *Italian Painting: The Creators of the Renaissance*, 1950, and *Italian Painting: The Renaissance*, 1951.

Drawing B. Berenson, *The Drawings of the Florentine Painters*, 1938; K. T. Parker, *Catalogue of the Drawings in the Ashmolean Museum* (Oxford), Vol. II, *Italian Schools*, 1956; A. E. Popham and P. Pouncey, *Italian Drawings, 14th and 15th Centuries* (catalogue of the British Museum, London), 1950–52; A. E. Popham and J. Wilde, *The Italian Drawings of the 15th and 16th Centuries in the Collection of His Majesty the King at Windsor Castle*, 1949; H. Tietze and E. Tietze-Conrat, *The Drawings of the Venetian Painters in the 15th and 16th Centuries*, 1944.

II SPECIAL SUBJECTS

Renaissance Style A. Chastel, *The Studios and Styles of the Renaissance: Italy, 1400–1500*, 1965; E. H. Gombrich, *Norm and Form: Studies in the Art of the Renaissance*, 1966; M. Levey, *Early Renaissance*, 1967; P. and L. Murray, *The Art of the Renaissance*, 1963; E. Panofsky, *Renaissance and Renascences in Western Art*, 1960; J. White, *The Birth and Rebirth of Pictorial Space*, rev. ed. 1967; H. Wölfflin, *Classic Art*, 1952.

Historical and Political Background H. Ba-ron, *The Crisis of the Early Italian Renaissance: Civic Humanism and Republican Liberty in an Age of Classicism and Tyranny*, 2nd ed. 1966; J. Burckhardt, *The Civilization of the Renaissance in Italy*, 1945; F. Gilbert, *Machiavelli and Guicciardini: Politics and History in 16th-*

century Florence, 1965; A. Hauser, *The Social History of Art*, 1965; D. Hay, *The Italian Renaissance in its Historical Background*, 1961; D. Hay, ed., *The Age of The Renaissance*, 1967; L. Martines, *The Social World of the Florentine Humanists, 1390–1460*, 1963; J. H. Plumb, ed., *The Penguin Book of the Renaissance*, 1964; N. Rubinstein, *The Government of Florence under the Medici, 1434–1494*, 1966.

Humanism and Renaissance Thought

A. Chastel, *The Age of Humanism*, 1963; W. K. Ferguson, *The Renaissance*, 1964; M. P. Gilmore, *The World of Humanism, 1453–1517*, 1962; P. O. Kristeller, *Renaissance Thought*, 1961; E. Panofsky, *Studies in Iconology: Humanistic Themes in the Art of the Renaissance*, rev. ed. 1962; N. Robb, *Neoplatonism of the Italian Renaissance*, 1935; F. Saxl, *Lectures*, 1957; J. Seznec, *The Survival of the Pagan Gods*, new ed. 1961; E. Wind, *Pagan Mysteries in the Renaissance*, 1958. See also the volumes by Burckhardt, Gombrich and Panofsky cited above.

Renaissance Aesthetics and Art Theory

A. Blunt, *Artistic Theory in Italy, 1440–1600*, 1940; R. J. Clements, *Michelangelo's Theory of Art*, 1963; E. Panofsky, *The Codex Huygens and Leonardo da Vinci's Art Theory*, 1940. See also Gombrich, above.

Contemporary Writings and Documents

R. J. Goldscheider and M. Treves, *Artists on Art*, 1947; E. Holt, *A Documentary History of Art*, 1957–8; G. Vasari, *The Lives of the Painters, Sculptors and Architects* (tr. A. B. Hinds), 1927; Leon Battista Alberti, *On Painting* (ed. J. R. Spencer), 1956; Leon Battista Alberti, *Ten Books on Architecture* (English translation of 1726 by G. Leoni, ed. J. Rykwert), 1955; Benvenuto Cellini, *Autobiography* (tr. G. Bull), 1956, and *Treatises* (ed. C. R. Ashbee), 1898; E. McCurdy, *The Notebooks of Leonardo da Vinci*, rev. ed. 1939; A. P. McMahon, *The Treatise on Painting by Leonardo da Vinci*, 1956; C. Pedretti, *Leonardo da Vinci On Painting: A Lost Book (Libro A)*, 1965; I. A. Richter, *Paragone: A Comparison of the Arts, by Leonardo da Vinci*, 1949; J. P. Richter, *The Literary Works of Leonardo da Vinci*, rev. ed. 1939; E. H. Ramsden, *The Letters of Michelangelo*, 1963; R. and M. Wittkower, *The Divine Michelangelo: The Florentine Academy's Homage on his Death in 1564*, 1964; Andrea Palladio, *Quattro Libri dell'Architettura* (English translation by G. Leoni), 1715–20.

Antique Borrowings in Renaissance Art

P. Pray Bober, *Drawings after the Antique by Amico Aspertini: Sketchbooks in the British Museum*, 1957; B. Rowland, *The Classical Tradition in Western Art*, 1963; C. Vermeule, *European Art and the Classical Past*, 1964. See also the works by Gombrich, Panofsky and Saxl cited above.

Portraiture

J. Pope-Hennessy, *The Portrait in the Renaissance*, 1966.

Landscape

K. Clark, *Landscape into Art*, 1949; A. R. Turner, *The Vision of Landscape in Renaissance Italy*, 1966. See also Gombrich, above.

Technique

E. Borsook, *The Mural Painters of Tuscany*, 1960; W. G. Constable, *The Painter's Workshop*, 1954; J. Rich, *The Materials and Methods of Sculpture*, 1947; C. de Tolnay, *The History and Technique of Old Master Drawings*, 1943; *The Great Age of Fresco: Giotto to Pontormo* (catalogue of an exhibition held at the Metropolitan Museum, New York, in 1968; preface by M. Meiss, introduction by U. Procacci. The catalogue of a similar exhibition held at the Hayward Gallery, London, in 1969 is entitled *Frescoes from Florence*; preface by J. Pope-Hennessy).

III MONOGRAPHS

Fra Angelico G. C. Argan (1955); J. Pope-Hennessy (1952); see also B. Berenson, *Essays in Appreciation*, 1958

Baldovinetti Ruth Wedgwood Kennedy (1938); see also F. Hartt, G. Corti and C. Kennedy, *The Chapel of the Cardinal of Portugal*, 1964

Giovanni Bellini R. Fry (1900); P. Hendy and L. Goldscheider (1945); G. Robertson (1968); M. Meiss (*B.'s St Francis in the Frick Collection*, 1964); J. Walker (*B. and Titian at Ferrara*, 1956); E. Wind (*B.'s Feast of the Gods: a Study in Venetian Humanism*, 1948)

Botticelli G. C. Argan (1957); W. Bode (1925); H. P. Horne (*Alessandro Filipepi, Commonly Called Sandro B.*, 1908); see also L. D. Ettlinger, *The Sistine Chapel before Michelangelo: Religious Imagery and Papal Primacy*, 1965

Bronzino A. McComb (1928)

Carpaccio J. Lauts (1962); T. Pignatti (1958)

Castagno G. M. Richter (1943)

Correggio G. Gronau (1921); A. E. Popham (*C.'s Drawings*, 1959); E. Panofsky (*The Iconography of C.'s Camera di San Paolo*, 1961)

Crivelli G. M. Rushforth (1900)

Donatello H. W. Janson (*The Sculpture of D.*, 1957)

Francesco di Giorgio A. S. Weller (1943)

Ghiberti R. Krautheimer and T. Krautheimer-Hess (1956)

Ghirlandaio G. S. Davies (1909); L. D. Ettlinger (*The Sistine Chapel …*, 1965); see also E. Borsook, *The Mural Painters of Tuscany*, 1960

Giorgione L. Baldass (1965); L. Coletti (1961); G. M. Richter (1937); E. Wind (*G.'s Tempestà*, 1969)

Giovanni di Paolo J. Pope-Hennessy (1937)

Giulio Romano F. Hartt (1958)

Leonardo da Vinci C. Baroni (1961); A. Chastel, ed. (*The Genius of L. da V.*, 1961); K. Clark (*Catalogue of the Drawings of L. da V. in the Collection*

of His Majesty the King at Windsor Castle, 1969; and
L. da V.: An Account of his Development as an Artist,
1958); L. Goldscheider (1943); E. McCurdy (1933);
L.H. Heydenreich (1954); C.D. O'Malley, ed.
(L.'s Legacy: An International Symposium, 1969);
C. Pedretti (Chronology of L. da V.'s Architectural
Studies after 1500, 1962); A.E. Popham (Drawings
of L. da V., 1946); see also under II, above

Filippo Lippi E. C. Strutt (1906); see also
E. Borsook, The Mural Painters of Tuscany, 1960

Filippino Lippi K. B. Neilson (1938); see also
E. Borsook, The Mural Painters of Tuscany, 1960

Lotto B. Berenson (1956); P. Bianconi (1964)

Mantegna M. Meiss (A.M. as Illuminator: An
Episode in Renaissance Art, Humanism and Diplomacy,
1957); E. Tietze-Conrat (1955)

Masaccio U. Procacci (1962); see also E. Bor-
sook, The Mural Painters of Tuscany, 1960

Michelangelo J. Ackerman (The Architecture of
M., 1966); R.J. Clements (M.'s Theory of Art, 1963);
L. Goldscheider (1953); F. Hartt (1965); A. Stokes
(M.: A Study in the Nature of Art, 1955); J.A. Sy-
monds (Life of M.B., 1893); C. de Tolnay (1943-
60); N. Wadley (1965); J. Wilde (Italian Drawings:
M. and his Studio, catalogue of drawings in the British
Museum, London 1953); see also under II, above

Palladio J. Ackerman (1966); see also under II,
above

Parmigianino A.E. Popham (Drawings of P.,
1953); S.J. Freedberg (P., his Works in Painting,
1950)

Perugino E. Hutton (1907); see also L.D. Ett-
linger, The Sistine Chapel ..., 1965

Piero di Cosimo R. Langton Douglas (1946);
see also E.H. Gombrich, Norm and Form ..., 1966

Piero della Francesca K. Clark (1951); B. Be-
renson (1954); P. Bianconi (1962)

Piero and Antonio Pollaiuolo M. Cruttwell
(A.P., 1907); see also E. Borsook, The Mural Painters
of Tuscany, 1960; and F. Hartt et al., The Chapel of
the Cardinal of Portugal, 1964

Pintoricchio P. Misciatelli (The Piccolomini Li-

brary in the Cathedral of Siena, 1924); E.M. Philipps
(1901)

Pisanello G. F. Hill (1905; also Drawings by P.,
1929; and Medals of the Renaissance, 1920).

Pontormo F.M. Clapp (1916); J.C. Rearick
(The Drawings of P., 1964)

Quercia A. Hanson (J. della Q.'s Fonte Gaia,
1965)

Raphael E. Camesasca (1963); O. Fischel (1948);
A.P. Oppé (1909); P. Pouncey and J.A. Gere
(Italian Drawings: Raphael and his Circle, catalogue of
drawings in the British Museum, London, 1962);
W.E. Suida (The Paintings of R., 1941 and 1948)

Luca and Andrea della Robbia A. Mar-
quand (L. della R., 1914; A. della R. and his Atelier,
1922)

Bernardo and Antonio Rossellino F. Hartt,
G. Corti and C. Kennedy (The Chapel of the Car-
dinal of Portugal, 1964)

Andrea Sansovino G.M. Huntley (1935)

Sarto S.J. Freedberg (1963); J. Shearman (1965)

Sassetta E. Carli (1957); J. Pope-Hennessy (1939)

Signorelli M. Cruttwell (1899, 1901); see also
L.D. Ettlinger, The Sistine Chapel ..., 1965

Tintoretto E. Newton (1948); H. Tietze (1948)

Titian J.A. Crowe and G.B. Cavalcaselle (The
Life and Times of T., 1881); G. Gronau (1904);
D. von Hadeln (T.'s Drawings, 1927); E. Panofsky
(The Iconography of T., 1969); C. Phillips (The Earlier
Work of T., 1897); A. Pope (T.'s 'Rape of Europa',
1960); F. Saxl (Lectures, 1957); H. Tietze (1950);
J.Walker (Bellini and T. at Ferrara, 1956)

Tura E. Ruhmer (1958)

Uccello E. Carli (1963); J. Pope-Hennessy (Com-
plete Work of P.U., 1950; and P.U.: The Rout of
San Romano, 1944)

Vasari E. Rud (V.'s Life and Lives, 1963)

Veronese G. Delogu (V.: The Supper in the House
of Levi, 1948); A. Orliac (1948)

Verrocchio G. Passavant (1969)

Acknowledgements

The author and publishers are grateful to the follow-
ing individuals and institutions who have supplied
photographs, or allowed them to be reproduced.

Alinari 1, 2, 31, 40, 41, 70, 82, 91, 92, 95, 99, 106,
110, 122, 143; Anderson 27, 57, 68, 83; Aragozzini,
Milan 104; Berlin, Staatliche Museen 11; Boston,
Mass., Museum of Fine Arts 138; Brogi 15, 48, 49;
Budapest, Museum of Fine Arts 126; Cambridge,
reproduced by permission of the Syndics of the Fitz-
william Museum 146; Castagnola, Thyssen-Borne-
misza Collection 170; Courtauld Institute of Art,
University of London 16; Cracow, National Mu-
seum 102; Deutsche Fotothek, Dresden 156; R.B.
Fleming, London 112, 158; Florence, Soprinten-
denza alle Gallerie 121; Giraudon 63, 77, 97, 101,
103, 150, 167; Grassi, Siena 54, 55; Hewitt, London
163; London, courtesy the Trustees of the National
Gallery 26, 33, 53, 56, 60, 72, 79, 80, 90, 131, 135,
148, 152, 169; Mansell-Alinari 4, 5, 8, 9, 12, 13, 14,
24, 28, 29, 30, 32, 35, 39, 42, 43, 44, 58, 59, 65, 69,
85, 93, 96, 98, 107, 117, 120, 129, 130, 137, 141,
164, 165, 166; Mansell-Anderson 10, 18, 21, 25, 47,
50, 67, 71, 73, 75, 81, 84, 86, 94, 109, 113, 114,
118, 125, 128, 139, 140, 142, 149, 168, 171, 172,
173, 174, 175, 176; Mansell-Brogi 3, 45; Marzari 151;
Mas, Barcelona 162; Georgina Masson 177; Meyer,
Vienna 154; Munich, Staatliche Antikensammlun-
gen 6; Naples, Soprintendenza alle Gallerie 147;
New York, Frick Collection 78; New York, Metro-
politan Museum of Art 178; Nova Lux, Florence 7;
Rome, Gabinetto Fotografico Nazionale 52, 66, 100,
127; Sansoni 17, 159, 163; Scala 20, 22, 23, 34, 36,
37, 61, 62, 64, 74, 76, 108, 115, 119, 123, 124, 132,
133, 136, 157; Steinkopf, Berlin 19, 88, 144; Va-
tican, Archivio Fotografico Gallerie e Musei 134,
155; Villani, Bologna 51; Washington, DC, Na-
tional Gallery of Art 89, 153; Worcester, Mass.,
Art Museum 87; Ill. 98 is reproduced by courtesy of
Professor Frederick Hartt and Professor Clarence
Kennedy, from *The Chapel of the Cardinal of Portugal*
(University of Pennsylvania Press, 1964).

The author also wishes to thank Messrs Purnell &
Sons for permission to quote from his monograph on
Fra Angelico in the series 'The Masters'.

Index

Numbers in italic refer to illustrations